MISSISSIPPI
AND THE
GREAT DEPRESSION

MISSISSIPPI
— AND THE —
GREAT DEPRESSION

RICHELLE PUTNAM

Foreword by Diane Williams

THE
History
PRESS

Published by The History Press
Charleston, SC
www.historypress.net

Copyright © 2017 by Richelle Putnam
All rights reserved

All cover images courtesy of the Library of Congress.

First published 2017

Manufactured in the United States

ISBN 9781467118767

Library of Congress Control Number: 2017948486

DEDICATION

I must first dedicate this book to author/mentor Diane Williams, whose guidance and wisdom continue to steer me as an artist, teacher, author and friend. Without her inspiration for this project, this book would not have happened.

Secondly, I thank my grandsons Lance and Brett for their patience in my hours and hours of research, writing and finishing several manuscripts. You guys mean so much to me. Living with grandparents can't be easy, but you two make it look easy.

Having tunnel vision also affects time with and attention to other family members. Thank you, Mom, Daddy, Robyn, Bill, Jeff, Kathy, Eric, Erin, John, Jessica and my grandchildren Brittany, Brianne, Dallas, Presley and Wes. I love you all so much.

Most of all, thank you to my husband, Tim. Without his love for me and our family and his belief and support in my work as an artist, there would be nothing within these pages. You are my thesaurus when I don't know the right word and my dictionary when I forget the true meaning of life: family.

CONTENTS

Foreword, by Diane Williams 9

1. Preceding Events and Circumstances 13
 The Great Flood of 1927 15
 The Drought 23
 Depletion of Mississippi's Forests 24

2. Life and Times 33

3. Ethnicities and Cultures 69

4. New Deal Programs 83
 Programs 84
 Schools and Teacher Houses 87
 Colleges and Universities 93
 Community Houses 94
 Homesteads and Cooperatives 95
 Courthouses and Jails 95
 Civic Auditoriums 96
 Airports 96
 City Halls 97
 Post Offices, Murals and Sculptures 97
 National Forests, State Parks, Lakes and Recreation 100
 Other 101

CONTENTS

5. Cooperatives and Homesteads 105
 Cooperatives 109
 Homesteads 112

6. Arts and Entertainment 119
 Film and Theater 119
 Music 122
 Writers, Artists and Other Entertainers 134

7. Farming, Food Service and Foodways 141
 Foodways 151

8. Religion 161

9. In Their Own Words 173

Conclusion 191
Notes 195
Selected Bibliography 211
Index 215
About the Author 223

FOREWORD

History, despite its wrenching pain, cannot be unlived,
but if faced with courage, need not be lived again.
—*Maya Angelou*

Nothing leveled the playing field economically more than the Great Depression, which occurred during the first part of the twentieth century. Many in America struggled to survive, and situations were diverse around the country. In the Midwest, dust and tumbleweed storms made life and the struggle hard for the good people living there. In northeastern America, in the big cities, people lived close to one another in houses often separated only by a small alley or in housing units jammed next to one another with no space in between. Of course, there were smaller communities where people were more spread out.

As the Depression years persisted, the competition for work caused even the most progressive, hardworking man to take on physical, backbreaking tasks to put food on the table for the family. ("The person who labors, labors for himself, for his hungry mouth drives him on." Proverbs 16:26, NKJV) Submitting to menial labor led to ruthless and unrelenting challenges and anxieties. Often one scrambled to get into soup lines to obtain one morsel for survival. Churches were at a loss when trying to help the masses ambushed by poverty and couldn't keep their doors open for weekly worship services.

Only a few people live today who experienced and remember the Great Depression. Some senior elders were children during the Depression. My

own grandmother is ninety-nine years alive. We both remember her father, my great-grandfather—a strong African American man, born in 1900. His journey as a black man was unique, but I believe everyone's journey through the Depression provides a rich history of the fortitude and stamina of the American spirit.

I have a picture of my grandfather wearing an applejack cap and a peacoat. He is eighteen years old. With only a sixth-grade education, he knew he had to work to survive, even as a young boy, prior to the enactment of child labor laws. He delivered blocks of ice to homes that had an icebox, or "cold closet." When making deliveries, he chipped off large chunks of ice with an ice pick and placed the chunks in tin boxes lined with cork, straw or other materials used for insulation. During the 1900s, this was how food items were refrigerated in many homes. As my grandfather grew older, he committed his dreams to self-employment, delivering coal to homes with coal-fired furnaces. He was resilient and advanced with each new era. He later purchased an old oil truck and delivered oil when people stopped using coal to warm their houses. My great-grandfather was one of few who progressed through the struggle, and later in life, he owned multiple rental properties (boardinghouses).

The story of Mahalia Jackson in Chicago during the Depression years and the Great Migration is another success story. A famous singer, she survived the era of spiritual music by helping to usher in a new era of music: gospel. She helped many people struggling on the streets of Chicago during those early days. Mahalia is also remembered for using her own money to buy what was needed to heat and warm the church where she worshipped. An entrepreneurial spirit, she made a living as a gospel singer, which was just one way she earned a living. She was also a song plugger for Thomas A. Dorsey. She sold haircare products, was a beautician and owned a florist shop. It was not unusual for her to style a parishioner's hair, provide the flowers for the funeral and to sing at their loved one's funeral. But not everyone could be as creative as my great-grandfather or Mahalia Jackson.

Not everyone survived the Great Depression. Many were broken and never recovered. There were illnesses, such as fevers and viruses, a lack of proper nutrition and tragedies that led to death. What is interesting is how Americans in different parts of the country dealt with the struggle. I'm originally from New Jersey, now living in Mississippi, so the sharp contrasts are particularly noteworthy.

People in the South who lived in or near the country were blessed with resources often at their fingertips. If you knew how to hunt, you could walk

from your back porch to the nearby woods and hunt coon, possum, rabbit or squirrel; you could go frog gigging or search the pond for turtles or fish. Some people were fortunate to have a few chickens and maybe even a pig or goat. The Great Depression years were desperate, but Mississippians remember innately possessing a spirit of sharing. Even today, folks in rural areas might bring something from their garden and place it on the kitchen counter at church for someone else less fortunate or take a few items to a neighbor. There are so many stories on the hardships and the ingenuity of what those years were like.

The people of Mississippi have a unique story to tell, and their stories about the Great Depression need to be told. We don't have dust or tumbleweed storms, but we've experienced devastating tornadoes and hurricanes that gravely affected our homes, workplaces and state's economy. Can lessons be learned from our experiences, through mind, spirit and faith? I think so. Today's creative economy is one of our greatest assets, and many work in creative industries in Mississippi. In an economic downturn, Mississippians have shared and worked together to build and rebuild. We are rich with resources—from the Gulf Coast, to the pine region, the Delta and on to the Black Hills. Mississippians come together because of our ability to move on and to usher in the next era, just as my great-grandfather did. Through the Depression years, the Great Flood of 1927, Jim Crow, civil rights, tornadoes, hurricanes and other storms, our experiences helped us to prepare and be ready for serious conversations. Take a look at us! Blacks and whites are striving together—because we have to—and when a man has a few seeds, he shares with someone who doesn't have anything. Both plant, hoe and grow something to sustain their families. This metaphor attests to the spirit and soul of Mississippians who persevered during the Great Depression.

DIANE WILLIAMS

1
PRECEDING EVENTS AND CIRCUMSTANCES

It's difficult to paint a clear picture of the Great Depression, what happened, why it happened, who made it happen and how it happened. We better understand when it happened, yet historians still don't agree on that. Author and professor Robert McElvaine sorted through opinions in *The Great Depression America, 1929–1941*, when comparing contrasting views of Milton Friedman and Anna Schwartz, Charles Kindleberger and Peter Temin. Friedman and Schwartz argued that prosperity depended on money supply, which had greatly declined and thus caused the Great Depression. Kindleberger and Temin heartily rejected this view, with Temin combating that as interest rates and prices declined, the supply of money would have begun to grow. President Herbert Hoover (1929–33) thought that World War I and the 1931 European financial collapse caused the Great Depression and that the 1929 stock market crash was a "normal recession."[1]

After World War I, the United States emerged as a major creditor and financier of a devastated Europe economically crippled by war debt. Great Britain and Germany, indebted to the United States, felt the hardest punches of the worldwide Great Depression.[2]

Prior detrimental factors contributed to Mississippi's inability to deal with the nation's unstable financial condition. In antebellum Mississippi, the tenant/sharecropping system had existed in regions with few slaves or plantations. Many whites immigrating to Mississippi came with no funds to purchase land, so they worked as tenant farmers or sharecroppers. But by 1860, the cotton boom had created more millionaires per capita in the

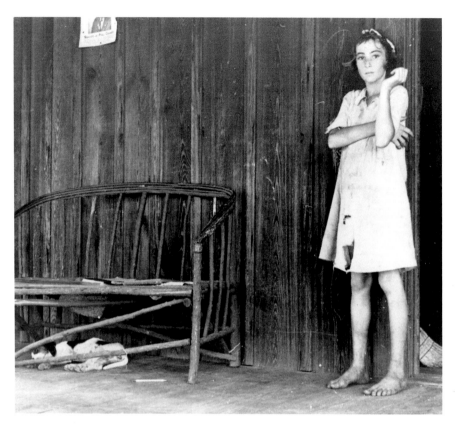

Daughter of a sharecropper, Lauderdale County. *Library of Congress.*

Mississippi River Valley than anywhere else in the United States, even though only 3 percent of whites owned more than fifty slaves. Two-thirds of white southern households didn't own any slaves, and in 1860, fewer whites owned slaves than in 1840.[3] After the Civil War, most white Mississippi farmers were reduced to tenant farmers and sharecroppers who landowners didn't treat much better than their black laborers.

In 1900, 36 percent of white farmers and 85 percent of black farmers were tenant farmers and sharecroppers, and by 1925, these white and black farmers subsisted under a staple-crop system of rising debts and declining prices. This disastrous farming system built around cotton, the major cash crop, depleted the soil for anything else to grow and flourish.[4] There was also the spread of the boll weevil across plantations in the 1900s and the depression of 1921.[5]

THE GREAT FLOOD OF 1927

Between Mississippi and Louisiana, the Mississippi River rushes southward toward the Gulf of Mexico. At the headwaters of the Mississippi, the average surface speed of water is about 1.2 miles per hour—which is about one-third as fast as a normal walking pace. At New Orleans, the speed of the river increases to an average of 3.0 miles per hour.[6]

In August 1926, torrential rains struck the ground like bullets, pummeling much of the central United States, from Nebraska, Kansas, South Dakota and Oklahoma to Kentucky, Ohio, Missouri, Illinois and Indiana. Driving rains continued for fourteen days, deluging crops and destroying harvests. And the rivers rose. By September 4, much of Indiana, Illinois, Nebraska, Kansas and Iowa was flooded. In the upper Midwest, the Mississippi River washed out railroads and bridges. Rains fell and the rivers rose through September and into October. As the Mississippi River swelled, tens of thousands of acres sank beneath its muddy depths. The 1,100 miles of the lower Mississippi from Cairo, Illinois, to the Gulf of Mexico were protected by watertight levees two and three stories high, expected to contain the force of the mighty Mississippi. The chief of the U.S. Army Corps of Engineers, General Edgar Jadwin, was confident that the levees were structurally sound enough to prevent the destructive effects of floods. But gauge readings told another story. The Weather Bureau stated, according to *Rising Tide: The Great Mississippi Flood of 1927 and How It Changed America*, "There was needed neither a prophetic vision nor a vivid imagination to picture a great flood in the lower Mississippi River the following spring." More alarming was the gauge at Vicksburg, which normally stayed at the low-water level and had historically exceeded thirty feet only six times. In October 1926, the gauge exceeded forty feet.[7]

Greenville, Mississippi resident Henry Waring Ball wrote in his diary:

April 8, 1927—The water is now at the top of the levee, and we have heavy showers and torrential downpours almost every day and night. The air is saturated with moisture, and the luxuriance of plant growth is extraordinary. Nell went through pouring rain to the garden club.

April 15, 1927—The worst Good Friday I ever saw. A night of incessant storms, wind, lightning, thunder and torrents of rain. Raining constantly all this morning, none of us slept much. A day too dark and stormy to go to church or even out of doors....River appallingly high, and levees in very precarious condition. Too dark to write, another big storm coming—noon.[8]

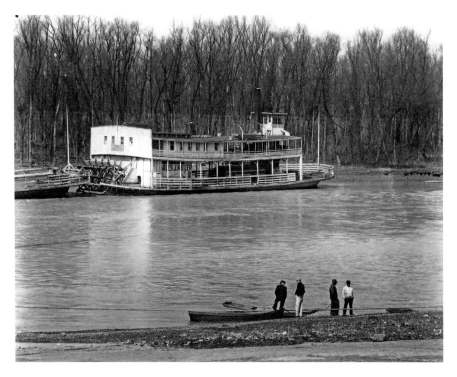

Ferry and river men, Vicksburg, 1936. *Library of Congress.*

Two levees north of Greenville, Mississippi—at the Miller Bend and the Mound Landing—caused great concern. A break at either levee would release water into Greenville, Washington County's largest city. The morning of April 21, 1927, with levee guards on duty and sandbags stacked almost even with the rising water, the levee at Mound Landing in lower Bolivar County broke. The notes of Greenville mayor John Aloysius Cannon reveal the confusion as the event happened. "We were somewhat late in turning on the alarm," wrote Mayor Cannon, "as we could get no one at the Levee Board with the proper authority to say where the break was."[9]

The crevasse allowed rushing water to flood nearly one million acres with up to ten feet of water. Almost two million acres of land became inundated. Lucy Somerville Howorth wrote in her diary that Greenville citizens had prepared their town and homes for the flood:

> *There was a low protection levee north of town. The east and south were protected, or so most people believed, by a railroad embankment. The people as a whole were confident the town would not get any water even should the*

levee break. For weeks the river rose, it passed the highest stage ever known before, 52.3 feet reached in 1922, and went up steadily, a foot a day, which, as well as the height, was unprecedented.[10]

Greenville resident David Cober remembered, "We heard this storm coming through the woods. It wasn't a storm. It was the water. Our house was six or seven feet off the ground. The water came in fourteen or fifteen feet deep." The water rose, so much so the family climbed onto tables. David knew he had to do something. It was dark when he dove into the water several times before finding his axe. He hacked an escape hole into the ceiling, and he and his family climbed out onto the roof.

All around, water rushed and roared. Everyone and everything were hurled into mayhem, animals and humans crying out in the rising water. Families from the black neighborhood, Newtown, waded to the highest ground in the Delta, the Mississippi levee. Others fled to the downtown courthouse.

Greenville resident Jesse Pollard recalled, "Water just kept rolling in like you see the waves down in Gulfport. They were high—you saw horses and cows floating. If you were standing on the levee, you could see people floating who had drowned. It was a sight you never forget."[11]

As whites and blacks worked and risked their lives together to save one another, skin color didn't matter. Blacks needed whites, and whites needed blacks. They became one strong community fighting the elements of nature. That would change.

Farmers relocated their stock—cows, horses, pigs, mules—to the eight-foot-wide levee. Dogs turned wild without food. Diseases such as rabies became major threats. As more refugees crowded onto the levee, Greenville's population grew. The city water became contaminated, and ten thousand people on the levee were destitute. General Malin Craig, commander of the army's IV Corps in Atlanta, warned the War Department, "Conditions in Greenville area critical." Steamboats came for white women and children. Black people and panicky livestock boarded barges.[12]

At the end of Washington Avenue in Greenville was a refugee camp on the seven-mile-long levee. Families, mostly African American sharecroppers from Greenville and other flooded areas, slept in tents of quilts and other materials. The American Red Cross provided immunizations to prevent the spread of disease, distributed tents and built kitchens and sanitary facilities. The National Guard maintained order among the many homeless. Author William "Will" Alexander Percy, appointed by his father, Leroy Percy, who served in the U.S. Senate (1910–13), headed the Relief Committee in

Greenville and wrote of the experience in his memoir *Lanterns on the Levee*.[13] Will had planned on evacuating everyone, including thousands of stranded blacks, on the levee. But his father said the blacks constituted the workforce needed to repair the levee. Also, large planters feared their black sharecroppers who left would not return to Mississippi, leaving unpaid debts, which were usually unreasonably exorbitant. Plus, planters needed sharecroppers after the water receded and protested to Leroy about Will's decision to evacuate everyone. Leroy contacted every member on the committee in secret, urging them to hold the black refugees on the levee. When Will took it to committee for a vote, he argued in vain when all committee members stood against his evacuation plan.[14]

Almost thirteen thousand African Americans remained on the levee. Around five thousand found shelter in warehouses, stores and oil mills. There was a vast difference in the food distributed among whites and blacks. To keep from "spoiling the blacks," no canned peaches were distributed to them.[15] With no pay, around five hundred black males worked twenty-four hours a day in two shifts to repair the protection levee and were threatened if they didn't keep working and unloading food from the barges. If they stopped, they weren't allowed any food from the Red Cross. The Associated

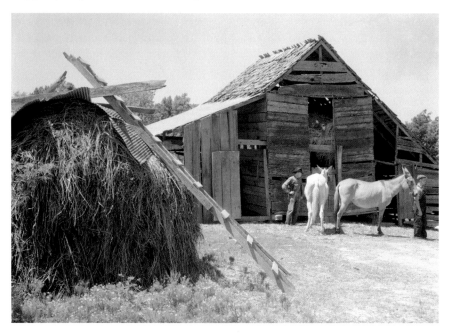

Tenant farmer with mules bought through rehabilitation loans. *Library of Congress.*

Negro Press reported the squalid living conditions and work requirements of the African Americans. By the end of May, it had spread to the white press and to Secretary of Commerce Herbert Hoover, chairman of a special committee to coordinate flood relief efforts. Hoover formed the Colored Advisory Committee and appointed Robert Moton of Tuskegee Institute to investigate the allegations. The investigating committee presented a harsh report to Hoover, but he failed to take any action.[16]

John and Willie Douglas had managed to slip away from the plantation at Thornton, Mississippi, leaving behind their six children. The couple claimed that the letters to their children were intercepted by the plantation owners. This, per Myron McNeil, was only one case in the hundreds of other workers from the hill counties being forced to remain in the Delta against their wills. He said, "These negroes were all originally from the hill counties and when the boll weevil struck the hill counties, the Delta farmers and planters came into the hills and solicited all this labor to go to the Delta, and it was released without objection by the hill farmers," reported McNeil. After the flood, Delta planters held laborers who wished to return to the hills against their will.[17]

The National Guard, armed with rifles and bayonets, patrolled levees and refused to allow any black person to leave without a pass. Blacks not wearing a "laborer" tag weren't given food. In contrast to other refugee camps where workers were paid, Greenville's black workers were not. Mrs. Henry Ransom, who was white, reported that guardsmen would come along and say, "There's a boat coming up. Go unload." If black workers were slow to respond, the guards would kick them or strike them with guns and pistols. Guard units specifically from Lambert and Corinth beat workers for talking back or trying to leave the camp. Often, as the steamer *Capitol* pulled away with its white occupants, the calliope played "Bye, Bye, Blackbird." Living conditions caused by the flood compelled blacks to leave Washington County, of which Greenville was the county seat, to seek better lives in the North.[18] This was part of the Great Migration, which began around 1915 and continued into the 1970s on migration routes leading to the urban Northeast and to cities in the Midwest and California. Wartime industries needed labor. African Americans from the South needed better jobs.[19] However, white landowners were not so quick to give up black laborers. Police even kept blacks from buying train tickets, so to remain unseen, migrants often chose nighttime travel.

Downtown Greenville was flooded, but businesses, banks and the newspaper still operated and electricity and telephone services were not

disrupted. People traveled in boats.[20] A week after the flood, thousands of whites sought shelter in the upper stories of hotels and offices. Peddlers set up stands along the scaffolding boardwalks to sell snack items like popcorn and peanuts and soft drinks. Even as dead livestock floated by in the muddy water, music and singing floated from the mezzanine of the Cowan Hotel, where the café, pool hall and cigar stand and dining room were open for business.[21]

Just north of Vicksburg, a major crevasse on the eastern bank of the river, now known as the Cabin Teele break, happened around noon on May 3, 1927. This levee had been purposely breached. Had the pressure of river water broken the levee naturally, a large portion would have swept into the river like the earlier crevasse at Greenville. The intentional break preserved much of the structure so the levee system could be reconstructed after the water receded. The *Vicksburg Evening Post* reported, "Trees alongside the break, and the 'buck shot' dirt are serving to retard the crumpling of the levees, thus holding narrow the outlet for the angry waters in that section."[22]

Many stories relate the tenacity of the people affected by the flood. Twenty-two-year-old Berta Miller was to be married that summer, but she and her sister evacuated from Tensas Parish, Louisiana, across the river to Lorman, Mississippi. On May 18, 1927, Berta and her fiancé married in Mississippi, and her family traveled to the ceremony by boat. After their honeymoon in New Orleans, also threatened by the flooding Mississippi River, she and her husband returned to their Highland Plantation home built four feet off the ground in Tensas Parish, on the outskirts of Waterproof.

In an interview, Berta reminisced:

> *JB, Little Harrison, and I would put on our bathing suits and go out there [in the yard] and go swimming and Uncle Elliott Coleman who had a very large barge, it looked to me like a large barge, and he would park it out in the deep water, and then we would go by boat out to where it was and we would all sit around on the barge and go swimming, it was wonderful.*[23]

After the break in the levee in Arkansas, Miles Smith's father wanted his wife and daughter taken to safety in Mississippi. Miles drove his mother and sister to Mississippi in their Model-T Ford, crossing on the ferry from Louisiana. Since the levee had been breached at Cabin Teele, Miles was unable to return by the same route due to the rising water. Leaving the car with his mother, he took the train from Vicksburg to Natchez and crossed on the ferry at Vidalia in Concordia Parish. From Vidalia, he walked the levee

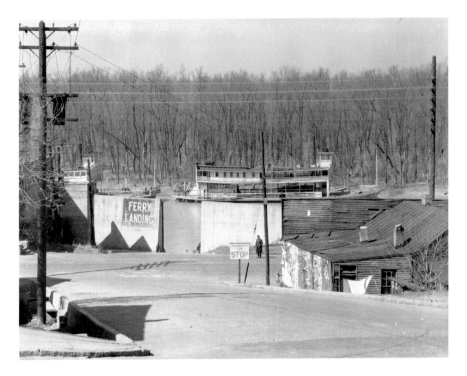

Ferry landing, Vicksburg, 1936. *Library of Congress.*

to Ferriday and continued on the train tracks built higher than the roads. North of Waterproof, he caught a ride back to St. Joseph.[24]

In the Yazoo-Mississippi Delta, the flood of 1927 caused around 1,000 deaths, per the National Safety Council. In Mississippi, flooding affected approximately 185,495 Mississippians, with 41,673 homes flooded, 62,089 buildings damaged and 21,836 buildings destroyed. Lost beneath the tumultuous flooding were 2,836 work animals, 6,873 cattle, 31,740 hogs and 266,786 poultry. An entire crop year was lost.[25]

Alex Scott of Greenville warned in July 1927, "A great deal of labor from the flooded section after being returned to the plantations is going north. It is thus a serious menace and it is going to offer a tremendous problem to all of us."

Leroy Percy agreed, telling L.A. Downs, the president of the Illinois Central,

The most serious thing that confronts the planter in the overflowed territory is the loss of labor, which is great and is continuing. I would hesitate to give

an accurate estimate of the loss of labor in Washington County but I am quite sure that 30 percent is too small. If eventually we get by with a loss of 50 percent I shall consider it fortunate.

Workers faced the daunting task of rebuilding washed-out bridges and buildings and digging out ditches and drainage canals that had been filled with sand. Delta Farms Company president Oscar Johnston cancelled all his old debts and built a refugee camp close to his sixty-thousand-acre plantation, but no workers remained to work his land. Johnston's concern in June 1927 was that "some of our neighbors are paying more than $1.25 per day for day labor which they are taking out of the camp." He added that "if we permit outsiders to pay more than this, I imagine it will be hard to get labor on Delta Farms."[26]

To African Americans, the Great Flood of 1927 was a metaphor for freedom, said Luther Brown, director of the Delta Center for Culture and Learning at Delta State University in Mississippi, in a 2011 NPR *All Things Considered* interview:

African-Americans viewed the flood as an act of God that liberated them.… In the 1920s, the majority of that black population made their living by sharecropping. Everybody got by on credit. The flood made it obvious that there was not going to be a crop during that year, so they were not facing one year of barely breaking even or being able to pay off debt, but two full years. Some people turned the whole story on its head and said that the Lord had washed away the debt and liberated the black sharecroppers to move on to other employment. Many of them did. They left the Delta and participated in the Great Migration and headed north and went to Chicago or Detroit or some other metropolitan area and sought new employment.… Ethnomusicologists tell us that there were about two dozen blues songs that were written specifically about the flood in the couple years that immediately followed it. There was probably an equivalent number of gospel songs. And then some of those songs have been re-presented by more recent artists, so the ripples of the flood continue to be with us.[27]

In March 1928, one year after the Mounds Landing crevasse, the Red Cross still provided food to twelve thousand Washington Countians. But the money was gone. Popular touring shows and opera house shows were gone. In addition, planters greatly feared the permanent loss of black labor due to their exodus.[28] The 1927 flood impacted eleven states and

resulted in the National Flood Control Act of 1928, passed by the U.S. Congress.[29] Richard Wright commented on the migration in his book *12 Million Black Voices*:

> *As we leave we see thousands of the poor whites also packing up to move to the city, leaving the land that will not give life to her sons and daughters, black or white. When a man lives upon the land and is cold and hungry and hears word of the great factories going up in the cities, he begins to hope and dream of a new life, and he leaves.*[30]

THE DROUGHT

Between 1930 and 1934, excepting 1932, catastrophic drought conditions affected broad regions of the United States. Humid states would be seriously affected in 1930 and to a lesser extent in 1931 and 1934. During 1930 and 1931, temperatures in drought areas broke records in Indiana, Kentucky, Tennessee, Virginia, West Virginia, Maryland, Florida, Alabama and Mississippi. States west of the Mississippi endured maximum temperatures of 112° F or more, except Louisiana, Oregon and Wyoming, where the maximums were 109°F, 110°F and 111°F, respectively. East of the Mississippi, and exclusive of New England, only three states did not reach or exceed maximum temperatures of 102°F and three states exceeded 110°F.[31]

In the last week of May 1930, rains stopped, and temperatures soared from June through August. Once green and lush with vegetation and king cotton, Mississippi became dry and scorched. Cotton withered. Vegetables shrank on the vines. Animals wandered aimlessly searching for grass to nibble and water to drink. Streams and ponds evaporated into the dusty, parched atmosphere. The Mississippi River was now at the lowest levels in history. The drought spread farther than the 1927 flood, but the Red Cross didn't respond with the same enthusiasm. Distribution of seed, food and clothing was mainly handed over to the locals. Of the $5 million allotted for drought relief, the Red Cross had spent only $430,000 by the end of 1930. Between November 1930 and February 1931, over five hundred banks closed their doors.[32]

DEPLETION OF MISSISSIPPI'S FORESTS

In the early nineteenth century, Mississippi's longleaf pine belt extended from the eastern boundary of Alabama to the Bluff Hills in the west and north about 150 miles from the Mississippi Gulf Coast. Between the Pascagoula and Pearl Rivers, 75 percent of forested land was pure longleaf. Longleaf pines covered much of Hinds, Rankin, Smith, Franklin, Amite and Jasper Counties while Jones, Hancock, Covington, Harrison, Lawrence, Jackson, Copiah, Greene, Lincoln, Perry, Pike and Marion Counties were totally covered with longleaf pines. Mixed longleaf and hardwood forested sections of Wayne, Jasper, Newton, Smith, Scott and Rankin Counties and all of Clarke. Mississippi was so saturated in timber, many thought the soil too poor for farming. Some 90 percent of longleaf counties were thought to be impractical for planting cotton.

In the mid-1800s, J.F.H. Claiborne, known for his series of sketches in the *Natchez Free Trade and Gazette*, wrote "A Trip through the Piney Woods":

> *The great source of wealth in this country must ultimately be—for it is now scarcely thought of—the lumber trade. The whole east is thickly planted with an almost unvaried forest of yellow pine. Finer, straighter, loftier trees the world does not produce. For twenty miles at a stretch in places you may ride through these ancient woods and see them as they have stood for countless years, untouched by the hand of man and only scratched by the lightning or the flying tempest. The growth of giant pines is unbroken on the route we pursued for a hundred miles or more, save where rivers or large water courses intervene, and then we find in the extensive swamps that bound them on each side a heavy growth of white oak, chestnut and evergreens.... The time will arrive when this vast forest will become a source of value. The smoke of the steam mill will rise from a thousand hills. Rafts and lumber boats will sweep down the Pearl, the Leaf and Chickasawhay, and a railroad will transport millions of feet to the city of Mississippi to be shipped in vessels, built there of our own oak, to the West Indies, Texas and South America, countries that furnish the best lumber market in the world, and to which we are so much more accessible than the hardy mariners of New England, that now monopolize the trade. A railroad to the gulf could be constructed at little expense.* [33]

In the last quarter of the nineteenth century, railroads in Mississippi had the greatest impact on the timber industry. Statistics show that in 1880, 295

sawmills had total investments of less than $1 million. In 1899, a capital investment of $10 million in 608 mills produced more than one billion board feet of lumber. (A board foot is the equivalent of a board one foot by one foot by one inch.)[34]

When the North's urbanization and industrialization depleted its forests by the late nineteenth century, the South's lush forests of pines and hardwoods were the next target. Commercial lumbering centered on steam engines pulling log cars on narrow-gauge tracks, called dummy lines, into the forests. Mississippi's railroad maze offered a way in and out of the forests.

The lumber industry migrated from the North and ran on borrowed money, or timber bonds, sold with forests as collateral. Lumbermen felled trees, and after delimbing, steam-powered skidders pulled the logs to the loaders propelled by steam, which lifted the logs onto the cars. The logs might also be dragged on big wheels or "caralogs" with slip tongues pulled by oxen or mule. The eight-wheel Lindsey Log Wagon was invented and manufactured in Laurel, Mississippi. Shay locomotives maneuvered tight turns while pulling logging trams on the narrow-gauge tracks.[35]

Chicagoan Edward Hines owned Mississippi's Hines Lumber Company. Mississippian L.O. Crosby established several lumber firms in his home state.

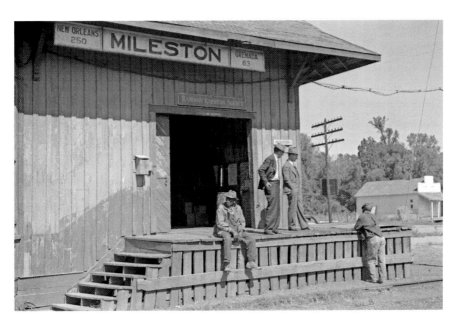

Railway station on cotton plantation, Mileston Plantation, 1939. *Library of Congress.*

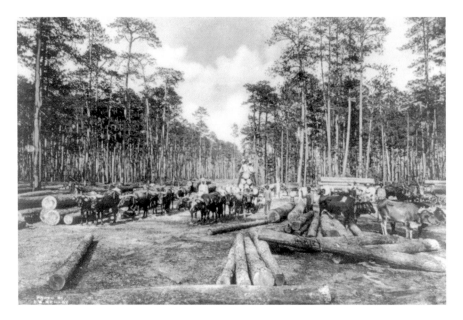

Logging scene, Hattiesburg, 1920. *Library of Congress.*

Philip S. Gardiner, who served as president of the Southern Pine Association in 1921, led Eastman-Gardiner Lumber Company of Laurel. Memphis, Tennessean E.L. Bruce started E.L. Bruce and Company and founded Bruce, Mississippi. Also from Memphis, Christopher J. Tully founded the Anderson-Tully Lumber Company, which ran mills in Vicksburg and Memphis. Frank W. Gilchrist founded Laurel's Gilchrist-Fordney Lumber Company. R.F. Learned and Son Lumber sawmill was located "under the hill" at Natchez. The Sumter Lumber Company was in Electric Mills and Crosby Lumber Company in Crosby. Quitman, Mississippi, was founded because of Long-Bell Lumber Company.[36]

By 1905, sawmills cutting more than twenty-five thousand board feet per day owned their own railroads. Many Mississippi towns and cities existed because of the railroads and sawmills built during the lumber boom. The timber industry thrived from 1904 to 1915, and Mississippi ranked third in lumber-producing states in the United States, behind Washington and Louisiana. By 1910, capital investment was more than $39 million and the value of production reached nearly $43 million. Longleaf pine counted for much of the total production in lower Mississippi. Hardwood was sourced from the Delta while east-central Mississippi produced shortleaf pine.[37]

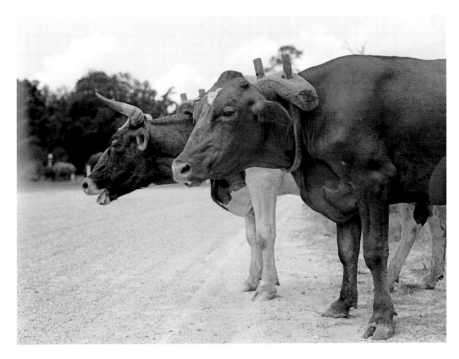

Ox team hauling pulpwood, Bay Saint Louis, 1937. *Library of Congress.*

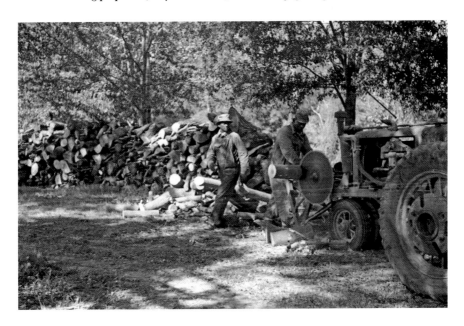

Sawing wood, 1939. *Library of Congress.*

In 1911, a Moss Point, Mississippi plant was built to produce paper from the waste products of the L.N. Dantzler sawmills. Laurel resident William H. Mason developed a process for manufacturing "Masonite," a building material from young second-growth timber, proving that young trees produced quick returns. In turn, a second forest was planted and sawmills provided local population employment during the first three decades of the twentieth century. People left family farms to become loggers or sawmill workers. George Teunnison, who worked in sawmills in southern Mississippi and for several railroads around 1900, said, "From about 1897 until 1919, an engineer could start out riding a local freight from Hattiesburg and he could just about always find a job on a log road long before he reached Lyman. It was the same way up toward Jackson."[38]

In 1905, there were 527 logging camps in Mississippi housing over eight thousand workers. By 1913, two-thirds of the mills had logging camps. Railroad cars became homes and stores. Some mill towns were independent from the company while others were owned by the company. The Eastman-Gardiner's Wisner camp housed over eight hundred workers and provided recreational facilities, including a YMCA, schools and churches. An Albany, New York newspaper called Eastman-Gardiner's Cohay camp "one of the finest of its kind." Carrier Lumber and Manufacturing Company,

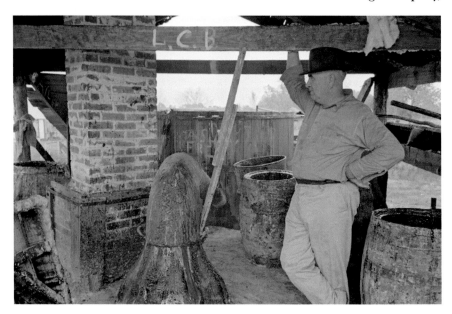

Turpentine still, State Line, Mississippi, 1938. *Library of Congress.*

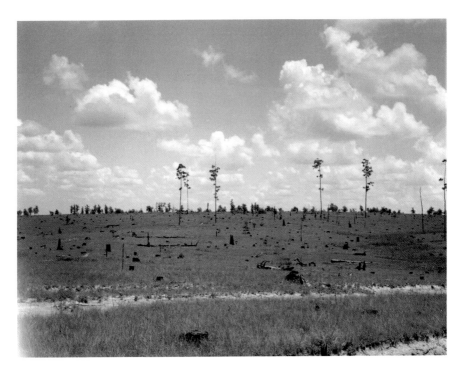

Cut-over longleaf yellow pine forest, Mississippi, 1937. *Library of Congress.*

established in 1910, had running water from artesian wells, electric lights, separate hotels and cottages for black and whites, segregated schools and churches, a hospital, an icehouse and commissary and even juke joints and pool halls. The turpentine industry arrived late in Mississippi from the Carolinas, which had exhausted their timber. By 1900, there were 145 stills in Mississippi. Hundreds of black workers came into Mississippi to work for lumber companies. Longleaf were worked for three years and then felled for timber. From the stumps, naval stores were extracted from the rosins.[39] Due to high interest rates, both lumbermen and lenders confronted the lumber jobs as "cut out and get out" to get the most of their labor, time and money. These lumber operations packed up and went to the next location, leaving behind devastated, cutover lands. As a result, mill towns that had been established around the operations became ghost towns.[40]

Mississippi lumber exported through Gulf Coast ports to Caribbean and European markets was used in the construction of the Panama Canal and during World War I. Incorporated in Missouri in 1884, Long-Bell Lumber Company moved into the southern forests, and it had become one of the

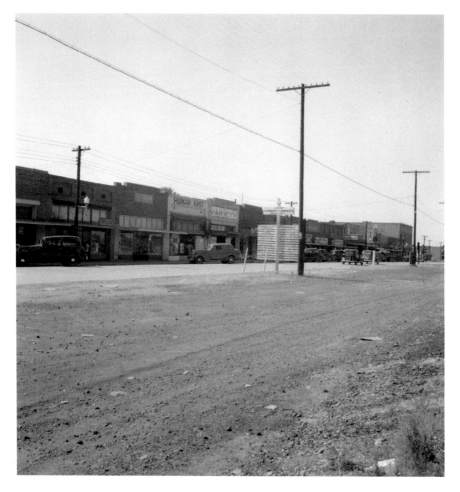

Main Street, Drew, Mississippi. *Library of Congress.*

largest lumber manufacturers in the country by 1920. But as the virgin forests of the South were depleted, Long-Bell, like other lumber companies, concentrated on territories in the Northwest.[41]

The grand era of lumbering in Mississippi ended by the late 1920s. Those who reaped the profits were from other parts of the nation and world who, after depleting lumber production in Mississippi, moved to the Pacific Northwest. The Eastman-Gardiner's Cohay camp was abandoned in the mid-1920s.[42]

The Mississippi Forestry Commission was established in 1926, but it would take years to replenish the forests and build economic prosperity

from the land. Some lumber companies let the county take back abandoned land for unpaid taxes. Some tried to sell stripped land to farmers to raise cattle or grow various crops and fruit. This saw little success. In the 1920s and '30s, others ran portable peckerwood or groundhog sawmills, which worked in the cutover areas and produced lumber in the leftover scattered patches.[43] Dwindling timber supplies, coupled with the effects of the Great Depression, forced most mills to shut down. For the most part, the timber boom that started in the 1890s was over by the 1930s.[44] Mississippi was left to deal with stripped land that would never fully recover. Over 65 percent of Mississippians had depended on the lumber industry. Mill towns became abandoned buildings filled with dust and debris. Cemeteries were long forgotten. Railroad cities like Hattiesburg, Meridian and Laurel persevered. Towns like Lucedale, Collins, Wiggins, Drew, Moss Point and Lumberton also remained viable communities. Others died away.[45]

2
LIFE AND TIMES

In 1900, there were 12,427 banks in the United States. After the Panic of 1907, Kansas, Mississippi, Nebraska, North Dakota, Oklahoma, South Dakota, Texas and Washington enacted insurance systems with low premiums for state-chartered banks, which probably encouraged more bank entry and risk-taking. By 1920, the number of banks had risen to 30,291. Much of this growth was in the southern agricultural states due to the commodity price boom during World War I. Yet by 1929, state insurance systems were either insolvent or had been closed by state authorities. There being no system with a state guarantee, depositors suffered losses. Mississippi, however, issued bonds to reimburse depositors of failed banks.

From 1929 to 1933, the United States' gross national product declined by 29 percent, price levels fell 25 percent, the unemployment rate rose to 25 percent and around nine thousand banks suspended operations. High percentages of deposits in failed banks were in South Carolina, Florida, North Carolina, Iowa, Mississippi and Arkansas, all above 7 percent. The extent to which per capita income fell between 1929 and 1932 ranged from 32 percent in Massachusetts to 56 percent in Mississippi (both mean and median declines were 44 percent).[46]

Other economic calamities made all social classes across the country too afraid to buy anything, which led to reduced product production, thus reducing the need for a workforce. As people lost jobs, they could not repay purchases bought on installment plans. Purchases were repossessed. Banks, trying to survive, stopped loaning money. In 1930, the U.S. government

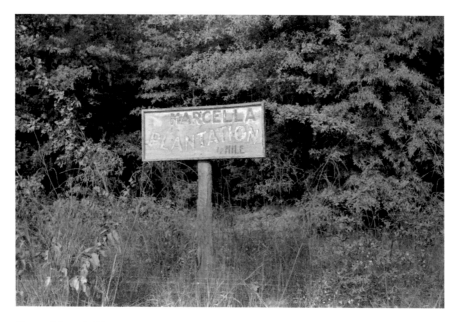

Sign to Marcella Plantation, Mileston, 1939. *Library of Congress.*

formed the Smoot-Hawley Tariff to help protect American companies. This tariff charged a high tax for imports from foreign countries and resulted in less trade between America and other nations.[47]

Despite the demand for raw materials, specifically cotton, after the 1918 armistice and through the 1920s, Mississippi became one of the poorest states in the country.[48] With the collapse of the national economy and the lack of demand for manufactured goods, there was little need for raw agricultural products like cotton. More and more farmers lost their land and became sharecroppers. The annual per capita income for Mississippians was $132.[49]

Mississippi Delta planters learned, after receiving appropriations of $325 million from Congress for flood control efforts, that federal assistance could help fortify social and economic order. Walter Sillers Jr., a pro-labor lawyer in the Delta, urged the federal government to support the Delta after the levees were rebuilt.[50] Sillers had joined the Mississippi legislature in 1916, during Governor Theodore Bilbo's first term, when Progressivism reigned in the state. Bilbo served twice as governor of Mississippi, from 1916 to 1920 and from 1928 to 1932. During his second administration, he advocated political and economic reforms designed to improve quality of life for his main

supporters: Mississippi's poor white farmers and workers. Sillers supported slow, steady reform that didn't affect the economic and social structure in Mississippi, which lined up more with the "business progressives" in the 1920s. Governor Bilbo, on the other hand, and the Mississippi legislature bankrupted the state by 1931. Bilbo was so afraid of being impeached that he ignored calls for a special session.[51]

Red Cross assistance and supplies were mainly distributed by the local white population. NAACP member Walter White warned that goods would not be distributed fairly because white planters would likely not share and might sell the free goods to black laborers or use the goods to hold black laborers in a state of peonage. Supporters of the sharecropping system claimed it provided clothing, food and shelter to those who would otherwise do without. In truth, the system forced landowners to limit costs to a bare minimum, especially relating to tenants. In 1930, the *Staple Cotton Review* out of the Delta reported that stock and tenants could be maintained at $0.15 per head per day and provided copies of this plan for free to planters. A study of participating Delta plantations in this plan revealed a net profit of $615 per plantation, even in 1932. On the other side of the coin, African Americans, according to diarist Harry Ball in February 1932, were starving and begging for food and work.[52]

At the beginning of the twentieth century, 90 percent of black Americans lived in the South and, in many areas, outnumbered the whites. Over 50 percent of black Americans worked in agriculture, the majority being sharecroppers.[53]

Sharecroppers and share tenants had different roles. Landowners usually provided sharecroppers with a house and a plot of land, as well as all the seed, fertilizer and tools needed to cultivate the crops the landowners decided to raise. From seed to harvest, landowners supervised the laborers working the fields, and laborers usually ended up in debt to the landowner. Sharecroppers making a profit eventually gained more independence, either by buying land or becoming the more independent tenant farmer, who, even though they didn't own the land farmed, oversaw their crops, provided all supplies and implements and selected the crops to be raised, which were theirs to sell or use as needed. Tenant farmers paid for the use of land by cash payment or a share of the crop. Unlike sharecroppers, some share tenants managed to remain debt-free long enough to save money to buy their own land.[54] Landowners extended credit to laborers for living and housing expenses while they worked the land, which was secured by a lien against their crop share. Merchandise and general supplies like fertilizer, feed and farm tools

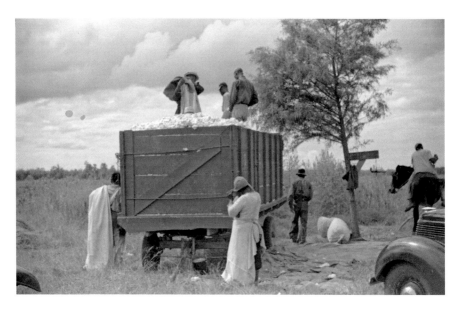

Weighing and picking operations on Nugent cotton plantation, Benoit, 1939. *Library of Congress.*

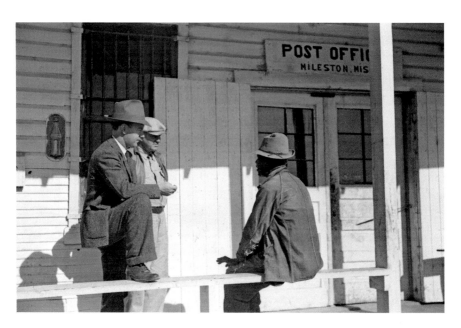

Plantation store and post office, Mileston, Mississippi Delta, 1939. *Library of Congress.*

could be bought on credit through furnish merchants, local store owners or plantation commissaries.[55]

Mississippi author Richard Wright said it best in his book *12 Million Black Voices*, first published in 1941, which combined Wright's prose with photographs selected by Edwin Rosskam from the Security Farm Administration files compiled during the Great Depression:

> *The economic and political power of the South is not held in our hands; we do not own banks, iron and seed mills, railroads, office buildings, ships, wharves, or power plants. There are some few of us who operate small grocery stores, barber shops, rooming houses, burial societies, and undertaking establishments. But none of us owns any of the basic industries that shape the course of the South, such as mining, lumber, textiles, oil, transportation, or electric power. So, in early spring, when the rains have ceased and the ground is ready for plowing, we present ourselves to the Lords of the Land and ask to make a crop. We sign a contract—usually our contracts are oral—which allows us to keep one-half of the harvest after all debts are paid. If we have worked on these plantations before, we are legally bound to plan, tend, and harvest another crop. If we should escape to the city to avoid paying our mounting debts, white policemen track us down and ship us back to the plantation.[56]*

By 1930, tenancy had peaked in the thirteen southern and border states, with 228,598 cash tenants, 772,573 sharecroppers and 759,527 other tenants, who were mostly share tenants. In the cotton belt, tenants and croppers counted for 65 percent of all farmers and 48 percent in tobacco regions while tenant farmers and their families constituted half of the 1930 southern farm population of 15.5 million. Because most all year-to-year agreements were verbal, when the time came to settle, many landowners changed the terms and conditions as they saw fit. Tenants and croppers who could not pay their bills after the harvest remained in debt to the landowner due to the high interest landowners charged. This potentially enslaved laborers on the land they worked and kept their families in poverty.

Tenant families usually lived in pine shacks with no electricity, plumbing, privies or wells and no glass or screens in the window openings. They often moved every year or two to different farms, which made accumulating personal property and educating children an impossibility. This transient way of life meant farms were not well maintained, which caused severe erosion. Landless farmers were often shunned because of their forced way

A Mississippi store, 1937. *Library of Congress.*

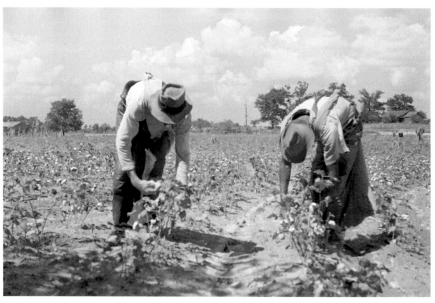

Picking cotton, Lauderdale County. *Library of Congress.*

of life. In the South, per the 1937 President's Committee on Farm Tenancy, two-thirds of tenant farmers were white, while among croppers, the lowest tenure group, the ratio of white to black was about the same.[57]

In 1928, Dorothy Dickins, a Mississippi home economist, described a tenant dwelling: "The average home has only the furniture they cannot do without, such as beds, chairs (usually not more than four), possibly a dresser and wash-stand, more often a dresser than a washstand."

A typical tenant family, per David Cohn, might have pots and pans, a bed, chairs, a Bible and a mail-order catalogue, indicating the desire to buy more things. Tenants purchased clothing, such as overalls and inexpensive cotton goods, brogan shoes and homemade underwear, once a year, but only if there was a profit. If not, tenants would have to be satisfied with the clothing they had. If shoes wore out, you went barefoot. There was great fear of being in debt.[58]

Most of the cotton in Mississippi, including the Delta, was raised by sharecroppers and their mules. For a ten-acre field, after all expenses were met, income was rarely over $300.[59] In 1932, cotton sank to $0.05 a pound, and one-fourth of the state's farmland was forfeited for nonpayment of

Sharecropper cabin, Lauderdale County. *Library of Congress.*

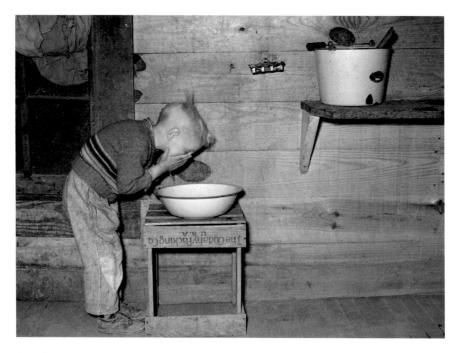

Son of a sharecropper washing his face, 1939. *Library of Congress.*

taxes.[60] Years of cultivating cotton had wreaked havoc on Mississippi's landscape and virtually destroyed the topsoil. Drought conditions persisted from 1930 to 1934, so that by 1933, most of the South was a disaster area. Henry Wallace, Roosevelt's secretary of agriculture, blamed soil erosion on "human erosion," saying that poor tenants and sharecroppers had little reason to care for soil they did not own and landowners refused to invest a dime of their profit.[61] Because of this, some farmers diversified into other agricultural businesses, like dairy operations. Others worked with what was left of the depleted forests in Mississippi, even the leftover stumps, from which companies like L.O. Crosby extracted resins to produce other products.[62]

In the 1920 and '30s, Delta & Pine Land Company (D&PL), chartered in 1886, operated the largest cotton plantation in the Mississippi Delta, with headquarters in Scott, Mississippi—fifteen miles north of Greenville, twenty-five miles southwest of Cleveland. In the late 1900s, the company divested its farmlands, concentrated on research and development of cotton and soybean seeds and was world-renowned for its development of Delta pine cotton varieties. It took only a few years for tenants to operate 92 percent of Delta farms, of whom 95 percent were African American.

In the Depression's early years, D&PL planted 14,000 to 18,000 acres. Its cotton plantation averaged 9,130 acres between 1933 and 1943 and produced an average yield of 653.3 pounds of cotton fiber per acre and 980 pounds of seed. A new variety of cotton introduced in 1942, Deltapine 14, yielded 737 pounds per acre. Acreage for corn averaged 2,183 acres between 1933 and 1943, while 7,736 acres provided food, animal feed and grazing lands. Sharecroppers included 1,400 workers and their families. In 1936, D&PL plantations yielded about 15,000 bales of cotton on 11,700 acres. Sharecroppers earned about $1,000 from their cotton crop, and the family's one-half acre provided for gardening and personal use helped to supplement that income. D&PL was the largest, most successful plantation in the country, and travelers from other countries, including Turkey, Australia, Egypt, France, China and South Africa, came to visit.[63]

By the 1930s, outside observers were drawn to the economic and cultural identity of the Mississippi Delta. In 1935, Rupert Vance identified the "cotton obsessed, Negro obsessed" Delta as the "the deepest South," filled with mansions and aristocratic mannerisms while oppressed black laborers were at their lowest in America.[64]

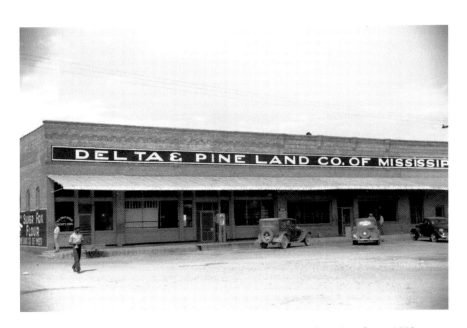

Post office and offices of Delta & Pine Land Company cotton plantation, Scott, 1939. *Library of Congress.*

Knowlton Plantation, 1939. *Library of Congress.*

Two-thirds of approximately two million black farmers earned nothing or went into debt, prodding hundreds of thousands of sharecroppers to abandon southern fields and homes and head for the cities. But unemployed whites were desperate during the Great Depression and sought out the "Negro jobs," like busboys, elevator operators, garbage men, porters, maids and cooks. The Black Shirts, a Klan-like group in Atlanta, Georgia, protested with signs that read "No jobs for niggers until every white man has a job." Residents in other cities shouted, "Niggers back to the cotton fields. City jobs are for white men." In Mississippi, unemployed white men sought the railroad positions blacks traditionally held and ambushed and killed the black workers. The rights of blacks seemed to only matter to the Communist Party. In Alabama, when nine black youths known as the "Scottsboro Boys" were falsely charged of rape, the Communist Party strived to save their lives. It also organized interracial unions and demonstrations for relief, jobs and to end evictions.[65]

At the end of the 1930s, two social scientists, John Dollard and Hortense Powdermaker, recorded their interpretations of the Mississippi Delta from the white and black perspectives in Indianola. Examples revealed the advantage of the whites within the caste system. One example included a case in which a sixteen-year-old black girl served as a nurse to children in a

white household, from six o'clock in the morning until seven at night. Her pay was $1.50 per week. She wanted to be a maid and earn $2.00 per week. Another case recorded a white woman boasting she could ring for her maid to bring her water at three o'clock in the morning. This obedience made her love blacks. However, when this same maid, who earned $2.50 a week, asked for a $0.25-cent raise, the white woman laughed and exclaimed, "Go to hell."

Working the Delta fields could bring in as much as $2.00 per day, so domestic servants would temporarily leave urban employers to earn extra cash for their families. A good cook might be paid between $3.00 and $6.00 a week and permitted to pack up leftover food from the table to take home to her family after her long day of service. The black cook tended other chores around the white home, such as the washing and taking care of the children. Typical pay for the washerwoman was $1.25 per week. The lawn boy received $0.25 and a light meal, such as pork.

Most banks refused to loan black Mississippians money, so they had no other choice but to borrow money from merchants who charged outrageous interest, up to 25 percent. Dollard reported that some planters boasted about cheating their tenants. Others rationalized dishonesty by believing that they kept the blacks working. The southern black had no voting, legal or economic rights.[66]

In "Southern Trauma: Revisiting Caste and Class in the Mississippi Delta," authors Jane Adams and D. Gordon examined the Dollard/Powdermaker findings:

Dollard and Powdermaker write with some sensitivity to variations within the black community, but their lack of historical knowledge largely misses the dynamic transformations of relations between white and black. Dollard notes that "Southerntown" is referred to as a "good town" by blacks and observed that "the Negroes in Southerntown were formerly much better off than they are now, owned more land, even ran business institutions in the town, and took especial pride in their bank." He does not, however, trace the reasons for Indianola's relatively benign conditions nor inquire into the social and political dimensions of these changes. His short five-month stay and his general unfamiliarity with the South may explain in part his superficial treatment of this important observation. But we now know that race relations were both in flux and contested. The populist "reforms" of the 1890 Mississippi Constitution attempted to strip African Americans of all civil rights, especially the right to vote.

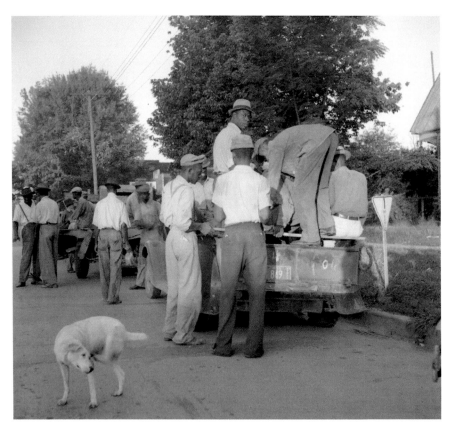

Displaced sharecroppers. *Library of Congress.*

Dollard and Powdermaker both note the importance of voting in terms of its practical consequences and in terms of the dignity it confers. However, neither explores the degree to which blacks carried memories of their political enfranchisement and subsequent disenfranchisement less than 40 years earlier. Nor does either note that African Americans in the Delta maintained limited and fragile access to the federal government into the 20th century through the Republican Party.

Gordon and Adams asserted that Dollard and Powdermaker "misconstrued the salience of class, which at the time was shaping public policy as an economic rather than normative ordering. And they obscured the variability of attitudes among white people and the achieved nature of white supremacy."

They concluded:

> *They* [Dollard/Powdermaker] *failed to see the people who do not fit into the dominant narrative: whites and blacks who made their living outside of the moral universe of the plantation economy or who reached across the caste divide to create relationships based on class and faith. Their accounts do not undermine David Cohn's romance of the aristocratic regime or Duncan's dystopian vision of the racially bifurcated social order that carves the world into eternal, irreconcilable opposites enshrined in myth. The Delta's real history is situated, created by actors whose narratives are more often told through the acts of daily life and intimate remembrance. Necessarily contingent and contested, this history remains to be written.*[67]

Between 1900 and 1930, Mississippi's white tenant population more than doubled and made up 27.8 percent of the population. Only 10 percent of white sharecroppers owned an icebox, and 14 percent had radios. Mississippi ranked last in the country regarding the number of people having radios and telephones in their homes. In 1937, less than 1 percent of the farms in Mississippi had electricity. Mississippi also ranked last in per capita sales and per capita wealth. The per capita income tax paid by Mississippians was thirty-four cents in 1934.

In Mississippi, the buying trends of men and women differed from the national trend. A study by Dorothy Dickins, Mississippi's leading extension service worker and writer, revealed that farm-owning men spent 50 percent more than their women when it came to clothing. While men bought their attire, farm women continued to cut and sew inexpensive material into dresses, nightgowns and slips.[68]

Dickens believed that women should make goods, not buy them, adding that the sewing machine is to the clothing budget what the milk cow, the garden and the orchard are to the food budget. Extension service publications reported how money was saved when women made their own clothing. Dickens calculated how much money women would save, reporting that "a garment-by-garment study in 1928 and 1929 of ninety-nine rural families showed they had more than five times as many ready-made clothes as homemade clothes and the poorest families had the lowest percentage of ready-made clothes." That same study showed ninety-eight out of the ninety-nine families sewed some clothes and more than 50 percent bought clothes from mail-order catalogues. Half the women took at least one fashion magazine, and many took the fashion sheets provided at dry good stores.

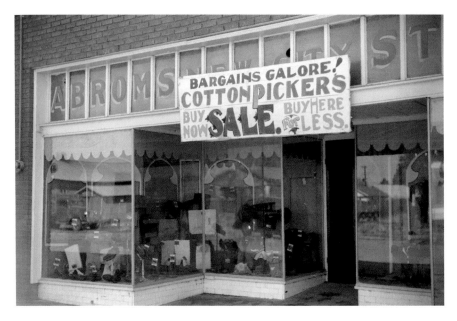

Store in Merigold, Mississippi Delta, 1939. *Library of Congress.*

Through another 1930 survey, Dickens confirmed that men still shopped more than women and spent more on men's clothing than women did on their clothing. Dickens encouraged women to become more involved with shopping for the family and in family planning.[69]

Although bargain shops of first-generation Jews catered to farming families in their area, most stores expected black customers to enter by the back door. Plus, they were not allowed to try on clothes.[70] White and black extension workers urged African American women to be content with few goods, to make clothing without spending money and to cut their clothing from feed, flour and sugar sacks. In 1930, these workers applauded the 50,000 garments crafted from sugar and flour sacks that African American women made for their families. An additional 1932 report lauded the African American women who had made 9,925 quilts, 9,017 dresses, 7,362 articles of underwear and 132,000 other articles like boys' and men's shirts, overalls, pillowcases, curtains and towels. In celebration, twenty-two African American home demonstration workers donned dresses made of sacks and marched down Capitol Street in downtown Jackson.[71]

Many Mississippians chose to work in garment factories and textile mills, which paid more frequently than farm work and timber labor. Unlike farmers, factory and textile workers tended to have electric lights in their

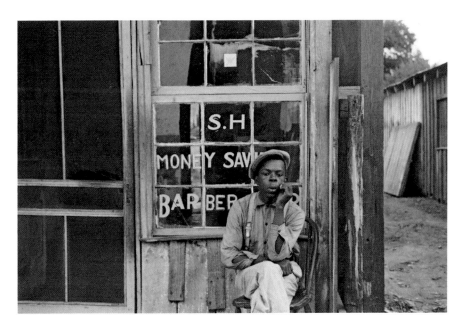

Natchez, 1935. *Library of Congress.*

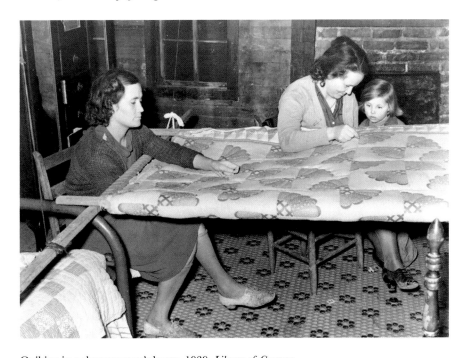

Quilting in a sharecropper's home, 1939. *Library of Congress.*

homes and could go to movies and own radios because their paychecks were steady and reliable. It was also easier for millworkers to get credit. In the late 1930s, 73 percent of factory and textile workers bought goods on installment plans. This was true for only 8 percent of farmers.

Most employees in factories and mills were women who had purchasing power. Advertising campaigns with drawings of tall, thin younger females who looked nothing like farm women replaced the drawings of men who had dominated clothing advertisements. In the 1920s and 1930s, women became the sole buyers of style goods. In the 1930s, Reeds Department Store in Tupelo advertised "Hollywood Creations by Justine," which were also advertised in *Vogue*, the popular women's magazine.

Since 1929, automobiles had been sold in 455 stores in over one hundred Mississippi towns, and of the 50 department stores located in the state, 12 were national chains. There were also 133 ready-to-wear clothing stores and 126 variety stores, five-and-ten stores and dollar stores, of which 25 were national chains.[72]

Nonetheless, prosperity was difficult to reach during the Great Depression years. According to an article in a national news magazine, the *Literary Digest*, on a single day in April 1932, one-fourth of the real property in Mississippi, including 20 percent of all farms and 15 percent of town property, was to be sold for taxes. The sale of forty thousand farms went to the State of Mississippi, which already owned about one million acres.[73] Also by 1932, 60 percent of the hardwood forests in the fertile Delta had been cut and plowed. The remaining 36 percent of forest was either swampland or not worth anything due to selective cutting. The remaining 4 percent of the land was made up of waterways, towns, levees and railroads.[74]

In "The Timber Industry in the Great Depression," an oral history through the Lauderdale County Department of Archives and History and Meridian Community College, interviewee Hoyte Delphine Moore Alley said that before the Depression, his father worked as a pipefitter for the Southern Railroad in Meridian. Because of the layoffs, he traveled to Atlanta to work and later worked for Roosevelt's WPA, which paid barely enough for the bills but offered commodities, such as peanut butter, cheese and white margarine complete with a food color button to produce a creamy yellow spread. Interviewee Lorene Culpepper lived in the Martin community on a farm. Her family made extra money from crops, such as corn, cotton and sugar cane, and lived off the butter beans, beets, peas, squash, tomatoes and corn from their family garden. M.F. Kahlmus said that the railroad was still a major employer in the 1930s, though many

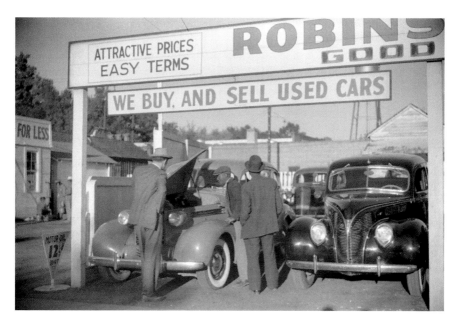

Used car lot, Clarksdale. Big sales go on after cotton picking season to get the money cotton pickers have made, 1939. *Library of Congress.*

lines went into receivership. The second-largest employer had been the timber industry. Lauderdale County had thirty sawmills, said Kahlmus, but timber harvesting was very dangerous. Oxen pulled logs to the road to be loaded onto a wagon or truck. Only hardwood was used for plywood production. At that time, pine was only used for construction lumber. Ham Sanders grew up in the timber industry and went broke in 1929. He began selling for Florsheim Shoe Company.[75]

It took a woman to recognize the grave effects of erosion and clear-cutting in Mississippi and the lack of conservation for wildlife habitats. Fannye A. Cook graduated from the women's school at Columbus and taught literature and history in Mississippi, Wyoming and the Panama Canal Zone. Upon her return to Mississippi in 1924, she wanted to make a difference conserving Mississippi wildlife and the environment. Recognizing Mississippi had no agency to regulate hunters and trappers, in 1926, she traveled the state, exhibiting at various fairs and clubs, campaigning for conservation programs. Mississippi A&M in Starkville provided Cook an office, and she founded the Mississippi Association for the Conservation of Wildlife. This agency advocated the establishment of a state department, something every other state had, to oversee wildlife

refuges, conservation and hunting licenses. The State Game and Fish Commission was established in 1932, and Cook became the director of research and education. She also worked with the WPA and supervised the National Youth Administration (NYA) until 1935, when her survey of plant and animal species initiative was financed by the WPA. These species remain the foundation exhibits for the Mississippi Natural Science Museum.[76]

The H. Weston Lumber Company was also committed to regeneration and the reforestation of its land by leaving seed trees after cutting. But with Mississippi's open range laws (in effect until 1926), farmers often burned to improve pasture land for herds and flocks. The company, to save its seed trees, formed a fire crew that rode the land in search of arsonists. In 1933, the company's board of directors authorized the president (Howard B. Weston) to mortgage land "to the United States Government" and borrow $200,000 toward "reforesting the lands of this Company." Another lumber company committed to early forestry was the Crosby Lumber Company, which owned over 100,000 acres in south Mississippi. Crosby recognized the need and value of growth from the residual stand and utilized selective cutting. The company attempted to educate its timber suppliers, but many sawmills continued scavenging the land.[77]

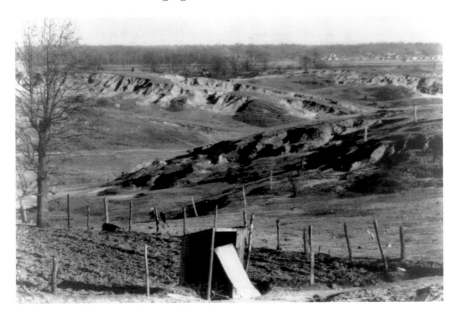

Erosion at Tupelo, 1936. *Library of Congress.*

Tom DeWeese, son of Ab DeWeese, the founder of DeWeese Lumber Company of Philadelphia, Mississippi, said:

There were large companies that came down here from the north. Nearly all of them cut out in the 20s and a few left over went out in the 30s…early 30s. They went back north where they came from, or some of them went out west and started a lumber business, but my father's business stayed here all the way through and survived the depression. It was very tough. And after the early 30s, there were hardly any of them left.[78]

In the early 1930s, Ab DeWeese paid his workers seventy-five cents for a ten-hour workday even though he couldn't afford to.

Senator Pat Harrison and the Senate Finance Commission committed $50 million toward the creation of national forests in Mississippi. Ray M. Conarro of the Forest Service was commissioned to survey and purchase land for these national forests. He bought large tracts of land around the state from big companies and corporations and some small farms in the Holly Springs area. On these tracts, five national forests were created—without trees. The Civilian Conservation Corps (CCC), one of President Roosevelt's New Deal programs, moved onto the land, lived in tents, cleared the land, constructed buildings and roads, planted 147 million trees and built lookout towers to control fires in Mississippi. The CCC, with the assistance of the Works Progress Administration—another New Deal program—and other federal agencies, created ten Mississippi State Parks by 1940. In the Delta, the Flood Control Act rebuilt dams to control flooding waters in the Yazoo basin. A comprehensive study of the situation was completed in 1931 and funded in 1936 with the construction of Sardis dam on the little Tallahatchie.[79]

An important negotiation during the Depression was between Masonite in Laurel and Celotex, which were both struggling through lean financial times. William H. Mason, an expert on wood derivatives, developed a tough, durable hardboard from leftover wood chips through heat and pressure. With the assistance of his wife's uncle Walter Alexander, the Wausau Group of Wisconsin underwrote a small insulation board facility and Mason's research at one of the paper mill laboratories. The company received two patents: one for insulation board and the other for hardboard, on which Mason had the patent. In 1928, the company changed its name to Masonite and became the world's first hardboard plant. That year, Celotex, a pioneer of insulation board, was unsuccessful in breaking the insulation patent. Celotex

signed on to be an agent of Masonite and sell it under the Celotex label. Additional manufacturers included Flinkote, Armstrong Cork, National Gypsum, Insulit and others that became licensed agents of the privately labeled Masonite.[80]

Innovators were also found in Meridian at its struggling airport managed by brothers and flight instructors Al and Fred Key, who had brainstormed an idea of setting a flight endurance record—even though they didn't own a plane. James Keeton, who had taken flying lessons and received his license in 1933 from the Key brothers, owned a used Curtiss Robin single-engine plane and operated Keeton-Parker Flying Services out of Bates Field in Mobile, Alabama. He learned of the Key brothers' plan and wanted in. The Key brothers borrowed Bill Ward's Curtiss Robin high-winged monoplane, with a 165-horsepower Wright Whirlwind engine, a 150-gallon gas tank and catwalk. They named it Ole Miss. Keeton would use his Curtiss Robin to refuel the Ole Miss and transfer meals to the Key brothers four times a day.

After difficulties during the first flight on June 21, 1934, forced a landing, two-way radio communication, made possible by Ben Woodruff, allowed flight problems to be communicated to the ground crew, and the ground crew could warn the Key brothers of bad weather areas. Blind Flying Instruments were provided by Captain Claire Chennault of the U.S. Army Air Corps, making the Ole Miss the first privately owned plane to use these instruments. Strong winds made in-flight refueling difficult. Weights were added to the refueling hose, and a ground crew member and machinist at Soule Steam Feed Works, A.D. Hunter, fashioned an automatic shut-off valve for when the hose dislodged from the tank. To solve the problem with the faucet, which needed several turns before releasing the fuel, Keeton used a blow-out valve from his family's dry-cleaning business that required only one ninety-degree turn to produce a spill-free air-to-air refueling nozzle. This later became the prototype used by U.S. bombers in World War II. To prepare for a night landing, the locals parked their vehicles on the airfield, aiming their headlights toward the landing strip.[81]

The airplanes made it through a near-miss midair collision, a fire on board and 52,320 miles of nonstop flight. In-flight fuel and supplies had been delivered to the Ole Miss 438 times. After twenty-seven days, totaling 653 hours and 34 minutes, the Key brothers landed on July 1, 1935, and still hold the flight endurance record. The Ole Miss is on permanent display in the Smithsonian National Air and Space Museum.[82]

In the late nineteenth and early twentieth centuries, school attendance rates for southern white children were much higher than black children. In 1890,

the attendance rate for white children aged five to twenty was 48 percent, 18 percent higher than that for blacks. By 1920, 63 percent of white children attended school during the census year, 10 percent higher than the black attendance rate during the same year. During the 1920s, white attendance continued to grow, slowed during the Great Depression and rebounded in the 1940s. Regarding instructional expenditures, black schools in Mississippi and South Carolina fell behind those in Virginia and Maryland. A 1941 study by the sociologist Charles Johnson using 1930 data revealed a negative correlation between the black-to-white spending ratio and the percentage of the black population. Johnson's investigation uncovered variations associated with the local economy, the "county types." In counties in which cotton was the dominant crop and "plantation" agriculture was practiced, and in which few blacks held nonfarm jobs, far fewer resources were devoted to the black schools than in counties in more urban settings.[83]

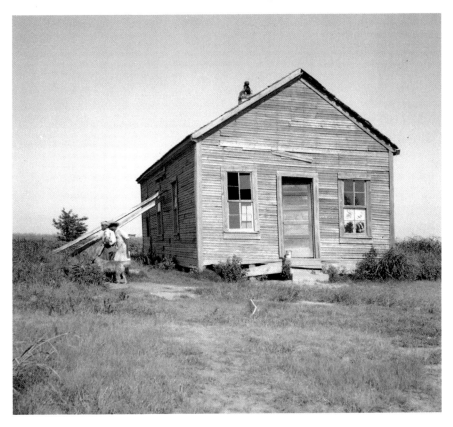

School in center of the mechanized plantation area. *Library of Congress.*

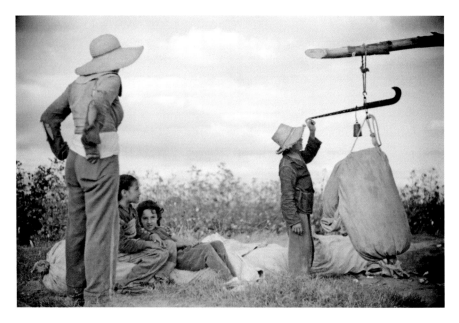

Mexican seasonal laborers weighing cotton they have picked, 1939. *Library of Congress.*

C.J. Duckworth of Smith County completed high school in 1933 and later taught at Bay Springs, Tiak and Heidelberg before entering the army and serving in France during World War II. As a youth, Duckworth asked his parents why they couldn't have a big nice school with a basketball team. "You are not white," they answered. Black youths only attended school four or five months out of the year. During his school break, Duckworth picked cotton for his white neighbors while their children attended school.

The city of Mound Bayou, Mississippi, was founded in 1887 by Isaiah T. Montgomery and his cousin Benjamin T. Green, both former slaves of Joseph Davis, brother of former president of the Confederacy Jefferson Davis. At the end of the Civil War, on November 15, 1866, Joseph sold the lands to Montgomery for $300,000, or $75 per acre. Mound Bayou became an all-black town in a white society. In 1911, the Farmer's Mercantile Cooperative was a merchandising store capitalized and controlled by black farmers. As an all-black community, Mound Bayou faced hardships, including the closing of the bank and the oil mill. High debt and agricultural problems caused many black landowners to lose their land, and by 1920, most had become sharecroppers. In 1929, the Mound Bayou Foundation was formed to attract $1 million in capital, and these efforts brought the resettlement program. In 1937, the fiftieth anniversary of the founding of Mound Bayou celebration

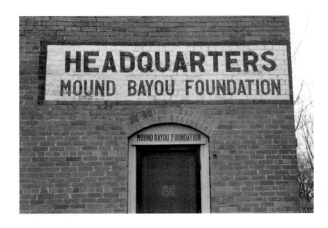

Headquarters of Mound Bayou Foundation, Mound Bayou. *Library of Congress.*

included a speech by Roscoe Conkling Simmons and an exhibition race by Jesse Owens, four-time Olympic gold medalist in the 1936 Olympics.[84]

Immigrants from China settled in Mississippi, like Joe Chow (aka Joe Bing), who moved to Cleveland and opened his grocery business in the late 1920s. In 1933, he married Hazel Taylor, a black woman, and they had four children in their common-law marriage. In *Chopsticks in the Land of Cotton*, the author explained that Joe and Hazel were often harassed by the police. Joe opened a second store in Greenville for his wife to manage. Joe ran the Cleveland store during the week and helped at the Greenville store on weekends. In 1938, a suspicious fire started at the Greenville store. Though no proof existed that it was racially motivated arson, Joe closed both stores and moved to Houston, Texas, around 1942. In Mississippi, Chinese and African American marriages and the children born into these unions were never accepted by any race, and they were treated worse by the whites and by the Chinese who did not mix.[85]

By 1941, most of the nine hundred Chinese in the Mississippi Delta were related to merchants of grocery stores. Greenville had fifty-two Chinese grocery stores, the largest number in Mississippi. Greenwood was second with twenty-six, Clarksdale with twenty-four, Vicksburg with fifteen and Cleveland with eleven. Other Mississippi Delta towns with Chinese groceries were Tutwiler, Hollandale, Itta Bena, Shaw, Boyle and Moorhead.[86]

In 1924, Ethel Wright married Lebanese-born salesman Hassan Mohamed, and they had eight children. They operated the H. Mohamed Store in Belzoni, Mississippi, where they lived most of their lives. Ethel ran the store after Hassan's passing until 1980, when a grandson took over.

In Mississippi's more urban areas, the scenery was quite different, as was daily life. Early downtown Hattiesburg had been home to theaters

and film houses, such as the Strand, the Royal, the Buck, the Pick, the Star, the Lomo, the Gem, the Rebel and the Ritz, with the Almo serving Hattiesburg's black community. The Saenger Theater opened in 1929, as did the Forrest Hotel built to attract out-of-town businessmen. Instead, the onslaught of the Great Depression crushed new and established businesses, and Hattiesburg residents faced bankruptcy and unemployment. The rising number of residential fires had the Hattiesburg fire department suspecting arson in some cases for insurance money. The *Hattiesburg American* newspaper managed to stay open by paying its employees with in-house currency, redeemable at local merchants that, in turn, traded for advertising space. Newspaper subscriptions could be bought with chickens and syrup.[87]

In 1930, the Hattiesburg Public Library opened with Parmelee Chevis as the first librarian. The Hattiesburg elite, with its many social clubs and organizations, looked nothing like the Mississippi Delta sharecroppers slaving in the fields and living in shacks. In 1932, there were two home and garden clubs, twenty-one literary clubs and one music club that sponsored junior clubs. Hattiesburg continued to enjoy its early tradition, the Krewe of Zeus, which spawned from Mardi Gras celebrations along the Mississippi Gulf Coast. The Depression failed to stifle the dinners, the business meetings and the dinner dances that began in 1938.[88]

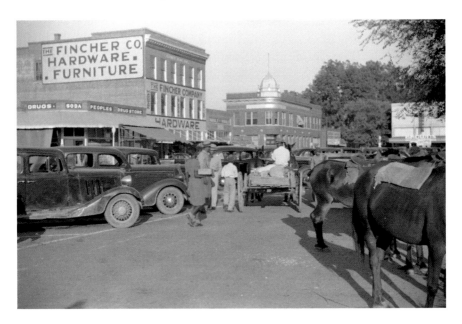

Center of town on Saturday afternoon, Belzoni, 1939. *FSA, Library of Congress.*

In Meridian, African American E.F. Young Jr. married Miss Velma E. Beal in 1927, the year he graduated from Haven Teacher's College. In 1930, Velma founded Young's Beauty Salon, the first ethnic beauty salon in Meridian. In 1931, Young bought the barbershop where he worked and from there sold the line of African American hair products he manufactured after hours in his kitchen. Due to the great demand for his products, he received his U.S. Patent Trademark in 1933. E.F. Young Manufacturing became the South's most prominent African American–owned business and branched into worldwide distribution.

Other businesses in Mississippi survived or opened during the Depression. Philips-Jones Factory opened in Lauderdale County on November 13, 1934, and produced eight hundred dozen shirts with a capacity of one thousand dozen per day. The Minor Hoe Works was organized in 1931 under proprietor J.H. Minor and produced the finest farmers' hoes and weed cutters in the South. Other surviving enterprises in Lauderdale County were Brookshire Ice Cream Co., established in 1912; White Lumber & Supply, specializing in longleaf yellow pine lumber, cypress shingles, composition roofing, paint, windows, doors, trim and other building materials; Coca-Cola; F.A. Hulett; MeyWebb Hosiery Mill; Meridian Brick Company; Emmons Brothers, organized in 1892; Meridian Grain and Elevator; Queen City Broom Company; and Alex Loeb, founded in 1887. Sinclair Floral Company, located on eighty acres five miles from Meridian on Dekalb Road, shipped to wholesalers throughout the country the flowers grown in open fields and under the semi-shade of lath shelters, like verbena, queen's wreath, peonies, calla lilies, poinsettias, chrysanthemums and Dutch irises.[89]

Between 1880 and 1890, Meridian's population increased by 165 percent, and it was one of the fastest-growing cities in the South. The Grand Opera House, built by Marks Rothenberg and his brothers, opened on December 17, 1890, when most every show in America came from New York City. It seated more than eight hundred people and received the same shows as the rest of the country, a variety of melodrama, Shakespeare, opera and popular minstrel shows. In 1920, as movies began replacing the Broadway stage market, on June 7, the opera house advertised that it was opening as a theater for "high-class photo plays." Finalizing the terms in 1924, the Grand Opera House leased its theater for twenty-five years to Plaza Amusement Company, operated by the Saenger Theater chain, for $850 per month. The name was changed to the Grand, but it could not compete with the newer, larger theater being built a few blocks away.[90]

The Temple Theater, built by the Hamasa Shriners, was completed in 1928. Its stage was second in size only to the Roxy Theater in New York. One year earlier, the Hamasa Shrine had signed a lease/management contract with the Saenger Theater chain, which continued for years.[91] Saenger wanted to break its lease with the Grand Opera House and suggested in a letter to Rothenberg that, since the Grand Opera House was outdated, it should be gutted and transformed into an office building. Rothenberg refused. Claiming the Grand was unsafe due to a cracked truss supporting the gallery, which had been repaired, Saenger stopped paying the notes. In turn, Rothenberg sued Saenger in the Lauderdale County Circuit Court. Since Saenger's case was based on unwarranted safety issues at the opera house, the Circuit Court found for Rothenberg. Saenger appealed to the Mississippi Supreme Court, which upheld the verdict. In 1930, after the case had been transferred to the equity docket and Rothenberg won again, Saenger offered $75,000 to satisfy the lease, but Rothenberg declined. Saenger raised the offer to $90,000. Rothenberg wanted $125,000. Even after Saenger appealed to the fifth circuit of federal court, the decree was affirmed. However, Rothenberg never received any money from Saenger and the Grand Opera House remained closed and shut off to the world throughout the Great Depression and until 2006, when it reopened.[92]

Marks Rothenberg Department Store also faced plummeting revenue during the Depression, yet it extended credit to its customers. Still, when they couldn't pay, the company had to foreclose on some land to try to make ends meet. Revenue from the Grand Opera House was gone, and banks—including First National Bank, which Marks Rothenberg headed—had collapsed. Levi Rothenberg bought bank shares for $0.20 to $0.30 on the dollar to resuscitate First National Bank, but in 1934, he was unable to pay his employees. To keep the store operating, the company issued $200,000 of common stock to raise money. At the death of Marks Rothenberg in 1932, his three surviving children were left his share of the business. But the financial toll was too much for the family. Lee Rothenberg moved to Richmond, and sadly, Simon Marks, overwhelmed by his own depression, committed suicide. In 1935, the space beneath the Grand Opera House prop room was leased to J.J. Newberry, who offered the first lunch counter in Meridian. Sam and Levi Rothenberg died in 1937.[93]

During strained economic conditions, the Threefoot family contributed to their Meridian community by helping to ensure the completion of the local YMCA in the late 1920s. They completed their sixteen-story Threefoot Building, the tallest building in Meridian, in 1929 but were immediately

met with financial ruin. The family approached Levi Rothenberg for financial assistance to save some of their property being sold at tax sales, but Rothenberg refused. The art deco Threefoot Building closed almost as soon as it opened.[94]

Within this declining business atmosphere, Meridian's medical mecca rose, joining Rush Infirmary, which opened in 1915. In 1929, Dr. Jeff Anderson purchased Turner Hospital in Meridian and renamed it Anderson Infirmary. There was a laboratory, two operating rooms and thirty hospital beds. During the Depression, Anderson mortgaged his home on Twenty-Third Avenue to keep the infirmary open. In 1915, Dr. F. Gail Riley received his degree from the University of Tennessee. He became the first physician in Meridian to intravenously administer fluid and electrolytes and to use blood transfusions and the hemogram as a diagnostic tool. In October 1929, construction began on Riley Hospital, the first specialty hospital dealing with maternity and pediatric cases in Meridian. In 1930, Riley Hospital opened as a ten-bed hospital and clinic for children. The American Board of Pediatrics, formed in 1933, certified Dr. Riley without examination.

Meridian's colored clinic at 2506 Fifth Street had a medical director, surgeon-in-chief and staff consisting of Dr. DeWitt A. Buckingham, Dr. L.F. Brooks, R.F. Spears and J.C. Macon. The dental staff was Drs. H.W. Wilson, W.B. Block and A.B. Blackwell. Nurses were Louise Tyler, GN, and Bertha Jack Emerson, RN. Because of segregation, Buckingham's clinic offered twelve beds, fluoroscope and x-ray rooms, an operating room and a laboratory. There were also consultation and reception rooms.[95]

With the loss of railroading and manufacturing, Meridian focused on diversifying farming, stock and poultry raising. Mississippi's largest stockyard, Meridian Union Stockyards, was established in 1935 on fourteen acres bounded by the tracks of the Southern, Mobile and Ohio; Illinois Central; and Gulf, Mobile and North Railroads.[96]

Jackson grew faster than any other major city in the United States, except Los Angeles. During the 1930s, the Jackson natural gas field opened. Industry included lumber, cotton seed oil and textile factories. As the political center of the state, most of Jackson's white citizens were government employees. The African American community in the city constituted 40 percent of the population and made up the "bulk of the city's unskilled labor," according to *The WPA Guide to the Magnolia State*. The city's black section was in the northwest, where houses crowded together in grassless yards that were swept clean. Clothes on the lines often did not belong to the residents of the house but to the white families for whom the resident washerwoman washed. White

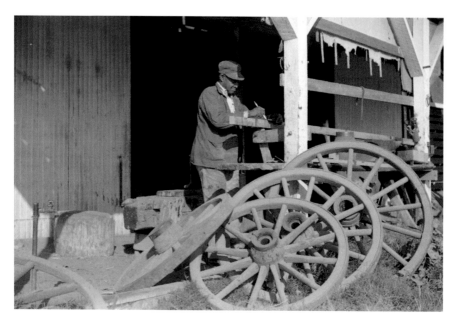

Uncle George in his blacksmith and carpentry shop on Marcella Plantation in Mileston, Mississippi Delta, 1939. *Library of Congress.*

women preferred black washerwomen to laundries, and black domestic workers who worked as cooks and nursemaids to white children often took in washing clothes to make extra money. African Americans who obtained positions as lawyers, doctors and educators lived on the opposite side of Jackson in better homes with grass lawns. In 1937, Jackson's population was sixty thousand.[97]

Since 1891, the Neshoba County Fair had opened its gates to crowds and political rallies. Nothing was going to change that—not even the Great Depression. For the first time in history, the 1930 Neshoba County Fair included a carnival with six riding shows, including the Ferris wheel, the Whip, a merry-go-round, the Thriller, Tilt-a-Whirl and others. Ignoring the country's downward economic spiral, the fortieth annual Neshoba County Fair broke attendance records.[98]

In 1934, fisher families confessed they preferred dancing to any other entertainment, so almost every special occasion included music and dancing. The Mississippi Gulf Coast, specifically Biloxi, was home to lots of dance halls.[99] Local Biloxi citizens started the Seafood Festival in 1930 to emphasize the importance of the seafood industry and to try to help the market. On September 26, Biloxi's canneries reported that twenty million

Eating oysters at a political rally, 1930s. *Library of Congress.*

cans of oysters and shrimp had been packed and seventeen thousand gallons of raw oysters had been shipped out of the city. Biloxi had been the "The Seafood Capital of the World" since 1903, and its population had grown to eight thousand. Entire families worked in the industry, dividing labor tasks along gender lines, with men being boat owners and fishermen and women and children working in the factories, until a 1908 Mississippi law made it illegal to hire children under age twelve. Nevertheless, the success of the seafood harvest relied on the entire family.[100] More than two thousand boatmen caught fish for factories, and three thousand people worked in factories. Of the eight hundred boats, shrimping and oyster fleets were equally divided. Oyster season ran from November to April, and shrimp season ran from August 15 to June 15. Croaker, speckled sea trout, mullet and redfish were shipped fresh to canning plants, some caught by pole and line, but most caught by seining. Most fishing boats and ships were built in Biloxi.[101]

There were several union disputes in Mississippi. In the fall of 1935, Gulfport longshoremen participated in the International Longshoremen's Association strike for higher wages and union recognition. The strike failed, but in 1938, Gulfport longshoremen did receive union wages.[102]

Textile mills in Mississippi played a crucial role in economic development, especially in the 1920s and 1930s. Regardless of the low wages and long hours, the social, living and working conditions in the textile mills were a great improvement over sharecropping and tenant farming.[103] Stonewall Manufacturing, named in honor of Stonewall Jackson, had opened in late 1868 and was sold in 1921 for $1.5 million to Crown Overall Company of Cincinnati, for the production and manufacture of denim overalls. In the 1930s, new and modern buildings and machinery gave the mill the latest in textile machinery. The village of Stonewall enjoyed the installation of city water and a modern sewage disposal system, which eliminated outhouses. The mill provided pay increases and paid vacations, plus employee benefits. Improvements in the village and housing were, at the time, unique in the Mississippi textile industry. In the late 1930s, in anticipation of World War II, the mill converted to the production of khaki and tenting. The military became its biggest customer, and the mill experienced prosperity during the war years.[104]

In 1911, James Sanders purchased his first cotton mill, which was located at Kosciusko. He also acquired mills in Mobile, Yazoo City, Natchez, Winona and Starkville. His son, Robert, after attending A&M College and serving as a captain in the army during World War I, became general manager of the cotton mills in 1920. Upon James's death in 1937, Robert inherited control of Sanders Industries. His expansion program included the motto "What Mississippi Makes, Makes Mississippi." The corporation included the Aponaug Cotton Mills at Kosciusko, West Point and Yazoo City; the J.W. Sanders Cotton Mills at Magnolia, Winona, Starkville and Meridian; the Delta Chenille Mills at Summit, Durant, Kosciusko and Winona; and Sanders Motors and Jackson Opera House at Jackson. Sanders Industries controlled most of the cotton manufacturing in Mississippi during the twentieth century, particularly through the Great Depression.[105]

Industry in Natchez included cotton and cottonseed mills, a shirt factory, a box factory and Mississippi's oldest sawmill. Of the population in Natchez, 53.5 percent was black, and the city was considered the African American cultural center of the state. Here, the blacks did most of their trade at black businesses, which contributed to and helped produce black wealth and professional standing in the community. Catherine Street was home to many commercial establishments and churches.[106]

The citizens of Tupelo, led by John M. Allen, John C. Clark, C.P. Long and E. Clovis Hinds, organized and financed the Tupelo Cotton Mill, the town's first large industry, in September 1900. Powered by five steam engines, the

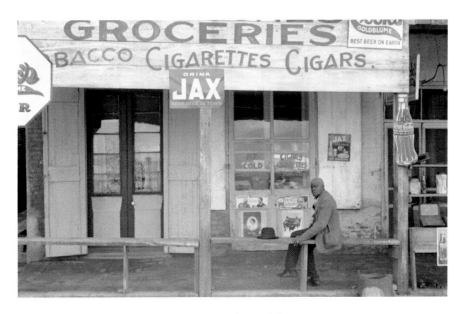

Natchez Resettlement Administration, 1935. *Library of Congress.*

mill employed 250 workers who operated 10,000 spindles and 320 looms, producing madras, denims, shirtings and pin checks. Workers within the plants lived in a village that held its own to other middle-class communities in Mississippi towns. By the early 1930s, the village of well-maintained houses painted in alternating white and yellow had electricity, city water, inside plumbing, paved streets and sidewalks. There were businesses, two churches and a brick elementary school for grades one through four.[107]

On April 5, 1936, a deadly tornado struck the village and the Tupelo community. The *Tupelo Daily Journal* reported, "In 33 seconds 201 persons were killed, 1000 injured; hosts of others wandered helplessly without homes, schools, or places of worship. The great oak trees were broken or uprooted. In less than a minute Tupelo received the most disastrous blow ever delivered to a Mississippi town." The final count was 230 dead, 2,000 injured and over 800 homes destroyed.[108]

One year later, on April 8, 1937, Jimmie Cox led fifty-two nightshift millworkers in a sit-down strike to demand a 15 percent wage increase and a reduced weekly workweek from forty-five hours to forty. The dayshift weavers joined the sit-downers the next day, which made up the entire workforce. Mississippi governor Hugh White met with the strikers on April 14, but neither the strikers nor the mill officials would settle their differences.

Post office, Perthshire, 1936. *Library of Congress.*

Three weeks of unproductive and fruitless negotiations led General Manager J.H. Ledyard to announce that the mill would close and liquidate its assets. Millworkers then had to vacate the village and find work at other mills nearby. Strike leader Jimmie Cox was "abducted from the streets of Tupelo, taken to a secluded spot…tied face down and severely beaten with belts." He was ordered to leave town and never return.[109]

Mississippi governor Martin S. Conner (1932–36) tackled Bilbo and his administration's $13 million deficit and went beyond his role as governor by writing a personal check to feed the state's mental patients. Unemployment was at a record high and institutions of higher learning were no longer accredited. Governor Conner convinced accrediting agencies to reinstate Mississippi's institutions to full accreditation after the legislature combined the three existing college boards and staggered the terms for board members. Governor Conner recommended cutting back on government services and the number of state employees to reduce state expenditures. His proposed sales tax made Mississippi one of the first states in the country to impose a sales tax. To provide new jobs for the state's unemployed, Governor Conner recommended a policy of tax incentives to attract new industry to Mississippi, which was later expanded into the "Balance Agriculture with Industry" plan. When Governor Conner left office in 1936, he left a treasury

surplus. "We assume our duties," said Conner, "when men are shaken with doubt and with fear, and many are wondering if our very civilization is about to crumble."[110]

His successor, Hugh White, won the governor's race on his promise to balance agriculture with industry as he had done as mayor of Columbia, Mississippi. In 1929, White initiated a plan to lure economic growth to Columbia by launching the Balance Agriculture with Industry Program (BAWI). The industry was Reliance Manufacturing, which promised, in exchange for $85,000 to construct a plant building, to employ 300 workers (increasing to 700) and inject back into the local economy $1 million in wages. White met with the community, detailed the proposition and garnered enough signed promissory notes to guarantee project funding. Once the plant was built and ready, over 1,500 women applied for jobs, many being rural women needing money to help run the farm. At an on-site training school, Reliance supervisors taught student workers on the factory's equipment. The training had no pay, but once workers reached certain skill levels, they were hired. Within four years of opening in July 1932, the factory fulfilled its employment and wage promises.[111]

BAWI, a two-tiered plan of "state sponsorship and control" balanced by "local financing and operation," resembled President Roosevelt's New Deal programs. The Mississippi Constitution, however, prohibited the use of the credit of the state to support industrial development as the BAWI proposed. The governor appointed six Jackson attorneys to author a BAWI bill to be presented as a "necessity to protect [the] people." The legislature passed the Mississippi Industrial Act in September 1936. The three-member commission narrowed 3,800 inquiries from interested firms to the final 21, which were issued certificates. Of the 21, 12 firms established plants in Mississippi: Ingalls Shipyard, Jackson County Mills and W.G. Avery Body Co. in Pascagoula; Grenada Industries, Grenada; Armstrong Tire and Rubber Co. in Natchez; Lebanon Shirt Co. in New Albany; I.B.S. Manufacturing Co. in Union; Crystal Springs Shirt Co., Crystal Springs; Winona Bedspread Co., Winona; Real Silk Hosiery Mill in Durant; Ellisville Hosiery Mills, Ellisville; and Hattiesburg Hosiery Co., Hattiesburg. These new plants helped increase wages in Mississippi from $1.4 million in 1939 to $17.9 million in 1942 on $980,500 in public bonds. Still, other than Ingalls Shipyard in Pascagoula and the Armstrong Tire and Rubber plant in Natchez, the new industries were low-wage textile industries employing mostly female labor. Training facilities, equipped and operated by the new factories and made possible through New Deal grants,

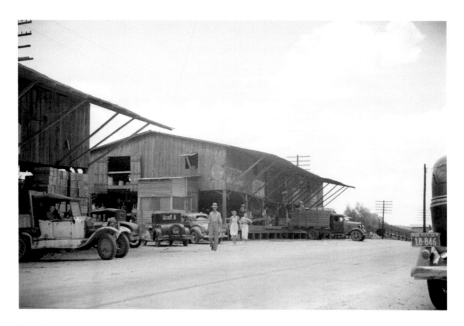

Box factory, Terry, 1936, Resettlement Administration. *Library of Congress.*

fell under federal scrutiny. Investigative journalists claimed that the WPA-funded vocational schools at Ellisville and Brookhaven were sweatshops for local mills and thereby demanded the return of federal money.[112]

With access to a deep-water channel and the railroad, shipbuilding became Pascagoula's chief industry. A result of the Mississippi Industrial Act, Ingalls Shipyard and the Ingalls Iron Works in Pascagoula, founded by Robert Ingalls from Birmingham, Alabama, in 1938, first built cargo and passenger ships and later military ships to prepare for the war.[113]

Construction in Mississippi in the Great Depression era utilized several architectural styles in the mid-1920s through the 1930s. Many post office buildings were constructed in a simplified Colonial Revival style, an example being the Belzoni Post Office (1937). The Neogothic style became popular in the 1920s and 1930s, and versions include Castle Crest (1925) and the Tudor Revival–style home of Eudora Welty (1925), both in Jackson. The twelve-story Lamar Life Building in Jackson (1925), Mississippi's first skyscraper, is also an example of the Neogothic style, as was Natchez High School (1927). Three good examples of the art deco style were the Threefoot Building (Meridian), the Plaza Building (Congress Street between Capitol and Amite Streets, Jackson) and the Tower Building (the Standard Life Building, northwest corner of Roach and Pearl Streets,

Textile factory built by Work Projects Administration, Brookhaven, 1936. *Library of Congress.*

Jackson). Examples of the "simplified, or stripped, classical mode" art deco styles included the War Memorial Building in Jackson (1940) and the Meridian Post Office (late 1930s). Art Moderne was sleek and plain rather than highly decorated, and Mississippi's best examples were the former Greyhound Bus Terminal in Jackson (1937) and the former Naval Reserve Building in Jackson (1949).[114]

No system for highways existed until the passage of the Stansel Act in 1930. Mississippi's first planned highway program was in January 1936 and would be a system of primary and secondary roads to all eighty-two counties in Mississippi. Air travel to and from Mississippi included two airlines that operated daily from Jackson.

Mississippi colleges and universities struggled during this time but managed to stay open. A WPA guide recorded enrollment for the 1936–37 school year as follows:

Mississippi State College for Women, Columbus: 952
Mississippi State Teachers College, Hattiesburg: 859
Delta State Teachers College: 367
Mississippi College, Clinton: 395
Millsaps College, Jackson: 415
Blue Mountain College, Blue Mountain: 301
Belhaven College, Jackson: 257
Mississippi Women's College, Hattiesburg: 176

The guide also reported that Mississippi had twenty-five landing fields, of which thirteen were equipped for night flying. From 1931 to 1936, new incorporated capital for Mississippi averaged over $400 million a year, which was about twenty-seven times greater than the five-year period between 1921 and 1926. In 1936, heavy construction increased in Mississippi by 333 percent, as compared to the national average of 71 percent. Increased car sales in Mississippi were 69 percent, with the national average being 25 percent, and farm income increased by 24 percent, as compared to the 13 percent national average. Against the rest of the nation, Mississippi was rated second in the increase in number of industrial establishments (number of manufacturing establishments, number of wage earners, amount of wages paid and value of manufactured products). Even with these increases, Mississippi remained the poorest state in the United States.[115]

3

ETHNICITIES AND CULTURES

During the Depression years, social scientists examined the unique makeup of southern families. In the 1930s, Margaret J. Hagood found, after her interviews with tenant farm wives in Alabama, North Carolina and Georgia, that family-centered activities dominated daily lives. In 1947, historian Francis Butler Simkins said, "In the decades after the Civil War the family was the core of southern society, within its bounds everything worthwhile took place." Another sociologist, Rupert B. Vance, added that family solidarity was so crucial, a clan mentality reigned.

As early as the settlement period in the South, Mississippians began sharing and preserving oral and material lore of the region, family records, photos and stories. With no resources, black families, too, found ways to preserve their ancestry, lore and way of life through stories and field songs as well as crafts, quilts and even toys and work tools passed from generation to generation. In 1935, Melville J. Herskovitz posed a question in the *New Republic*: "What has Africa given America?" In his answer, he mentioned language, foodways, manners and American music. Most examples came from the South.[116]

Other ethnicities, immigrants and cultures blended into various regions of Mississippi, preserving and sharing many homeland cultures and traditions. The Choctaw refused to give up their traditions and heritage to the white man. Their reservation established in east-central Mississippi in 1918 provided the environment to do that. The Choctaw language continues to be first in the bilingual Choctaw schools.[117]

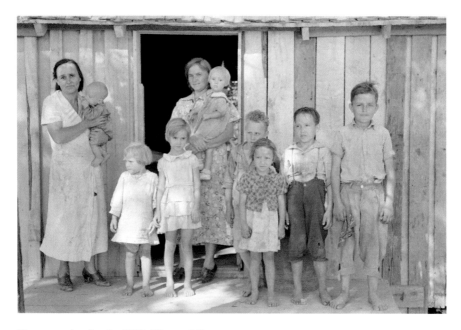

Sharecropping family, 1938. *Library of Congress.*

The largest number of immigrants were from the British Isles. Many of the early settlers were Irish, and they established the Roman Catholic Church in Mississippi. Others from Scotland and northern England brought views and attitudes regarding religion, government, social habits and relations and even labor unions, as detailed in Barbara Carpenter's book, *Ethnic History of Mississippi*. The large number of Celts settling in the South greatly affected southern culture, which, as historian Grady McWhiney noted in his research, influenced the "disdainful attitude toward the plow, a bent toward leisure in hunting, fishing, drinking and horseracing, and unpretentious manners and lifestyles combined with hospitality. Perhaps one of their greatest strengths lies in self-sufficiency and storytelling."[118]

For many immigrants, employment in the fields and railroads became their initial line of work. The British-owned Delta and Pine Land Company, one of the world's largest cotton-producing operations, attracted many ethnic groups, including Chinese, Jews, Italians and Syrians, who moved into the region.[119] This venture started through three separate companies established by British businessmen to get around the 1890 federal law prohibiting farm operations from owning more than 12,500

acres of land. The Mississippi Delta Planting Company leased land from the other two companies: the Triumph Planting Company and the Lake Vista Planting Company. The three companies consolidated under the charter of D&PL in 1919. Formed as a land speculation company in 1886, the company was exempt from the landownership law because D&PL's charter predated the law.[120]

In Mississippi, Jim Crow laws pertained to the Chinese to ensure that races of color remained segregated. For minorities, separate drinking fountains, waiting rooms, toilet facilities, train cars and seating at the back of public transit buses were common. Cafés, restaurants, churches, schools and barbershops often refused blacks, though some theaters had entrances for the "colored" to sit in a separate section. So, minorities opened their own cafés and theaters. White-owned stores did not cater to the black population, but the Chinese, like the Jews, did. In turn, they developed a good relationship with black consumers, even offering credit lines to some.[121]

Very few Chinese women lived in Mississippi because early Chinese laborers were mostly young single men who came to America to work. Marriages were arranged in China. Men traveled back to their homeland to marry and reside with their new spouses for one or two years before returning to America. Lawmakers favored the Chinese merchant over the Chinese laborer. In 1882, exclusion laws allowed merchants to bring their families to America. These laws did not include laborers already in America, so to combat this law, the Chinese developed "paper sons."[122]

Paper sons were "born" when Chinese men returned to China to visit their families. After returning to America, Chinese men falsely reported births of a son or daughter they fathered while in China. This practice created immigration slots for Chinese claiming to be the offspring of an American citizen. Paper sons paid their Chinese American fathers to sign false birth papers for them. The goal of Immigration Service officials was to catch these paper sons and daughters. Known as *luk yi*, or "green-clothes men," officials grilled immigrants for hours to determine whether an applicant was really the son or daughter on the birth papers.[123]

Here follows a sample interrogation:

> *QUESTION (Q). What is your name? ANSWER (A). Leong Sem. Q. Has your house in China two outside doors? A. Yes. Q. Who lives opposite the big door? A. No house opposite. Q. Who lives opposite the small door? A. Leong Doo Wui, a farmer in the village; he lives with his wife, no one else. Q. Describe his wife. A. Chin Shee, natural feet. Q. Didn't that man*

have any children? A. No. Q. How old a man is he? A. About thirty. Q. Who lives in the first house in your row? A. Leong Yik Fook, farmer in the village; he lives with wife, no one else. Q. Describe his wife. A. Wong Shee, bound feet. Q. Didn't that man ever have any children? A. I don't know. Q. How many houses in your row? A. Two. Q. Who lives in the first house, first row from the head? A. Yik Haw, I don't know what clan he belongs to. Q. Why don't you know what clan he belongs to? A. I never heard his family name. Q. Do you expect us to believe that you lived in that village if you don't know the clan names of the people living there? A. He never told us his family name. Q. How long has he lived in the village? A. For a long time. Q. What family has he? A. A wife and one son, his wife's name I don't know, released feet. Q. Who lives in the second house in the third row? A. There is no house there.[124]

The population of Chinese women increased, partly due to Delta grocers marrying American-born Chinese women through arranged marriages. By the 1920s, a thriving Chinese community existed in Mississippi, including school-age children. The government did provide public education for minorities; however, it was sorely inadequate and anything but equal to

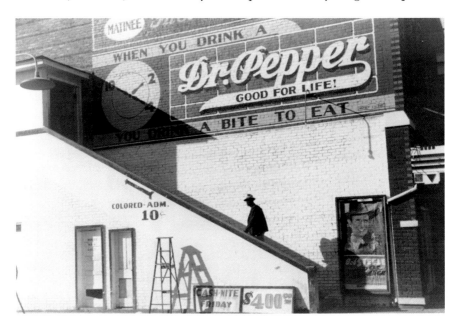

Colored entrance of movie house, Belzoni, 1939. *Library of Congress.*

schools for white students. Chinese, like African Americans, were unable to attend the white schools. In 1924, Rosedale Consolidated High School forced Martha Gong Lum, daughter of a prosperous Chinese grocer, to leave the school because of her ethnicity. The Gong Lums sued, but the Mississippi Supreme Court ruled, "Chinese are not white and must fall under the heading, colored races." On appeal to the U.S. Supreme Court, the high court justices agreed with the Mississippi court, stating, "Similar laws [of segregation] have been enacted by Congress under its general power...over the District of Columbia as well as by...many of the States...throughout the Union, both in the North and South."[125]

The first Italians in Mississippi were with Hernando de Soto's expedition in the 1540s during the French and Spanish explorations in the Mississippi River Valley. The first European to see Pascagoula Bay was an Italian, Berardo Peloso, in 1558. Italians tended to settle more in the river cities, like Natchez and Vicksburg, feeling more accepted by the population. Sicilians settling along the Mississippi Gulf Coast worked in the fishing and canning industry or opened grocery, tobacco and liquor stores.[126] Italian William Cruso arrived in Biloxi in 1919 and opened CC Company there. He bought fresh fish from Gulf Coast fishermen and sold it to restaurants.[127] The U.S. Immigration Commission report of 1911 found that 100,000 Italians, mostly farmers, lived in the states of the Mississippi Valley.[128]

In the Mississippi Delta, planters began replacing black labor with European peasants as effective forced labor. The Italians suffered from disease and endured prejudice and oppression from the community.[129] Greenville had the largest population of Sicilian immigrants. There, Mississippi planter LeRoy Percy orchestrated Italians workers on his eleven-thousand-acre Sunnyside Plantation across the Mississippi River in the Arkansas Delta. With no knowledge of the American legal system or the financial ability to challenge the sharecropping system, Italian farm tenants fell into a life of peonage.[130] Always in fear of the black exodus, Percy had hoped to lessen the need for black laborers by encouraging Italian farmers to immigrate to the Delta. But Percy treated Italians the way he treated his black laborers and was severely criticized by Italian officials and journalists.[131]

In Mississippi's larger towns, Italians established restaurants, grocery stores and fruit stands. In 1921, Italian immigrants Charles and Marie Lusco started a grocery store in Greenville where cotton farmers played cards, drank Charles's homemade wine and ate Marie's cooking.[132] In the 1930s, according to an Immigration Commission report, there were 100 Italian

families in Shaw, another 60 in Shelby and 130 in Rosedale, Mississippi. Decades later, Italians would become some of the biggest farmers in the Delta and own much of the land.[133]

In the late 1800s, Austrian immigrants moved from the coastal region of Yugoslavia to work in Mississippi's seafood industry and to escape the draft into the Austro-Hungarian Empire's army. Yugoslavian immigrants opened other businesses along the Mississippi Gulf Coast. Around the same time, Polish workers traveled by railroad to the Gulf, where they and their children worked in the seafood factories in Biloxi and lived in company-owned housing called camps. Some Polish workers settled permanently. By 1904, Biloxi, one of the world's most fertile fishing grounds, was the world's largest exporter of seafood by tonnage. There weren't enough people to fill all the positions at the seafood canneries. From 1914 through the 1930s, factory owners recruited "Frenchmen," known better as Cajuns or Acadians, from south Louisiana to work in the Biloxi seafood industry. These were descendants of Catholic French Canadian settlers who refused Protestantism and swearing allegiance to the new British overlords. Expelled from Canada by the British in 1755, they endured hardships as wandering refugees for thirty years. Many settled in Louisiana and from there moved to Mississippi.[134]

Biloxi had the largest foreign-born population in Mississippi. *The WPA Guide to the Magnolia State* stated that the eastern end of Howard Avenue was built for the European people brought to Biloxi as laborers in the fishing industry. These rustic cabins on stilts in a poverty-stricken area were still temporary structures for the Poles, Austrians, Czechoslovakians and Yugoslavs in 1925.[135]

By the time eastern European Jewish immigrants arrived in the late nineteenth and early twentieth centuries, Jews from Germany and Alsace were already peddling in Mississippi. Jews had been forbidden to own land in Europe and knew little of farming, so they educated themselves on entrepreneurial skills as traveling peddlers. They bought merchandise from wholesalers in New Orleans or Memphis and then sold those supplies and goods to farmers and their families around Mississippi. With the money saved from sales, a Jewish peddler could open a business in one of the towns or cities where he had done business. The Jewish population in Mississippi began to grow.[136]

There were 375 Jews in Greenville the year of the great flood. On April 21, 1927, the breaking of Mounds Landing levee twelve miles north of Greenville released more than double the volume of Niagara Falls. Lillie

Johl Waldauer had died two days before the levee broke. Her body could not be interred until months later, when the water subsided. Even in his grief, her son, Ernest, assisted in flood relief efforts. Red Cross volunteers included Ruth Blum, Alberta Lake and Ben Wasson, all Greenville Jews. In Washington County, the flood displaced thousands of people. Property damage was estimated at $350 million, which today would be around $5 billion. After the flood, Jewish businesses confronted the Great Depression. Some closed. Some took out loans.[137] Russian Jewish immigrant Sam Stein had opened a dry goods store in Greenville in 1908. This business persevered and later evolved into Stein Mart, a national department store chain. In 1937, 450 Jews lived in Greenville and were a major part of the city's merchant class.[138]

Fewer than forty Jews lived in Belzoni because most chose the larger Delta towns like Yazoo City, Greenville and Indianola or more urban cities like Meridian. Still, general goods establishments and clothing stores opened in Belzoni during the 1920s, like Goldberg's, whose motto was "The Home of Good Things to Eat," and later Goldberg's Department Store. Belzoni Jews traveled to and worshipped in Greenwood at either Ahavath Rayim or Beth Israel. Jewish immigrants, like the Davidow family, came to Belzoni from rural areas in Europe.[139]

The Greenwood Jewish community experienced growth through the 1920s and 1930s and grew to about three hundred by 1937. Businesses included J. Kantor's and Weiler Jewelry Store, Kornfield's Inc. Department Store and Starr Tailors. Moody Grishman began farming as a boy on a forty-acre farm in Gulfport, raising milk cows and chickens and growing onions, pecans and vegetables. The only Jewish family in the region, Grishman's farming lasted through the Great Depression from 1930 to 1939.[140]

In the 1920s, dry goods stores, department stores, haberdasheries, jewelry stores, grocery stores and tailor shops opened in Clarksdale, but the flood of 1927 greatly impacted the area. To get to the synagogue for worship, Jews had to follow the levees. To salvage his Rose Seed Company, Herman Damsker built scaffolds to protect his seeds. During the Depression, some stores went bankrupt and reopened under new ownership. Jewish shops could be found on Issaquena Avenue, Delta Avenue, Third Street, Yazoo Avenue and Sunflower Avenue. Jews chose to live near their businesses or in Jewish neighborhoods. Some lived in mixed areas with African Americans. Nearby, the Lovitz family operated a department store in the town of Webb, and Aaron Kline operated the Whale Store, a dry goods store, in the town of Alligator.[141]

The municipal
levee at
Greenville, 1937.
Library of Congress.

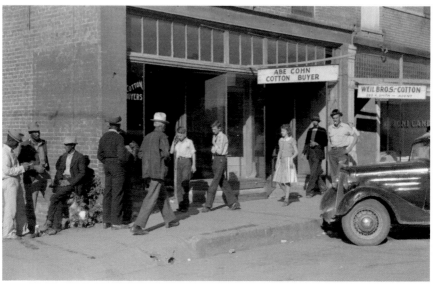

Cotton offices, main street, Saturday afternoon, Belzoni, 1939. *Library of Congress.*

Cotton brokers' offices. Clarksdale, 1939. *Library of Congress.*

Despite hard times, seventy to ninety Jewish families lived in Cleveland, Mississippi, between 1928 and 1937. There was Kaplan's Variety Store with its slogan, "So Much for So Little," Fink's Drug Store and the Solomon Coal and Transfer Company. Jewish-owned car dealerships included Klingman Chevrolet, which started in the 1920s and continued into the 1930s, and later Goodman Wooten Motors and Kossman's. Between 1926 and 1927, Joe Fink and Leo Shoenholz led the capital campaign for the first building of the congregation of Adath Israel (Community of Israel). In February 1927, four years after the first organization of the congregation, members dedicated the building on the corner of Bolivar and Shelby Streets. The congregation hired Rabbi Jacob Halevi as their resident rabbi in 1928, and his tenure continued until 1931. Then, Carl Schorr, Hirsch L. Freund and Newton Friedman served the congregation. In 1934, Adath Israel joined the Union of American Hebrew Congregations and used the Reform Union Prayer Book. The Great Depression caused the building to fall into disrepair, but charity drives brought in over $1,000 annually. The congregation's income was enough to take care of a rabbi's salary.[142]

In downtown Columbus, Jewish-owned stores, mostly dry goods, ladies' wear or shoe stores, included Simon Loeb and Brothers Department Store, Kaufman Brothers, L. Rosenzweig & Co., Isenberg Brothers, Feinstein's,

the Fashion Center, Loeb's Furniture Company, S.B. Scwab, Hirshman's Dry Goods, Rubel's Store, the Columbus Cash Store and the Darling Shop, owned by Morris and Zelotta Zlotnick. The Globe, a men's clothing store, was founded by Jack Gordon in 1937. Simon Loeb had arrived in Columbus in 1867 almost broke. In 1874, Loeb and his younger brother, Julius, opened Simon Loeb and Brothers Department Store, and by the 1930s, Simon Loeb and Brothers was the largest department store in northeast Mississippi, selling just about everything from groceries and clothing to shoes and dry goods. Kaufman Brothers was founded in 1896 by three sons of German Jewish immigrant Herman Kaufmann. According to legend, the sign was too long for the narrow building, so, to make it fit, they cut the last "n" off Kaufmann. After a catastrophic fire in 1931, the brothers sold what remained and closed the store.[143]

A native of Jablonow, Poland, Louis Buchalter moved from New York to Natchez to take a job. Then, with seventy-five dollars, Louis and his wife, Jennie, moved to Hattiesburg, where he opened Louis Tailoring Co. in 1915 on East Pine Street. Buchalter tailored for fifteen years without a sewing machine. When he purchased a sewing machine, he only used it for alterations. The store made it through the Depression and didn't close until 1982, after sixty-eight years of business in the same location. In 1937, 215 Jews lived in Hattiesburg.

The 1936 Balance Agriculture with Industry legislation enticed northern industries with lower taxes and labor costs, which adversely affected the Jewish businesses in Holly Springs, especially Jewish merchants in the cotton business. The Jewish population in Holly Springs decreased to twenty by 1937 due to tighter immigration laws and deaths among them.[144]

In 1929, after local Arabs attacked Jewish settlers in Palestine, non-Jewish Laurel citizens donated money for a Jewish relief fund. In 1935, the *Laurel Leader Call* reported on the confirmation of William Henry Amber, Herbert Joseph, Rosemary Pellman, Irene Percoff and Harold Maurice Matison and the service officiated by Rabbi William Ackerman of Meridian. A 1937 survey confirmed sixty-five Jews living in Laurel.

By 1927, eighty Jews lived in Lexington, but during the Great Depression years, due to the decline of cotton, Jewish businesses closed and many left.[145]

In Natchez, Saul Laub served as mayor from 1929 to 1936. In 1927, brothers Isidore and Leon Levy built the historic Eola Hotel, named after Isidore's daughter. The Levy family ran the hotel until the stock market crash in 1929. In 1936, nineteen businesses were still under Jewish ownership in Natchez, like Geisenberger & Friedler, Krouse Pecan Co. and Abrams Department Store. In 1932, Jane Wexler, a Jewish woman, was the second

Courthouse steps, Lexington, 1939. *Library of Congress.*

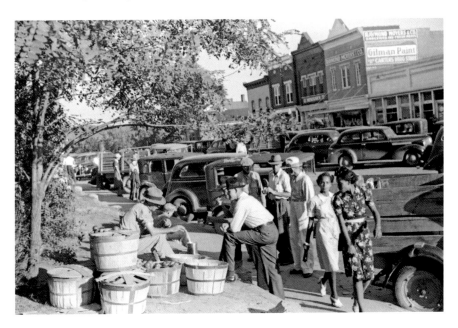

Selling apples on main street on a Saturday afternoon, Lexington, 1939. *Library of Congress.*

queen of the Natchez Mississippi Pilgrimage. Her mother was a founding member of the organization celebrating the old southern plantation heritage with balls and historical reenactments.[146]

McComb supported a Jewish population of twelve in the late 1930s, but the Jewish population in Summit dwindled, most likely because of the infestation of the boll weevil and its devastation of the crops. McComb's industry related to the railroad and oil due to the 1936 BAWI Program, while Summit depended on its traditional lumber and cotton industries.[147]

Sam Rosenthal was born in Brooklyn, New York, to Russian immigrants Charles and Alice Rosenthal, who moved to Natchez when Sam was three. In 1919, the Rosenthals moved to Rolling Fork to help Monroe Rosenthal, Sam's brother, with his clothing store. Sam was elected as an alderman on April 8, 1924, and served as mayor from 1924 until 1969. Rosenthal also served as a city judge and was a charter member of the Lions Club alongside other Jews: Sam Lamensdorf, Ed Danzig and H.C. Glazier Jr. Rosenthal oversaw the construction of sidewalks, paved streets and recreational facilities and introduced a credit structure for the local lumberyard. His investment in a new generating motor improved electricity. During the 1927 flood, when the levees broke, Rosenthal evacuated everyone on a train to Vicksburg before Rolling Fork completely flooded while he remained behind to serve as chairman of the Red Cross. Rosenthal used one of Roosevelt's New Deal programs, the WPA, to pave the roads.[148]

Of the five thousand Tupelo residents entering the Great Depression, only twenty were Jews. This changed in 1935, with the coming of the Tennessee Valley Authority (TVA), electricity and paved roads. By the late 1930s, there were many new residents to Tupelo, including Jews. In 1936, they formed the Northeast Mississippi Sisterhood under the leadership of Marion Peltz and Mrs. Sol Weiner, which afforded women opportunities to socialize and form charities. In 1938, Sol Weiner formed Tupelo's B'nai Brith Lodge. On August 24, 1939, the Jewish community officially organized Temple B'nai Israel, with Weiner as its first president. The congregation first met in the Tupelo City Hall before renting space above the Fooks' Chevrolet dealership on South Spring Street.

By 1937, eighty-five Jews lived in Canton, and Jewish merchants were an integral part of the commercial economy. Jewish stores included Schlesinger's Smart Shoe Store, Hesdorfferr's Grocers, Stein's Golden Rule Store, Frey's Food, I. Rosen's Apparel Shop for Women, Kaplan's Dry Goods and Clothing and Hirman Brumberg's Busy Bee Café.

The year of the great flood, 467 Jews lived in Vicksburg. An estimated 171 Jews had lived in Port Gibson in 1905, but by 1937, only 44 Jews remained. The Jewish population in Yazoo City numbered 61.[149]

Meridian grew to be one of the largest Jewish communities, with 575 Jews in 1927. Downtown Jewish businesses included Levy & Tanenbaum Confectionary, Lowenstein & Brothers Grocery, Eagle Cotton Oil Company, Strauss & Lerner Jewelry Store, Metzger & Kahn wholesale and retail grocers and many others. Louis Davidson founded the St. Louis Junk Company. Meridian Jews also went into business with gentiles, representing diverse thinking and planning for economic development. Harold Meyer and Hunter Webb founded the Meywebb Hosiery Mills in 1930. Meyer later built the Lamar Hotel, which now serves as the Lauderdale County office building.

Jewish immigrant Israel Marks had traveled from Germany to Mississippi by way of the New Orleans port in 1856. He and his wife, Sara Sugarman Marks, had one child, a son, Israel Marks, named after his father. Marks Lichenstein & Co. formed in 1870 on Front Street. After the death of her husband, Sara married Sam Rothenberg, and they had three sons: Levi, Sam and Marks Rothenberg. These brothers, along with half brother Israel, established Marks, Rothenberg and Company, the grocery and general merchandise business that became the largest in Mississippi. They also established the Grand Opera House, which opened in 1890 as a premier theater destination in the South. As stated earlier, the changing times and the Great Depression devastated both.[150]

Abraham Threefoot (originally Dreyfus) had established his family name in the late 1860s with his grocery store on Twenty-Fifth Avenue in Meridian. At his death, sons H. Marshall, Kutcher and Lewis took over the business, and by 1910, sales exceeded $100,000 per year.[151] Threefoot Bros & Co. occupied the two lower floors of the new Marks Rothenberg building on Sixth Street and the ground floor of the Grand Opera House before they erected the Threefoot Building on the Seventh Street and Twenty-Second Avenue block. Completed in 1929, the Threefoot Building went bankrupt along with the business due to the Great Depression.[152]

In Jackson, the Lehman family served breakfast to many hungry children walking to the school. A dedicated school board member, Aaron and his wife, Celestine Lehman, started a home for elderly women in Jackson. At the turn of the century, Isidore Lehman's career in Jackson began as a shirt washer for a Memphis laundry company. From there, he became partner and owner of Jackson Steam Laundry at 730 State Street. Its slogan was

"When clothes are dirty, 730." Lehman's store also served as a bathhouse for people without running water and stayed open until the 1960s. The Gardner and Kahn Cleaning Company opened in the Jackson area in 1924 and operated until the 1980s. In the 1920s, Jackson's leading department store was the Emporium, located on the corner of Congress and Capitol Streets, owned by Simon Seelig Marks, son of Israel and Hettie Marks of Meridian. After graduating from Yale, Simon had worked at Marks, Rothenberg and Company in Meridian. Married to Josephine Hyams of Jackson, Simon was a member of the Kiwanis Club as well as director of the Mississippi Merchants Association and vice president of Jackson's chamber of commerce. During the Great Depression, Simon served as the state director for the National Emergency Council. The Emporium building was restored in 1988 and is listed in the National Register of Historic Places.[153]

By 1937, Jews lived in 107 Mississippi towns, per Stuart Rockoff, former executive director of the Goldring & Woldenberg Institute of Southern Jewish Life.[154]

4
NEW DEAL PROGRAMS

Responding to the 1929 stock market crash, President Herbert Hoover (March 4, 1929–March 4, 1933) insisted the American economy was stable and that business could and would continue as normal in America—and it did...at first. But by 1933, over 40 percent of the country's home mortgages were in default and 25 to 30 percent of the American population was out of work, a figure probably grossly underreported. Because loaning institutions could not rent, sell or maintain defaulted homes, foreclosures were kept to a minimum.[155]

The resources of churches and charity organizations fulfilling missions of "feeding, clothing, and caring for the hungry, the widows, the orphans, and the homeless" dissipated to the point that they, too, were in desperation.[156]

Until Franklin Delano Roosevelt stepped into his role as the thirty-second president of the United States on March 4, 1933, Americans had rarely experienced the federal government in their daily lives except through the U.S. Postal Service. Now, amid the greatest economic collapse in American history, the new president's acceptance speech offered America something different: "I pledge you, I pledge myself, to a new deal for the American people."

Americans seemed more than ready.

The New Deal was an array of programs and agencies created by the Roosevelt administration and Congress to stabilize the economy, put Americans to work and assist people in dire need. The first New Deal program began during Roosevelt's first week as president with the passing of

the Emergency Banking Relief Act, which required federal inspection of all national banks and state banks joining the system. Some 90 percent of banks reopened within two weeks, and depositors began to regain confidence in the banking system. To protect small deposits and end panicked runs on the banks, the Federal Deposit Insurance Corporation (FDIC) was also established. The Home Owners Loan Act allowed banks to trade defaulted loans for government bonds. The Securities Act (1933) and later the Securities Exchange Act (1934) oversaw the stock market. In addition, the Government Economy Act cut federal spending and salaries by 15 percent, a testament to the American people that the federal government was in this, too. Plus, the Roosevelt administration presented the Twenty-First Amendment to repeal the Eighteenth, the nationwide ban on alcoholic beverages, while also revising the definition of intoxicating beverages, specifically beer and wine, in the Cullen-Harrison Act. Three-fourths of the states ratified the Twenty-First Amendment. Mississippi did not and, in fact, would be the last state to repeal prohibition, in 1966.[157] The second New Deal included union protection programs, the Social Security Act and programs to aid tenant farmers and migrant workers. Many New Deal acts or agencies were better known by their initials and became known as Roosevelt's Alphabet Agencies or his alphabet soup. There were many.[158]

PROGRAMS

Programs for Regulation of Trade, Transport and Communications

Civil Aeronautics Act (1938)
Communications Act (1934)
Export-Import Bank (EXIM) (1934)
Reciprocal Trade Agreements Act (RTAA) (1934)
Repeal of Prohibition (1933)
Robinson-Patman Act (1936)

Other Bank Stabilization and Financial Reforms

Agricultural Adjustment Act (AAA)
Banking Act (1935)

Frazier-Lemke Farm Bankruptcy Act (1934)
Glass-Steagall Banking Act
Gold Reserve Act
Indian Reorganization Act, legislation for American Indians in Oklahoma
and Native Alaskans (IRA)
National Industrial Recovery Act (NIRA)
Public Utility Holding Company Act (PUHCA) (1935)
U.S. Travel Bureau
The Virgin Islands Company (VIC)

Relief and Welfare Programs

Federal Emergency Relief Act (1933)
Federal Surplus Commodities Corporation (FSCC) (1933)
Social Security Act (1935)

New Public Works Programs

Civilian Conservation Corps (CCC)
Civil Works Administration (CWA)
Federal Emergency Relief Administration (FERA) (1933)
National Youth Administration (NYA) (1935)
Public Works Administration (PWA)
Puerto Rico Reconstruction Administration (PRRA) (1935)
Rural Electrification Administration (REA) (1935)
Soil Conservation Service (SCS) (1935)
Tennessee Valley Authority (TVA)
Works Progress Administration (WPA) (1935)

Roosevelt also expanded existing public works programs:

Army Corps of Engineers
Bureau of Public Roads
Bureau of Reclamation
U.S. Armed Forces and National Defense Industries
U.S. Post Office Department

Arts and Culture Programs

These initiatives provided jobs for writers, artists, historians and other creative professionals:

Art and Culture Projects of the Federal Emergency Relief Administration
 (FERA) (1934)
Public Works of Art Project (PWAP) (1933)
Treasury Section of the Fine Arts (TSFA) (1934)

The WPA created the Federal Project Number One (Federal One) (1935), which encompassed the following:

Federal Art Project
Federal Music Project
Federal Theatre Project
Federal Writers' Project
Historical Records Survey

In 1939, a reorganization blended the Federal Art, Music and Writers' Projects into the WPA Arts Program, eliminating the theater project. The Historical Records Survey became part of the WPA's Research and Records Program.

Reorganization of Public Works Programs

Bonneville Power Administration (BPA) (1937)
Federal Security Agency (FSA) (1939)
Federal Works Agency (FWA) (1939)
Public Buildings Administration (PBA) (1939)
U.S. Treasury, Public Branch (PBB) (1933)

Rural and Farm Assistance Programs

Agricultural Adjustment Act (AAA) (1933, 1938)
Bankhead-Jones Farm Tenant (1937)

Farm Credit Act (1933)
Frazier-Lemke Farm Bankruptcy Act (1934)
Resettlement Administration (RA) (1935)
Rural Electrification Act (1936)
Soil Conservation Act (1935)
Virgin Islands Company (1934)

Housing Aid and Mortgage Reform

Home Owners' Loan Act (1933)
National Housing Act (1934)
U.S. Housing Act (1937)

Labor Law Programs

Fair Labor Standards Act (1938)
National Industrial Recovery Act (1933)
National Labor Relations Act (Wagner Act) (1935)
Social Security Act (1935)
Wagner Peyser Act/U.S. Employment Service (1933)[159]

President Roosevelt needed powerful advocates from the states to ensure and secure New Deal legislation. From Mississippi, there were Congressman John Rankin (Tupelo) and Mississippi senator Pat Harrison (chairman of the Senate Finance Committee). Their support and cooperation, along with others, helped secure many New Deal programs in Mississippi, especially in Tupelo.[160]

SCHOOLS AND TEACHER HOUSES

Ackerman High School, a two-story Art Moderne building dating to 1941, was a PWA project in Ackerman. In Philadelphia, the WPA constructed the Arlington Vocational High School Administration building, a single-story Colonial Revival building, in 1936. That same year, the WPA constructed the auditorium for Chalk School in Meridian and added a rear auditorium and

cafeteria to the East End Italianate/Craftsman school originally constructed in 1888. The auditorium annex to Meridian's Highland School, originally constructed in 1907, was completed by the WPA in 1936.

The WPA initially funded the Biloxi Junior High School project, which included eighteen classrooms, including home economics, science and manual training facilities, but the project was halted due to lack of WPA labor in Biloxi. The WPA had spent $27,937 on the construction and voters approved bonds for $47,000, but bids for building, plumbing and heating exceeded the funding available. The FWA provided additional funding to complete the building, and the school opened in September 1943.

Bailey Magnet High School in Jackson, a PWA project, was a two-story building with a basement containing locker and shower rooms, a cafeteria, a kitchen, club rooms, an assembly room, industrial arts rooms, shops, workrooms and laboratories. The first floor contained the gymnasium and band room; the domestic science department, including an apartment, a sewing room and a cooking room; twelve classrooms; rooms for the fine arts and natural sciences; an auditorium with a stage; a clinic; and administrative offices. The second floor contained the bleachers for the gymnasium, ten classrooms, a science laboratory and rooms for fine arts, natural science and music. Built of reinforced concrete with structural-steel trusses over the auditorium and gymnasium, the art deco building was an architectural wonder, showcasing at the front steps carved stone reliefs of Andrew Jackson with his troops alongside Chief Pushmataha and his braves, allies in the Indian Wars. The halls were terrazzoed, and the auditorium possessed ornate columns and a stylized horse-and-rider sculpture. The project was completed in November 1937 at an estimated construction cost of $317,040 and a project cost of $388,641.

The athletic field at Biloxi High School started development in 1940, prior to beginning with the new junior high in 1942. The $17,000 project included grading, drainage and fencing of the new field and a playing field, three practice fields and a quarter-mile track. The field was used for the first time by Biloxi High School versus Moss Point on September 17, 1941.

The NYA funded the new frame construction of Bond School's home economics building in Winston County. It also funded the Bowdry School Building, an eight-room frame building constructed for use by African American students in the segregated school system of Tate County, near the town of Senatobia, Mississippi. Construction began in 1937 and was completed in 1938, replacing the one-room shack previously used by the district.

The NYA constructed the rock cafeteria for the Hickory Flat School in 1939. The original building featured a double-door entrance in the center and single-door entrance/exits on either side of the center doors. The doors were wooden, with nine-pane lights in the upper half of the door. The NYA built a one-and-a-half-story gymnasium for De Kalb High School in 1938.

Carmack Community School in Kosciusko was a one-story frame school with a distinctive T-shape built in 1938 and constructed with funds from the NYA.

Carrie Stern Elementary School in Greenville received funds from the Federal Emergency Administration of Public Works (later the PWA). Completed on September 9, 1939, the Georgian Revival–style elementary school, with its art deco and Streamlined Moderne interior, reflected modern ideas of teaching. Funded by the city and the PWA, the estimated cost was $151,000.

Carthage Elementary School was a Federal Emergency Administration of Public Works project in 1937. Construction of the Colonial Revival elementary school began on December 30, 1937, and was completed on September 23, 1938. The brick building featured a one-story front and a two-story rear portion containing the auditorium. Tuscan columns supported the recessed front entrance featuring an arched fanlight above the double-leaf wood doors. The PWA provided a grant of $42,924 toward the total estimated cost of $95,454.

Charlotte Hyatt Elementary School in Moss Point, a "one-story building with brick and white mortar, cast stone, seven classrooms, an auditorium, a clinic room, an office and a boiler room," began construction after approval of PWA funds. Moss Point issued $40,000 in school bonds, and the PWA provided the remainder. Construction began in 1935 and ended in 1936. Walthall School in Spring Hill was built in 1934 by the PWA with $8,000 of federal funding. It was destroyed by fire in 1940.

The Church Street Primary School in Tupelo was an "ultra-modern" design and good example of the Moderne style of architecture in Mississippi, with an interior featuring terrazzo floors, round windows and other Art Moderne influences. Constructed of concrete, the school was funded by the PWA. Construction began in 1936 and finished in 1938 at a cost of $225,000.

The Clinton School complex was listed among the WPA projects in Mississippi in 1942 and included the Colonial Revival–style elementary building built by the FWA.

Columbia High School in Columbia, PWA project 1212 in Mississippi, was a two-story, reinforced concrete building erected in 1938 that attracted national attention due to its International style. When the school opened, it was featured in *Architectural Forum* and the *New Yorker*.

The original Eupora High School was built by the WPA between 1938 and 1940. It held fifteen classrooms, laboratories, a library and an auditorium. No decorative details were included to keep within the allocated funds, $110,000, with $40,000 provided by the school district. The sole decorative features were molded plaques across the front of the building. Concrete canopied porches provided shelter for the two front entrances.

The PWA approved construction of a school building in the city of Oxford to house Oxford's "Negro Elementary and High School," started in 1938 and finished in 1939.

Harris High School for African Americans was started in 1937 and completed in 1938 with PWA funding that also constructed the Meridian High School, gymnasium and vocational buildings. Harris High School was smaller and less elaborate than Meridian and contained no additional buildings.

In 1937, Public Works Project Mississippi No. 110 enlarged Canton High School and added a gymnasium with stadium seating, eleven classrooms, a library, a study hall, a dark room, a music room and recital hall, a club room, a clinic, the principal's office, restrooms, the athletic director's office and janitorial and storage rooms. Leland Elementary School was constructed in 1935 by the forerunner of the PWA.

In Pontotoc, Longview School was a rock veneer school building constructed in 1941 by the NYA using rock from the nearby Tishomingo County quarry and lumber from a sawmill at Longview, both operated by the NYA. A gymnasium and a teacher's house were also constructed in Longview.

The Madison-Ridgeland High School annex in Madison, started in 1935 and completed in 1936, was designed as a two-story, buff brick structure to serve as the gymnasium for the existing high school. It connected to the earlier school with a one-story walkway. Funded by the PWA, it was an example of the art deco style in Mississippi. The addition featured brick piers, circular windows, mouse tooth detailing, concrete canopies and stylized griffon sculptures on the front entrance. Total construction cost was $37,432.

Meridian High School, a two-story brick building with limestone trim, was started in 1936 and completed in 1937 for a construction cost of $591,489 and project cost of $688,195. The project included a separate gym

and Ray Stadium, the adjoining sports field. Ray Stadium features "two steel-reinforced concrete stadium bleachers facing each other set in a man-made slope. The bleachers are supported at the rear by concrete columns attached with segmental arches." The gymnasium (1936–37), a two-story red-brick former gymnasium, was constructed by the Federal Emergency Administration of Public Works.

In 1938, the PWA completed additions to the existing 1920 school and constructed a new gymnasium for the Merigold Public Schools.

Moss Point High School was a WPA project in 1941. The two-story art deco high school was approved for $195,000 in WPA funds, and the city provided the remaining $130,000 to construct the school.

North Central Ward School in Gulfport, started in 1936, completed in 1937, is one of two schools built with PWA funds. The two schools combined were constructed for about $205,500, with the PWA providing 45 percent of the funds. The school contained an auditorium to seat 498.

Oakhurst and Elizabeth Door Schools Arcade Sidewalks in Clarksdale were a WPA project in 1940 and had an approximate cost of $6,000. The project was an extensive arcade system of walkways at the two schools in Clarksdale.

PWA Docket Mississippi No. 1219 DS approved additions and alterations to the Oxford Grammar/Elementary School in 1938–39. The school gymnasium at Batesville Elementary School was PWA Project No. 1371, constructed in 1938.

Ross Collins Vocational School, Meridian, an Art Moderne vocational school, was built as part of the Meridian High School complex. Construction was completed by the NYA in 1942.

Salem High School in Ashland was constructed by the NYA in 1941 to serve African American students. It was covered in a faux brick design shingle, pier-and-beam construction, and had two classroom wings with a central auditorium.

Another NYA project was Salem High School Vocational Building in Ashland, constructed in 1941 for African Americans. It was a pier-and-beam wooden building with a pent awning over the double-door entrance and contained a brick chimney, likely fitted for a woodstove vent.

Randolph Vocational Building was constructed by the NYA in 1939 in Randolph during an expansion of the school in the 1930s. A teacher's house was also added behind the vocational building. The Edwards High School Gymnasium was designed in the Art Moderne style and constructed in 1941 by the NYA.

Zama Vocational Agricultural and Home Economics Building, a white wood frame building, was constructed by the National Youth Administration in 1937.

Senatobia High School was a Federal Emergency Administration of Public Works project constructed in 1938 in an Art Moderne style. The auditorium was one and a half stories of reinforced concrete with a brick and stone veneer. The entry to the auditorium was separated by pilasters featuring bas-relief sculptures and a sundial above glass block lights.

The Shady Grove School in Tippah County was constructed by the WPA in 1936. In 1940, the WPA built the Shaw Gymnasium in the Delta community of Shaw. In 1936, with WPA support, architects Krouse & Bradfield designed additions of classrooms, an auditorium and a lunchroom for the 1888 South Side School in Meridian.

Vaiden High School in Vaiden, an Art Moderne school, was completed in 1943 as WPA Project No. 7233. Work began in 1941 but was halted due to lack of money resulting from the war. WPA workers mixed concrete on site and carried it in wheelbarrows to construct the poured monolithic concrete two-and-a-half-story U-plan school.

The Ecru High School FFA/FHA Building was built in 1938 by the NYA. The Vocational Building in Ethel was started in 1935 and completed in 1936 by the WPA. The PWA began construction on the one-story Vocational Building (Project 1305) in Shelby in 1938 and completed it in 1939. The NYA completed the Vocational Building in Vardaman in 1941. The main classroom building of the Whitfield Line Vocational High School was constructed in 1936 by the WPA.

The Vocational Building in Magee was undertaken in 1934 with the assistance of labor provided by the Civil Works Administration (CWA), a job creation program established under the Federal Emergency Relief Administration (FERA). The CWA was replaced with the WPA after 1934.

Jeff Davis Vocational Building in Water Valley was built in rock veneer in 1938 by the NYA.

West Ward School in Gulfport was one of two schools constructed with 45 percent funding from the PWA. The West Ward school had sixteen rooms with a capacity in each for forty to forty-five students. A library/conference room was upstairs. The two schools were erected between 1936 and 1937 at the same time by the same architects and builders and cost a total of about $205,500.

The Pontotoc Teacher's House in Pontotoc was built in 1938 by the NYA. The rock for the Colonial Revival–style house was quarried from nearby

Tishomingo County, at the NYA quarry. Pontotoc Teacher's House 2, a WPA project that same year, was constructed of wood siding and built next door to the first teacher's house. The floor plan for both houses was the same.

Two Teacherage locations in Hickory Flat were 1939 NYA projects constructed for the Hickory Flat School District.

COLLEGES AND UNIVERSITIES

A 1936 WPA project in Cleveland was the outdoor swimming pool at Delta State Teacher's College (now Delta State University). The pool, built with $20,000, opened in May 1936 for the senior class party. Doolittle Building at Delta State was a WPA-funded project constructed as the annex to the Hill Demonstration School, built in 1938 and dedicated in 1939. The Art Moderne building was named for the director of the demonstration school. Marshall Home Management House, PWA Project Miss. 1225, was constructed in 1938. The 1939 PWA library, Robert Memorial Library, constructed at Delta State was designed in an Italian Renaissance/Mediterranean style. Whitfield Gymnasium was WPA Project Miss. 1225. It was started in 1938 and finished in 1939 as another Art Moderne structure of the Great Depression period.

Between the years 1936 and 1941, the PWA constructed thirty-nine buildings on the University of Mississippi campus. Kennon Observatory was constructed in 1939. An adaptation of classicism, the observatory faced due south and aligned east to west. Two copper-roofed domes housed a five-inch telescope and a fifteen-inch telescope; the transit's slanted roof opened for observations using a three-inch telescope. The rear entrance railing featured an example of the Pythagorean Theorem. The front entrance featured Doric columns, and the rear entrance was accentuated with pilasters. A 1938 FERA/PWA project, Leavell Hall, named for Dr. Richard Leavell, professor of philosophy and political economy from 1890 to 1909, was built as a men's dormitory housing sixty-eight students and was one of six dormitories constructed on campus with PWA funds during 1938.

Over the next five years, the University of Mississippi used federal funds to build and improve sports facilities. In addition to sports facilities, UM added six new dormitories, eight faculty apartments, twenty-two faculty houses, a fraternity house, a student union building, Kennon Observatory and the physics building. The physics facility on the UM campus was built

in 1939 as one of the last construction projects during the PWA's tenure. New Deal agencies graded the baseball field and added a new grandstand. The golf course was also enlarged and reconstructed, with new grass greens replacing the sand greens. Barnard was built in 1938 as a women's dormitory and was attached to existing dormitory Isom Hall, built in 1929. Three dormitories were constructed in Georgian Revival style as Federal Emergency Administration of Public Works Mississippi Project 1216-DS and dedicated on October 21–22, 1938, along with three other new dorms built with New Deal funds. A 1939 PWA project, the Eastbridge Faculty and Staff Apartments, was constructed in 1939 and consisted of eight two-bedroom apartments. UM faculty housing, constructed primarily with WPA funding, consisted of twenty-two Vernacular cottage–style houses on a new street named Faculty Row in 1939. The three-bedroom, clapboard-side houses ranged from 1,200 to 1,600 square feet. Each had a garage or carport. A 1936 WPA project grant of $20,000 supported the construction of an Olympic-sized swimming pool west of the gymnasium in July 1936. Congress granted permission for universities to use WPA funds for fraternal housing, and the Sigma Alpha Epsilon House was the first built on Fraternity Row after the ban on fraternities and sororities was lifted. It was occupied in fall 1935. Somerville Hall was built in 1938 as a women's dormitory as Mississippi Project 1216-DS. The concrete structure football stadium was begun in 1937 and completed in 1941. The west side was completed in 1938. The student union was completed in 1939 and housed the bookstore, the university post office, a grill, a game room, a barbershop, a clothing store and several meeting rooms.

COMMUNITY HOUSES

The Biloxi Beach community house was approved as WPA Project 20,814 in 1938. The newly constructed wood-frame Colonial-style building replaced the former community house on the same site. The design featured a banquet hall, a recreation room and an 850-seat auditorium with a 350-seat balcony. The portico and columns from the existing community house were planned to be used. Biloxi provided $6,287 of the total cost of $17,051. The building was "nearing completion" in January 1939 and scheduled for dedication in late February or early March. It was demolished following damage from Hurricane Camille in 1969.

Enterprise, Mississippi's rustic-style log community house was constructed in 1935 by the WPA. The building featured a porch with a shed roof and a stone chimney. The community house in Eupora, a one-story stone and brick structure with a stone veneer, was constructed with WPA funding in 1938. In Teoc, the community house was a rustic log cabin with a stone chimney built by the WPA in 1935. The Grenada Community House was a Tudor-style stone-veneered building with false half-timbered gables built in 1936 on Line Street. The Carrollton community house, erected between 1935 and 1936, was of native pine logs in a rustic style. The superintendent of construction was David Felts, a local contractor.

Pontotoc's Tudor-style community house was constructed in 1935 by FERA as a stone-veneered building with false half-timbered gables. The Leland Community House/Garden Club in Leland was built by FERA in 1935 as a "one-story gabled, rectangularly-massed, frame club house with brick veneer exterior in a transitional Tudor Revival/Craftsman style." The Macon Community House was a one-story wooden bungalow-style structure built by FERA in 1935.

The Winona Community House, built by the WPA in 1936, was constructed with native rock in a Tudor style. Initially, the public library was housed in the building. The first event held at its completion was a celebration of WPA Project Day to acquaint the public with the accomplishments of the program during its first year.

HOMESTEADS AND COOPERATIVES

See chapter 5 for information on resettlement homesteads and cooperatives.

COURTHOUSES AND JAILS

The 1905 Beaux Arts Lauderdale County Courthouse was redesigned by the PWA in 1938. Construction removed the traditional features, including a dome, a cupola and the classic portico, and added a three-story setback tower with curved walls to enhance both space and architectural design. The PWA provided a grant of $127,147, and the county issued a $140,000 bond to fund the project as Mississippi W 1182. It was completed on December 4, 1939.

Leake County Courthouse in Carthage was a three-story, brick and cast stone art deco courthouse completed in 1936 as PWA Project 1042. Lincoln County Courthouse in Brookhaven was remodeled by the CWA in 1933. Newton County Jail in Decatur was a CWA/FERA project to add a jail to the existing Newton County Courthouse. The Holmes County Art Moderne jail in Lexington was constructed in 1936 as PWA Project 1019 with an estimated cost of $24,528, of which the PWA funded $10,000. The two-story Choctaw County Courthouse was built in Ackerman by the WPA.

The Scott County Jail and Courthouse Annex in Forest was a PWA project started in 1938. The courthouse was remodeled in an Art Moderne style; a PWA grant funded $24,545, and the work was completed on June 21, 1939.

CIVIC AUDITORIUMS

The Natchez City Auditorium was Mississippi Project No. 1350. The 995-seat arena was headed by a large stage and designed in a squared-corner horseshoe, with seats on both sides and the back. The building featured a broad, hexastyle pedimented Doric portico.

Clarksdale Civic Auditorium in Clarksdale was built by the WPA in 1939. The auditorium, designed in the Art Moderne style, had a seating capacity of 1,500.

AIRPORTS

Biloxi Airport in Biloxi was a CWA project in 1934. The third CWA allotment amounted to $10,371 for the Biloxi landing field, making the total approximately $40,000. The Coast Guard Air Field and Biloxi Municipal would share space. The municipal airport hangar was constructed in 1938–39 by the WPA.

Hawkins Field Terminal Building in Jackson was constructed in 1936 by the WPA for Davis Field (Jackson Municipal Airport). The airport continued to expand with new runways and other amenities funded by the WPA until 1941 and was used for pilot training during World War II.

The Oxford Municipal Airport was constructed by the WPA in 1937.

CITY HALLS

The Picayune City Hall was built by the WPA in 1938–39 in the style of an English manor house. The architect, Wilford Lockyer, originally from England, ordered the metalwork, hardware, railings and banisters from an English manufacturer and had them shipped to Mississippi. He was employed by the federal government for the CWA in 1934, PWA in 1935 and WPA from 1935 to 1940. The city hall cost $43,000.

New Albany City Hall was designed as a two-story art deco–style building with Art Moderne characteristics of a simple rounded wall with its metal railing, lack of ornamentation other than the simple design in the concrete and the curved aluminum canopy. It was constructed in 1937 and funded by the Federal Emergency Administration of Public Works/PWA.

Macon City Hall, a small, one-story red brick Colonial Revival building, was constructed as Federal Emergency Administration of Public Works/ PWA Project 1366-F in 1938–39. The city hall in Oxford, a 1938–39 WPA project, was an International Modern edifice.

POST OFFICES, MURALS AND SCULPTURES

AMORY, a Treasury Department (TD) project built in 1936, contained a mural titled *Amory in 1889* painted in 1939 by John McCrady.

BATESVILLE, constructed by TD in 1940, originally contained the mural *Cotton Plantation* by Eve Kottgen, completed in 1942.

BAY ST. LOUIS, Colonial Revival style from TD funds in 1935–36, the oil-on-canvas mural titled *Life on the Coast* was painted in 1938 by Louis Raynaud. The original design showed the mother in a bathing costume playing in the water next to her child. However, in the final work she stands on the shore in a more conservative dress.

BOONEVILLE, Prentiss County Chancery Court Building, mural titled *Scenic and Historic Booneville* painted in 1943 for Treasury Section of Fine Arts by Stefan Hirsch.

CARTHAGE, completed in 1940, was the site of Peter Dalton's 1941 wood carving, *Lumbermen Rolling a Log*, completed with funds provided by the Treasury Section of Fine Arts.

CHARLESTON, completed in 1939.

CLEVELAND, Colonial Revival style constructed in 1934, the first federal building constructed in Bolivar County.

COLUMBUS, constructed in 1939, the post office housed the mural titled *Out of Soil* by Beulah Bettersworth, completed in 1940.

CRYSTAL SPRINGS, mural by Henry La Cagnina, completed and installed in the post office in 1943 at a cost of $700, *Harvest* illustrated the important truck farming industry in the 1930s.

DURANT, TD Colonial Revival–style post office building completed in 1939, mural by Isidore Toberoff, *Erosion, Reclamation and Conservation of the Soil*, completed in 1942. Toberoff was a 1942 Pulitzer Prize winner in art and helped to provide therapy for wounded soldiers in the occupational therapy program at Fort Benjamin Harrison in 1943 while he recovered from his own war injuries.

EUPORA, completed in 1945, was the site for Thomas Savage's 1945 mural, *Cotton Farm*, completed with funds from the Treasury Section of Fine Arts.

FOREST, constructed in 1938, *Forest Loggers*, by Julien Binford, TD Section of Fine Arts, 1941.

HAZLEHURST, a Colonial Revival–style building featuring English bond brick pattern, wooden fluted Doric pilasters, a cast metal eagle over the door, a terrazzo tile floor, marble wainscoting and a wooden vestibule, a Treasury Section of Fine Arts mural, *Life in the Mississippi Cotton Belt*, painted by Auriel Bessemer in 1939 and installed the same year,

HOUSTON, a Colonial Revival–style, one-story red-brick building funded by the Public Building Administration of the Federal Works Agency, contained a 1941 mural, *Post Near Houston, Natchez Trace, 1803*, by Byron Burford Jr.

INDIANOLA, a one-story Art Moderne–style building constructed in 1935 and originally contained the New Deal mural *White Gold in the Delta*, which was destroyed in the 1960s. Bettersworth, who also completed a mural for the Columbus, Mississippi post office, was selected as a replacement for the commission awarded to Walter Anderson after his health prevented him from executing the Indianola mural.

JACKSON, James O. Eastland Federal Building, constructed 1933–34, a five-story, limestone art deco interpretation of a classical building, a controversial New Deal mural painted in 1938 by Simka Simkovitch titled *Pursuit of Life in Mississippi*.

LELAND, a one-story, buff-colored brick Colonial Revival building constructed with PWA funds, mural painted by Stuart R. Purser, *Ginnin' Cotton*. Purser's design was the winning design for Mississippi in a forty-eight-state mural competition.

LEXINGTON, one-story, flat-roofed building constructed with federal TD funds.

LOUISVILLE, Colonial Revival–style building built by the TD in 1935, the mural, *Crossroads*, was installed in 1938. Karl Wolfe of Jackson was one of three Mississippi artists commissioned by the Treasury Section of Fine Arts for one of the twenty-eight works installed in the state. He was paid $310 for the painting and installation.

MACON, constructed by the TD in 1941, contained a mural by Douglas Crockwell, *Signing of the Treaty of Dancing Rabbit Creek*, completed and installed in 1944 with funding from the Treasury Section of Fine Arts.

MAGNOLIA, contained three murals by John H. Fyfe celebrating the cotton industry, *July 4th Celebration at Sheriff Bacof's*, *Cotton Harvest* and *Magnolia, 1880*, completed and installed in 1939 at a cost of $1,120.

NEW ALBANY, Colonial Revival constructed in 1936 with TD funds and contained a mural by Robert Cleaver Purdy, *Milking Time*, completed and installed in 1939.

NEWTON, constructed in 1936, *Economic Life in Newton in the Early 1940s* by Franklin and Mary Boggs, completed in 1942.

OKOLONA, a 1937 PWA/TD project, briefly contained a New Deal mural painted by Harold Egan, *The Richness of the Soil*. It was ordered painted over by the postmaster within days of its installation for reasons unknown.

PASCAGOULA, *Legend of the Singing River*, an oil on canvas mural in 1939 by Lorin Thompson.

PHILADELPHIA, with TD funds in 1935–36.

PICAYUNE, a 1938 TD project, contained mural *Lumber Region of Mississippi* by Donald H. Robertson in 1940.

PONTOTOC, built in the Georgian/Colonial Revival style, *The Wedding of Ortez and SaOwana—Christmas 1540*, depicting the feast given by Spanish explorer Hernando de Soto to honor the first recorded Christian marriage in North America, which took place near Pontotoc. It was completed and installed in 1939.

POPLARVILLE, Colonial Revival–style building constructed with federal TD funds, completed 1941.

RIPLEY, built in 1938 with TD funds, contained bas-relief sculptures by George Aarons, *Development of the Postal Service*, installed in 1939.

STARKVILLE, Colonial Revival building built in 1935 with TD funds for $14,750.

TYLERTOWN, TD funds built this Colonial Revival–style building in 1940, and contained a mural by Lucile Blanch, *Rural Mississippi—From Early Days to Present*, completed in 1941.

WAYNESBORO, completed in 1939 with funds provided by the TD, contained Ross E. Braught's 1942 mural, *Waynesboro Landscape*, painted with funds provided by the TD Section of Fine Arts.

NATIONAL FORESTS, STATE PARKS, LAKES AND RECREATION

BIENVILLE NATIONAL FOREST. Here the CCC completed projects such as building roads, clearing trails and reforestation and educated the locals about forestry and natural resources.

CHOCTAW LAKE RECREATION AREA Ranger's Residence, 1936–38, a WPA project, one-story rustic building. The recreation area was developed between 1936 and 1938 by the WPA for the Soil Conservation Service.

CLARKCO STATE PARK. This park was constructed in 1938 by CCC Company 1437, which resided in the camp barracks on U.S. Highway 45.

HOLLY SPRINGS NATIONAL FOREST. Much of the land was abandoned farmland with terrible erosion. The CCC planted loblolly pine to help replenish the north-central hills' soil and prevent further erosion.

HOMOCHITTO NATIONAL FOREST. In the mid-1930s, the CCC began reforestation of the area and developed a system of roadways and recreational areas.

LEGION STATE PARK. One of the original Mississippi state parks developed by the CCC in the 1930s, it includes the Legion Lodge, a hand-hewn log structure that has remained unaltered since its construction.

LEROY PERCY STATE PARK. Dedicated on July 25, 1935, and named after the Delta planter and lawyer Leroy Percy, a U.S. senator from Mississippi in 1909–13, the park facilities were built by CCC Companies 2422 and 5467 between 1934 and 1936.

ROOSEVELT STATE PARK. One of nine state parks constructed by the CCC in the 1930s. Named after President Franklin D. Roosevelt, it opened in 1940.

SARDIS LAKE AND DAM. Constructed between 1938 and 1942 by Army Corps of Engineers, this New Deal flood-control project dammed the Tallahatchie River and created Sardis Lake, an artificial reservoir that covered hundreds of square miles in western Lafayette and eastern Panola Counties. It is one of the world's largest dams.

TISHOMINGO STATE PARK. In the foothills of the Appalachian Mountains in Tishomingo County, this park is named for an early Chickasaw leader who served with General Anthony Wayne against the Shawnees in the Northwest Territory. The park was constructed by the CCC during the 1930s.

OTHER

ABERDEEN, National Guard Armory. A two-story Art Moderne building constructed by the WPA in 1938, and from 1939 to 1940 served as the armory for Company G, 155th Infantry.

ACKERMAN, FERA Recreation Center. A rustic-style building with walls of vertical logs is conjectured to have been constructed by the Emergency Relief Administration.

BILOXI, Mattress Factory, 1934, FERA. The Federal Emergency Relief Administration operated two mattress and pillow factories in Harrison County and shipped finished products to areas in Mississippi without factories.

The West End Fire Station, West End Fire Company No. 3, was built in 1937 with WPA funding.

CLEVELAND, National Guard Armory, 1941–42. The WPA-built Art Moderne–style armory adjacent to Delta State Teachers College (Delta State University) provided facilities beginning in 1946 for one of the earliest guidance centers.

GREENVILLE, Benjamin G. Humphreys Bridge, WPA. The U.S. 82 bridge between Greenville, Mississippi, and Lake Village, Arkansas, was constructed to improve access between the two states and benefit economic development in the Delta. The Reconstruction Finance Corporation lent $2.55 million toward the cost of the original bridge. WPA funds were secured in 1938 for the remainder.

GREENWOOD, Main Street Railway Bridge Underpass, 1938, WPA. Built to allow traffic on Main Street to pass under the railroad tracks of the Yazoo and Mississippi Valley Railroad and re-route U.S. 49 and U.S. 82 into Greenwood, with concrete and brick highway to replace the gravel roads. The underpass cost $400,000 and was built by the Mississippi State Highway Department with WPA funds. An art deco pump house was also constructed.

GULFPORT, Waterfront Facilities, 1936. PWA Mississippi Project 1102 improved waterfront facilities and a harbor for small craft, including slips and pier with recreational features, a clubhouse, a swimming pool and tennis courts. Project 1419 made more improvements for oceangoing vessels consisting of a wharf with three lines of railroad tracks and a warehouse composed of eight compartments.

JACKSON, The Georgian Revival building currently housing the Mississippi Federated Women's Club was constructed in 1936 by the WPA.

Mississippi State Capitol Painting, WPA. Taking color cues from mosaic tiles in the Senate chamber, the WPA painted details of the main rotunda dome as well as other areas of the capitol.

War Memorial Building, 1939–1940. The Art Moderne building was PWA Mississippi Project 1279.

WPA-constructed buildings at the Jackson Zoological Park, including Livingston Park Pavilion, 1936.

LELAND, Deer Creek Dam. A concrete dam with metal gates and fixtures built with WPA funds in 1940 to help control drainage and flooding on Deer Creek.

Water and Sewer Plant, 1940. Improvements to streets, sidewalks, bridges, drainage and sewerage systems.

LOUISVILLE, WPA, 1936. The Winston County Library was the first public library in Winston County, Mississippi, a Colonial Revival, one-story building. The library was built using WPA funds, with Winston County, the City of Louisville and individuals contributing to the cost of the building.

MACON, Noxubee County Health Office. The Colonial Revival building served as the county health office and was constructed in 1939–40 by the WPA.

MEADVILLE, National Guard Armory was designed in an Art Moderne style and was constructed by the WPA in 1938.

MERIDIAN, Mountain View Village, 1940, FHA. A white housing complex, one of four low-rent housing projects. Contracts were awarded in January 1940.

NATCHEZ, Choctaw, a historic mansion built in 1836 for Joseph Neibert, renovation. The WPA worked to renovate Choctaw during the New Deal. It is on the same block as the City Auditorium, another WPA project.

Natchez Trace Parkway CWA, PWA, 1939–2005. The 445-mile parkway runs the general path of the old Natchez Trace, an early trail of the Choctaw and Chickasaw Indians. Work began under the PWA and included the WPA and CCC. In May 1938, the Natchez Trace Parkway was established by Congress as part of the NPS. Moreau B. Chambers of the Mississippi Department of Archives and History, with the CCC and NYA, completed work in Lee County, Mississippi, in 1937.

Vidalia Bridge and Toll Plaza. A cantilevered truss bridge spanning the Mississippi River on U.S. Highway 84 connected Natchez with Vidalia, Louisiana. Mississippi Project 1126 opened to traffic on September 26, 1940, and originally operated as a toll bridge. Ferries operated between

Natchez and Vidalia before the bridge was completed in 1940. In 1939, the entire town of Vidalia was relocated by WPA workers and moved six blocks inland in a federal flood control project. WPA workers laid out the street design, built streets and sidewalks and moved over one hundred homes and businesses by jacking them and transporting them on rollers. Some buildings were demolished.

PHILADELPHIA, Neshoba County Library, Reconstruction Finance Corporation (RFC), 1935. The rustic log cabin was the first library built in Philadelphia and was a community effort spearheaded by the Twentieth Century Club. The WPA also provided the first paid librarians.

SHELBY, Gymnasium, PWA, 1939. Two-story gym, Mississippi Project 1144D constructed by the PWA in 1939.

STONEVILLE, Delta Experiment Station Improvements, 1940. WPA Project 41003—$107,000 was approved for the Delta Station Forest Tract for fire lanes, roadways and general improvements.

TUNICA, Tunica Penal Farm, CWA, 1934. A concrete one-story building constructed in 1934 at $11,000 for which the county furnished $4,000 and the CWA furnished the remainder.

TUPELO, Woodworking and Auto Shop, 1937. Following the 1936 tornado, the City of Tupelo abandoned the old city jail and the NYA remodeled the building the following year and established a woodworking and auto body shop for students in the building.

VICKSBURG, Vicksburg National Military Park. The CCC worked to develop Vicksburg National Military Park during the 1930s and planted trees and other vegetation in the park to combat erosion.[161]

COOPERATIVES AND HOMESTEADS

Mississippi's sharecroppers had to rely on salt pork, cornmeal and flour for daily sustenance. Because few owned cows or poultry and were able to plant gardens in the cotton fields, malnutrition became a chronic condition among families. Malaria, pellagra and hookworm infections stunted the growth of children and caused bone deformities, like bowed legs. Delta plantation owners, who often used food, or the lack of it, to control their laborers, denied that hunger existed and believed that hungry workers picked cotton more eagerly than those with bellies filled with relief rations.[162]

In 1929, Coahoma County health workers claimed the spending habits of the tenant farmers caused the high rate of pellagra and that the high percentage of death was "due to faulty diet and is especially hard to combat among the negro tenants who are prone to spend all cash allowed them on their crops on such things as cars, tires and gasoline." This mentality about the spending of African Americans began after emancipation and became the perfect rationale for keeping black Mississippians from full access to goods and stores.[163]

The Lords of the Land receive your mail and when you go to the Big House to ask for your check, they look at you and say: "Boy, get back in the field and keep working. We'll take care of your check. Here, you'd better make your mark on it so's we can cash it. We'll feed you until it is used up." Ordinarily you are so deep in debt when you receive a check from the government that you sign it entirely over to the Lords of the Land and forget about it.—Richard Wright[164]

Mailbox. *Library of Congress.*

Cold temperatures rolled in during the drought of 1930, blowing through cracks and holes in the walls and ceilings of the tenant shacks. Red Cross relief workers distributed enough food to keep people from dying but not enough to sustain the energy needed to work. Monthly rations for a family of five might be thirty-six pounds of flour, twenty-four pounds of split beans, twelve pounds of cracked rice, two pounds of coffee, twenty-four pounds of cornmeal, half a gallon of molasses, lard and bacon and baking powder, all offering little nutrition and little improvement on the three-M diet: meat (fatback), meal and molasses. The Red Cross also distributed the USDA's Bureau of Home Economics instruction pamphlet titled *The Family Food at Low Cost*, directing parents to provide children with milk at every meal; serve potatoes, tomatoes and green or yellow vegetables once a day; and offer eggs, legumes and lean meat two to four times a week. For the sharecropper, this was rarely possible, but the Red Cross stated that it was not its duty to provide a better standard of living than what existed during normal times. When journalists began noting the increase in malnutrition and pellagra, Dr. William DeKleine, medical director for the Red Cross, surveyed the region and reported:

Home of family left stranded when the mill "cut out," 1937. *Library of Congress.*

In all the homes and schools I visited I did not find any evidence of malnutrition more than exists in the normal times....I can therefore see no particular reason for alarm over health problems that may develop because of the present shortage of food, unless it is recognized that these problems have existed for a long time....This does not mean that no attempt should be made to promote better food habits, but rather that under the circumstances the most important thing to do is to provide food for the hungry and actually prevent starvation....Hungry families want food and they want the kind they know and like the best. Folks who are accustomed to using flour, meal, salt meat, molasses, lard, rice, beans and coffee, want these now, and the relief agencies must furnish these staples. The habits of people cannot be changed overnight.[165]

Toxic water, 1939. *Library of Congress*.

Cooperatives

On the richest land in the world, parents and children were starving, and some died of malnutrition. Though food was plentiful, it wasn't profitable to transport it. Though warehouses were filled with clothing, entire families wore rags. The Agricultural Adjustment Administration (AAA) program was designed to increase the price of farm products by paying farmers to take some land and livestock out of production, a tactic that saved some large, medium and small landowning farmers but drove poor white and black sharecroppers to destitution. As planters received government AAA payments, they evicted the sharecroppers who had joined the Southern Tenant Farmers Union (STFU) to gain better working conditions and fair dealings from the planters. In 1935, Parkin, Arkansas planter C.H. Dibble evicted from his land almost one hundred sharecropper families. The following March, in search of better economic and social opportunities, several families relocated to a cooperative farm at Hillhouse, Mississippi, a 2,138-acre farm in Bolivar County.[166]

Cooperative organizers were William Amberson, a physiology professor and leader of the Memphis chapter of the Socialist Party of America; Sherwood Eddy, an ordained minister, missionary and former student of Reinhold Niebuhr, America's renowned intellectual; Sam Franklin, Eddy's student; and H.L. Mitchell, executive secretary of the STFU. Cooperative members signed a contract stating that, in accordance to their labor, they would share in the farm's profits and produce.[167]

The Delta Cooperative Farm was integrated. Cabins of white and black families were separated only by the road running through the farm. Because the State of Mississippi only provided four and one-half months of schooling for black children, the council established a school for the black children to make up the difference in the educational months.

The council managing the farm consisted of five elected cooperative members. No more than three council members could be of the same race. This council, with the direction of Sam Franklin, decided on what crops to plant and when and where to plant them. It also planned and oversaw construction of cooperative buildings and assigned members to work duties. Franklin retained the authority to veto or change any council decision. The first year, farm members planted a vegetable garden to provide a balanced diet to cooperative families. They also established a sawmill, started a logging business, began dairy operations, ran their own furnishing store, built houses for cooperative families, cleared land, produced 152 bales of cotton and

Left: Ex-sharecroppers from Arkansas established on Sherwood Eddy's cooperative experiment at Hill House, 1936. *Library of Congress*.

Below: Children at Hill House, 1936. *Library of Congress*.

raised chickens and hogs. With the additions of nurse Lindsey Hail and Dr. David Minter, Delta Cooperative members enjoyed medical care.[168]

Lawyer A. James McDonald arrived in 1938 to take over the duties as farm secretary. He, on occasion, served as stenographer at meetings. In 1939, he recorded the meeting that revealed the tyrannical farm management methodology of Sam Franklin. Constance Rumbough, a former missionary of the Methodist Church and a part of the Emergency Peace Campaign, also joined the cooperative. During the time Constance was there, from spring until late fall 1937, she taught Sunday school to the black children and put the poultry operation in order.[169]

More than economic success for the cooperative, Franklin expected social, educational, religious and racial success. Religious services were held separately for blacks and whites, although they did occasionally worship together. But the cooperative started losing money in 1937. The large operating deficit was met by donations from charitable individuals, churches and organizations. The Delta Cooperative management statements to the public concerning the success and financial condition of the cooperative were misleading. Plus, racial harmony within the cooperative was strained. In 1938, the cooperative trustees bought 2,880 acres in Holmes County and moved operations to the newly purchased farm known as Providence located near Cruger, about eighty miles south of Delta Cooperative Farm.[170]

In 1939, Amberson resigned from the board. This is part of his statement:

The most common form of hypocrisy among the privileged class is to assume that their privileges are the just payments with which society rewards especially useful or meritorious functions....It must be proved or assumed that the underprivileged classes would not have the capacity of rendering the same service if given the same opportunity. This assumption is invariably made by privileged classes. The educational advantages which privilege buys, and the opportunities for the exercise of authority which come with privileged social position, develop capacities which are easily attributed to innate endowment. The presence of able men among the privileged is allowed to obscure the number of instances in which hereditary privilege is associated with knavery and incompetence. It has always been the habit of privileged groups to deny the oppressed classes every opportunity for the cultivation of innate capacities and then to accuse them of lacking what they have been denied the right to acquire.[171]

After selling the Delta Cooperative Farm in 1942 to a levee contractor, the trustees concentrated on the Providence Cooperative Farm, naming A. Eugene Cox as resident director. Cox spent the next twenty years serving the two cooperatives that operated mainly on charity rather than operational profits.[172]

In 1938, after moving to Jackson, Constance Rumbough started Mississippi Farms, located near Hattiesburg, with the financial assistance of past alliances and Methodist connections. Mississippi Farms was not successful, but Constance, with the aid of Delta Farm Cooperative store manager Art Lanes and her older sister, repaid investors and sold the farm to her best clients, a black farmer who paid full price on a long-term arrangement. He also sent his five children to college. They all graduated.

HOMESTEADS

Signed into law in 1933, the National Industrial Recovery Act (NIRA) was President Roosevelt's answer to the industrial decline. This program's mission was to create a new class of American consumer/producer from urban centers and nonproductive farms and, with the federal assistance, help them produce for their own needs on their own land while buying the products of American industries.[173]

The first bill, introduced on March 9, 1933, died in committee, but after the subsistence homesteads provision was attached to the NIRA, the homesteads provision passed without discussion or opposition. In its rural rehabilitation efforts, the Federal Emergency Relief Administration (FERA) established a program of subsistence homesteads to help make self-sufficient the farmers receiving relief and thereby revitalize the agrarian community.[174]

The Subsistence Homestead Division (DSH) advisory committee identified three types of clientele and three types of proposed communities:

> *Homestead colonies established for industrial workers and located in the out-skirts of cities or large towns; rural settlements in which small industries or branches of large industries can be established; and agricultural settlements. The program will deal largely with city dwellers, stranded populations (i.e. those left jobless by the moving of local industries or the exhaustion of natural resources, as for instance coal and copper mines, sawmill workers, etc.), and farmers now working lands too poor to be profitable.*

Rehabilitation client and son, Pike County. *Library of Congress.*

Each subsistence-homestead project will be established in accordance with the industrial and agricultural trends as they relate to the population problems of a given region or State. Every undertaking will be regarded as experimental. The experiment is to test a method of living that may conserve the best of both urban and rural life, afford greater stability in family living and point the way to a more permanent adjustment for workers in the shorter hour week and part-time employments.

The homestead program was not to be a welfare effort.[175] There were twenty-four projects designated "industrial," and of the twenty-four, six were in Mississippi: the DSH farm community at Richton and industrial projects in Hattiesburg, Laurel, Meridian, McComb and Tupelo. The Laurel project was never started. Not one Mississippi town was overpopulated or an industrial center, but 20 percent of the projects were to be in the

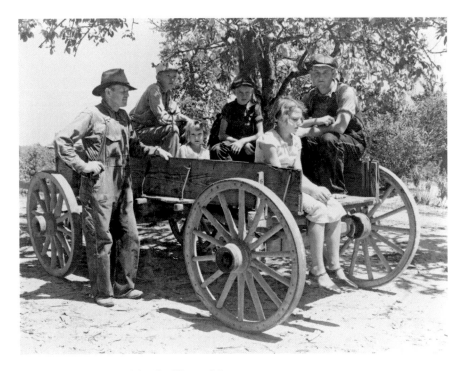

Rehabilitation client and family. *Library of Congress.*

least industrialized state with the fewest industrial workers, making it easy to assume that Roosevelt's DSH needed the continued support of Representative John Rankin and Senator Pat Harrison.[176]

In 1932, Harrison had been an early supporter of New York governor Franklin D. Roosevelt as the Democratic candidate for president. He and Senator Hubert D. Stephens of New Albany held the Mississippi delegation for Roosevelt at the National Democratic Convention in Chicago. After Roosevelt stepped into the presidency in 1933, Harrison became the chairman of the Senate Committee on Finance. From this committee emerged the economic legislation of the First New Deal (1933–35) and the passage of the Economy Act, repeal of Prohibition, the National Industrial Recovery Act and the Reciprocal Tariff Act of 1934. From the First New Deal, Mississippi received at least $100 million. In the Second New Deal (1935–37), Harrison supported the Social Security Act (1935) and the Revenue Act of 1935, which included a "share-the-wealth" feature, which Harrison agreed to because of his loyalty to the president. A 1936 issue of *Time* magazine read, "Better than any living man, Senator Byron Patton

Magnolia homesteads, Meridian. *Library of Congress.*

Hattiesburg homesteads. *Library of Congress.*

Harrison of Mississippi represents in his spindle-legged, round-shouldered, freckle-faced person the modern history of the Democratic Party."[177]

The DSH announced on December 15, 1933, its proposed twenty-five-unit complex in Tupelo, Mississippi. The city had already signed an agreement on October 27, 1933, with the Tennessee Valley Authority contracting for power and mapping of a direct power transmission line, making Tupelo the first TVA city. Community leaders on the Tupelo Homesteads of Mississippi local board of directors included Tupelo mayor J.P. Nanney, J.M. Thomas Jr., L.T. Wesson, J.E. Redus, Mrs. T.F. Elkin, R.V. Road, L.A. Olsen, V.S. Whitesides and J.H. Leonard. On March 26, 1934, Tupelo Homesteads purchased—for twenty dollars per acre—170.58 acres from W.W. and W.M. Thompson, that land consisting of timber and Pheba silt loam soil for growing vegetables and fruit, located six miles north of Tupelo and divided by the new Highway 45.[178]

Clearing the hurdles of cost and governmental bureaucracy, Tupelo Homesteads awarded a contract of $50,600 to Tupelo Lumber Company for the construction of twenty-five houses, septic tanks and outbuildings on July 18, 1934. On September 27, 1934, the Tupelo Homesteads Corporation

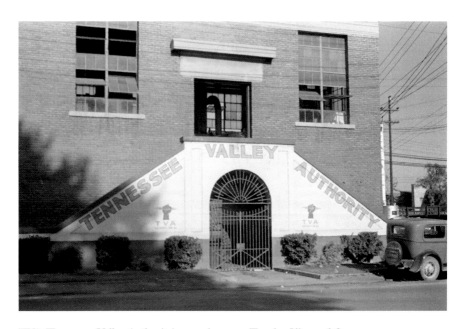

TVA (Tennessee Valley Authority) powerhouse at Tupelo. *Library of Congress.*

House at Tupelo Homesteads. *Library of Congress.*

granted an easement to TVA to supply electrical power to the homesteads, which would be

> *a house and outbuildings located upon a plot of land on which can be grown a large portion of the foodstuffs required by the homestead family. It signifies production for home consumption and not for commercial sale. In that it provides for subsistence alone, it carries with it the corollary that cash income must be drawn from some outside source. The central motive of the subsistence homestead program, therefore, is to demonstrate the economic value of a livelihood which combines part-time wage work with part-time gardening or farming.*

On November 16, 1934, homesteaders moved in. Each was provided a hog pen, chicken run and cow stall. Being located near Tupelo, children from the homesteads rode the Tupelo Municipal Public School District transportation to Tupelo public schools. With running water, electricity and single-party lines, these homesteads were unlike other industrial homesteads.[179]

Two days after the residents moved in, President Roosevelt and First Lady Eleanor visited, making a special stop at homestead no. 20, the Barron residence. While the president waited in the car, inside Eleanor and Mrs. Barron carried on a friendly conversation.[180]

However, no one bought the homes as the DSH had expected because the homesteaders thought the price too high. Some did not fully understand what had been expected of them in buying shares in the corporation. Plus, it would be after 75 percent of the aggregate debt had been paid before the homesteaders received simple title to the property. Compared to other industrial projects, the income of Tupelo homesteaders ranked among the highest; Tupelo ranked fifth in family income. Roosevelt's original idea of helping impoverished plain folk did not fit in with Tupelo residents. The project quickly passed to the control of other government agencies and became associated with New Deal welfare programs.[181]

After the tornado of April 1936 demolished hundreds of homes and businesses in Tupelo, the construction boom afterward created affordable homes and apartments of much higher quality than the Tupelo Homesteads. These houses, reconstructed under the advice of a planning committee, were mostly one-story Colonial structures white in color with green roofs and shutters.

In turn, employees of the TVA and the National Park Service rented some units in the Tupelo Homesteads on a short-term, month-to-month basis on rental option Contract B. Contract A provided the homesteader a two-year lease, and after satisfying the lease term, the homesteader was to pay 25 percent of the homestead's selling price and begin mortgage payments. Now better built homes in the area were available for less money.[182]

In late 1939, the National Park Service and the Tupelo Homestead Corporation discussed the possibility of the parkway's acquisition of the homesteads for employees dealing with the high rents in Jackson. On October 31, 1940, the National Park Service assumed ownership of the Tupelo Homesteads, which then became a part of the Natchez Trace Parkway. Surveyors made the inclusion of properties possible by diverting the path of the parkway eastward so the property was on the path of the trace.[183]

The WPA Guide to the Magnolia State stated that Tupelo "is perhaps Mississippi's best example of what contemporary commentators called the 'New South'—industry rising in the midst of agriculture and agricultural customs….It is a pioneer city at heart and was among the first to practice successful[ly] the economic philosophy that factory employees should live on subsistence farms outside of town and commute to and from their work."[184]

Industrial employment and subsistence gardening were nothing new in Tupelo and had been going on since the end of Reconstruction. By 1934, most Tupelo residents grew their own food, even while being employed full time.[185]

6

ARTS AND ENTERTAINMENT

A declining economy did not stop innovative technologies and industrial processes that improved phonograph recordings, electrical amplification, radio and film in the 1930s. New marketing practices advanced the entertainment industry and commercialized music. Only a few years earlier, silent films depended on live music for audio. Now there was the movie musical, the musical western and the singing cowboy. Movies like *The Jazz Singer* (1927) and *The Broadway Melody* (1929) mesmerized audiences with drama and humor seasoned with song and dance. The potential of the musical and America's fascination with money spurred Warner Bros. to release its Gold Diggers series in 1933: *42nd Street, The Gold Diggers of 1933* and *Footlight Parade*.[186] From Mississippi came many artists and entertainers who rocked the world through their art during the Great Depression years.

FILM AND THEATER

Earl Bascum, the "Cowboy of Cowboy Artists," was known to be the first professional rodeo cowboy to become a professional cowboy artist and sculptor. As a rodeo cowboy, Bascom followed the rodeo circuit internationally, from 1916 to 1940, when he won several all-around championships. Bascom invented rodeo gear and equipment, including the modern bronc saddle in 1922 and the modern bareback rigging in 1924.

He competed in the rough stock events of saddle bronc riding, bareback riding and bull riding and in the timed events of steer decorating and steer wrestling. In 1933, he set a new arena record and a new world record time and won third place in the world standings in the steer decorating event. Between rodeos of 1936 and 1937, Earl was a missionary for the Church of Jesus Christ of Latter-day Saints (LDS Church) in Mississippi, serving under President LeGrand Richards of the Southern States Mission. In the mid-1930s, Earl Bascom worked on the B Bar H cattle ranch in Lawrence County, Mississippi, which was once owned by Senator Stephen A. Douglas, who was famous for his 1858 political bouts with Abraham Lincoln known as the Lincoln-Douglas debates. Earl Bascom has been called the "Father of Brahma Bull Riding" and the "Father of Mississippi Bull Riding," as he was the first rodeo producer to use Brahma bulls in a rodeo in Columbia, Mississippi, in 1935. Bascom would go on to work with the cowboy actor Roy Rogers in the filming industry and star in a few films.[187]

In 1931, Alvin Childress (born September 15, 1907, in Meridian, Mississippi) received his bachelor of arts degree in sociology from Rust College and intended to become a doctor. But being involved in theater outside of his studies changed his mind. He moved to New York. When his play *Savage Rhythm* folded, he went to work for the WPA Project at Columbia University, which involved him in writing twenty-six playlets that would be used within schools. In 1935, he joined Harlem's Lafayette Players and became a regular on radio broadcasts. During the Depression, his stage credits included *Savage Rhythm* (1931), *Brown Sugar* (1934), *Sweet Land* (1936), *The Case of Philip Lawrence* (1937), *Haiti* (1938), *Hell's Alley* (1938) and *Natural Man* (1941), and his screen credits during that time included *Harlem Is Heaven* (1931), *Hell's Alley* (1931), *Out of the Crimson Fog* (1932), *Dixie Love* (1934) and *Keep Punching* (1939). He would become best known in the 1950s for his major role as Amos Jones in *Amos 'n' Andy* (1951).[188]

Actor Willie Best (born May 27, 1916, in Sunflower, Mississippi) was one of the hardest working but unappreciated African American actors of Hollywood's golden era. Best achieved good work with whatever role given him, and Bob Hope said he was one of the finest actors with whom he had ever worked. Best starred alongside other comedians like the Marx Brothers and Laurel and Hardy and worked in three films with Shirley Temple. A gifted comedian and character actor, Best was also a musician/songwriter. Due to racial attitudes during the Jim Crow era, Best never had roles other than the stereotyped porters and janitors he was offered. He appeared in more than one hundred films in the 1930s and 1940s. In a 1934 interview, he

said, "I often think about these roles I have to play. Most of them are pretty broad. Sometimes I tell the director and he cuts out the real bad parts.…But what's an actor going to do? Either you do it or get out."[189]

In 1931, Dana Andrews (born in 1901 near Collins, Mississippi) left Sam Houston State University in Houston, Texas, to seek opportunities as a singer in Los Angeles. He found a job in Van Nuys at a gas station, and the owners offered Andrews fifty dollars a week so he could pursue his music study at night. In exchange, Andrews was to give them a five-year share of his future earnings in the entertainment field.[190] Andrews studied opera and entered the famed theater company and drama school Pasadena Community Playhouse. In the 1930s, he performed in a variety of plays, including one about the composers Gilbert and Sullivan, in which he played opposite future star Robert Preston. Andrews became a company favorite, and Samuel Goldwyn offered him a contract.[191]

A screen, stage, vaudeville and television actor, Roscoe Ates (born in 1895 in Grange, Mississippi) became known for the stutter he spent his childhood overcoming. He first entered show business as a concert violinist but switched to vaudeville as a comedian. He revived his stutter for humorous effect as a comedian and in his movie roles and is best remembered for his roles in *Freaks* (1932), *Cimarron* (1931) and *The Champ* (1931). He also had parts in the *Wild Bill Hickok* serial (1938), *Check and Double Check* (1930), *Come on Danger!* (1932), *Renegades of the West* (1932), *The Roadhouse Murder* (1932), *Lucky Devils* (1933), *Alice in Wonderland* (1933), *Fair Exchange* (1936), *God's Country and the Woman* (1937), *Gone with the Wind* (1939), *Three Texas Steers* (1939), *Cowboy from Sundown* (1940), *Captain Caution* (1940), *Bad Men from Missouri* (1941) and others.[192]

Lehman Engel (born in 1910 in Jackson, Mississippi) attended Central High School, where writer Eudora Welty also attended. In 1935, he attended the Cincinnati Conservatory of Music and the Juilliard Graduate School of Music. For the 1939 Broadway revival of *Hamlet*, starring Maurice Evans, he composed the musical scores. He became a leading composer for Broadway musicals, radio, TV and film and won many awards, including the 1946 Society for the Publication of American Music Award, the 1964 Henry Bellamann Foundation Award and an Antoinette Perry (Tony) Award for *Wonderful Town*. At his death in 1982, his half-century work as a composer and conductor and leader in musical composition included thirteen books and other awards such as ASCAP's Deems Taylor Award and the Consular Law Society Award for Outstanding Achievement in the Theater.[193]

MUSIC

Many Mississippi musicians escaped the drudgery of the fields in Mississippi and the Jim Crow South, taking with them their gospel, jazz and twelve-bar blues songs, which inspired the hillbilly, swing and rock 'n' roll genres. The Great Migration of Mississippi's black artists to cities like Memphis, Chicago, Detroit and New York spread these genres like fever, thanks to the growing technologies of recording, radio and television. Radios, phonograph records and jukeboxes showcased all musical styles, and some began blending style and instrumentation to form their own unique voices. From 1930 to 1934, major recording companies sent talent scouts and publishers in search of new talent in southern and western states.[194]

Radio became popular during the Great Depression probably because it was free entertainment. President Roosevelt's Fireside Chats sought to comfort America, while weekly dramatic radio programs like *The Shadow* or *Little Orphan Annie* entertained and distracted listeners from oppressive times.[195] In December 1931, the U.S. Census Bureau reported that twelve million families had radios, roughly two out of five households. In 1930, about 74 percent of radio owners played their radios every evening. Radio began losing its audience in 1932, when America's top radio program was *Amos 'n' Andy*. By August 1933, 74 percent had dropped to 55.5 percent.[196] In contrast, of one thousand rural black southern households canvassed in the mid-1930s, only 17.4 percent owned radios and 27.6 percent owned a Victrola.

The music market was segregated. Race records were recorded by black artists (later labeled R&B), and hillbilly albums (later labeled country) were recorded by white artists. In the 1920s and 1930s, records were "cut" into beeswax and kept under ice, which made cutting records in the hot, humid South difficult.[197] For relaxation and entertainment, blacks listened to music from a windup Victrola, since most of them did not have electricity, and on Saturday nights, musicians played for nickels or dimes on the streets.[198]

From 1925 to 1935, H.C. Speir worked as a talent broker during the golden age of the blues recording to promote his music store, established in 1925 at 225 North Farish Street in Jackson, and later located at 111 North Farish Street. Speir's customers tended to be black women who were cooks and maids in the homes of white families.[199] The average cost of a 78-rpm record, depending on the label, ran between thirty-five and seventy-five cents.[200] Speir started as a talent broker in 1926. For a standard fee and expenses, he provided record companies, like Columbia,

Victor, Okeh, Brunswick, Paramount, Gennett and Vocalion, with the recordings of Mississippi bluesmen such as Charlie Patton, Skip James, Tommy Johnson, Ishmon Bracey, Bo Carter, the Mississippi Sheiks, William Harris, Blind Joe Reynolds, Blind Roosevelt Graves, Washboard Walter, Geeshie Wiley, Elvie Thomas, Isaiah Nettles and Robert Wilkins, among others. Speir also played an integral part in the recording careers of Son House, Willie Brown and Robert Johnson. In the early 1930s, when Son House and Willie Brown released their first records, they didn't sell very well, probably because seventy-five cents was a lot of money to blacks in the South.[201]

It's likely that the first blues player Speir discovered was outside of Jackson: William Harris. Speir sent him to Birmingham to record for Gennett around April 1927. That year, he also found Tommy Johnson and Ishmon Bracey, who thought Speir was a detective because of his suit and tie. Speir charged five dollars per recording session for the use of his audition recording machine.[202]

Bracey (born in Byrum, Mississippi, in 1901) became best known for "Cool Drink of Water Blues" and "Canned Heat Blues."[203] Johnson (born in Terry, Mississippi, in 1896) made test recordings upstairs at Speir's music store, where the equipment was located. Speir sent the recordings to Ralph Peer at Victor. Peer told Speir they weren't interested, but something or someone must have changed Peer's mind because Speir received a telegram telling him to send the guys to Memphis to record. Still, Victor didn't trust Speir's judgment, so Ralph Peer did a test with the Victor Talking Machine Company. Victor later became the Victor Phonograph Machine Company, and in 1929, RCA (Radio Corporation of America) bought out Victor and it became RCA/Victor.[204]

Paramount, however, accepted any artist Speir recommended and reimbursed him for his expenses in sending them musicians. This usually included a train ticket and spending money. Speir also received $150 cash each time he sent a musician to Paramount—if they could perform at least four songs.[205]

Tommy Johnson only had two songs, so Speir had him make up two more. Johnson cut "Big Road Blues," "Maggie Campbell Blues," "Cool Drink After Blues" and one more. Bracey and Johnson recorded in February 1928 in Memphis, and because they had sold well enough, they returned to Memphis to record for Victor in August. Bracey's "Saturday Blues" sold around six thousand copies. It took five hundred copies to break even. Johnson's big hit, "Canned Heat Blues," was released in 1929.[206]

Speir found Charlie Patton in 1929 on Dockery Plantation. He brought Patton to Jackson and put him on a train to the Gennett Company in Richmond, Indiana, via Chicago, Illinois. Once there, Patton recorded sixteen sides. By December, his records were selling so well that Paramount wired Speir to send Patton to their new studio in Grafton, Wisconsin, where Patton's session included a fiddler, Henry "Son" Sims from Clarksdale, who backed Patton on a few sides.[207]

Speir found most of the Mississippi string bands, such as the Leake County Revelers from around Carthage, Freeny's Barn Dance Orchestra from the community of Freeny and the Newton County Hillbillies. Speir recorded them for Okeh, as well as Grand Ole Opry star Uncle Dave Macon, who had contacted Speir. Speir recorded Macon in Jackson in December 1930.

In April 1930, Otto Moeser of Paramount offered to sell Speir the company for $25,000, which basically amounted to the cost of moving the equipment and facilities from Wisconsin to Jackson, but Speir couldn't raise the money.[208]

Speir found Bentonia's Skip James in 1931 when James came to Speir's shop and played four or five songs. Speir bought James a train ticket to Milwaukee. In Mississippi, Speir did three sessions with James: in Jackson for Okeh (1930), in Jackson for ARC (American Recording Corporation, 1935) and in Hattiesburg for ARC (1936).[209]

Two big performers Speir missed out on were Mississippi John Hurt and Jimmie Rodgers. Rodgers had auditioned for Speir in his shop, but Speir, not thinking much of Jimmie's songs, told Jimmie he was not ready. The next time Speir heard from Jimmie Rodgers was on RCA Victor.[210]

Jimmie Rodgers's style reflected the blues he'd heard from black railroad workers. Born in Lauderdale County on September 8, 1897, Jimmie Rodgers was thirteen when he got his first job as a water boy on his father's railroad gang. He later became a brakeman on the New Orleans & Northeastern with his eldest brother, Walter, a conductor on the Meridian–New Orleans line. In 1924, tuberculosis (TB) halted Jimmie's railroad life but allowed him to concentrate on music. He incorporated his love for the blues into the songs he wrote by himself and with sister-in-law Elsie McWilliams. In late July 1927, Jimmie Rodgers and the Tenneva Ramblers were to audition in Bristol, Tennessee, before Ralph Peer of the Victor Talking Machine Company.

Ralph Peer, an executive of Okeh Records, decided to become a music publisher for hillbilly recordings for Victor and surveyed southern cities to find musicians to record. In Bristol, Tennessee, after Peer put out a call for talent on radio and in newspapers, musicians answered in droves.[211]

"Jimmie Rodgers telephoned from Asheville," Ralph Peer wrote in his 1953 tribute to Jimmie Rodgers. "He said that he was a singer with a string band. He had read the newspaper article and was quite sure that his group would be satisfactory. I told him to come on a certain day, and promised a try-out."

Peer agreed to record the group, but the group couldn't decide how to be billed on the record. Jimmie Rodgers decided to go it alone. Rodgers's peculiar style and his yodel impressed Peer, but Rodgers was singing current hits by New York publishers, not originals. His only original was "Soldier's Sweetheart." Peer told Jimmie that he would give him a week to provide around twelve songs for recording:

> *I let him record his own song, and as a coupling his unique version of "Rock All Our Babies to Sleep." This, I thought, would be a very good coupling, as "Soldier's Sweetheart" was a straight ballad and the other side gave him a chance to display his ability as a yodeler. In spite of the lack of original repertoire, I considered Rodgers to be one of my best bets.*

Still, because of his TB, Rodgers was a very sick man. "Unfortunately, he was generous to a fault, and when he received a large check he shared it with friends and relatives," Peer said in his tribute. "The best doctors told him that he would not live because his tuberculosis was incurable."[212]

On their first recording, Peer and Rodgers worked continuously into the night. To have enough material, Peer used Jimmie's blues songs, one he titled "Blue Yodel." It became so popular that Peer changed the names of Jimmie's other yodels to "Blue Yodel No. 2," "Blue Yodel No. 3" and so on.

As a guitarist, Rodgers was an individualist, wrote Peer, meaning that often his chords were off-beat and had an odd chord structure. "Whatever he used always sounded right, but upon examination it was quite often not the chord which would ordinarily have been used."[213] This only added to the originality of Jimmie Rodgers's songs, even though it could be difficult finding other musicians who could perform in his recording style.

Jimmie Rodgers lived his life to the fullest and headed his own traveling show. He enjoyed doing "tent shows" with other performers and especially enjoyed his tour with Will Rogers through north Texas and Oklahoma through a Red Cross charity drive. Yet Jimmie was practically unknown north of the Mason-Dixon line. Peer decided to change that by booking Jimmie on the Radio-Keith-Orpheum Circuit as a single act in most of the leading vaudeville theaters with a salary of $1,000 per week. Peer had to

cancel the project after Jimmie became ill. But Jimmie refused to give up the life he had worked so hard to achieve.[214]

In spring 1933, Jimmie traveled to New York for a series of recordings with Peer. The record business was facing the financial difficulties of the times, but Jimmie Rodgers was now the "standard." Plus, it was time to negotiate a new agreement between Victor and Rodgers. While in New York, Jimmie Rodgers died in his room at the Taft Hotel on May 26, 1933. Ralph Peer had the task of sending his body home to Meridian for burial.

His fame as a performer during the Great Depression traveled throughout the world. He connected with everyday people struggling to make ends meet. Integrated into his songs were the blues, jazz and styles of Tin Pan Alley songs. Tubas, clarinets and ukulele added uniqueness to his music. Rodgers's yodeling songs became a trademark in country music, and around the world he is known as the Father of Country Music. Between 1927 and his death in 1933, Jimmie Rodgers recorded more than one hundred songs and sold around twelve million records.[215]

Mississippi John Hurt, born in 1893 (or 1892 or 1894), wasn't like other Mississippi Delta blues musicians with his ragtime fingerpicking style and soft singing voice. Hurt never played in juke joints but would play dances. Yet the topics of his songs included murder, domestic violence and the tired working man. He recorded for Okeh Recordings in 1928.[216]

Pinetop Perkins, born Joe Willie Perkins in 1913, worked as a guitarist in the 1930s and early 1940s alongside other blues artists like the King Biscuit Boys, Robert Nighthawk, Earl Hooker and Sonny Boy Williamson. After Pinetop's arm was slashed at a party, he could only play piano, which led to his fame as the pianist for Mississippi bluesman Muddy Waters. Perkins became one of the most noted blues piano players of all time.[217]

Sonny Boy Williamson (born Aleck Ford "Rice" Miller) began playing guitar and harmonica at age five. By age twenty, he was playing under the name Little Boy Blue in clubs and juke joints. In the 1930s, he performed at the Grand Ole Opry and worked with blues legends Robert Johnson and Howlin' Wolf.[218]

Robert Johnson (born in Hazlehurst, Mississippi, in 1911) grew up in the Delta town of Robinsonville and hung out with older musicians like Charlie Patton and Son House. These blues musicians didn't think much of Johnson's guitar playing until much later when Johnson returned after traveling and listening to other blues musicians. Legend tells of the story of Robert Johnson standing at the crossroads of Highways 49/61 selling his soul to the devil in exchange for the musical ability to sing and play the

Pinetop Perkins. *Courtesy of Ken Flynt.*

blues better than anyone else.[219] Johnson released twenty-nine songs from his recording sessions for ARC-Brunswick in Texas. He died on August 16, 1938, in Greenwood, Mississippi. Legend says he was poisoned by the husband of his lover at Three Forks Juke Joint outside of Greenwood. Johnson remains one of the most influential musical artists of the twentieth century.[220]

Son House (born Eddie James House on March 21, 1902, in Riverton) started preaching at the age of fifteen near Lyon, Mississippi, and didn't play guitar until he was around twenty-six. House and Charlie Patton met in 1929 and recorded "race" records for Paramount. Some of his most memorable recordings during that time were "My Black Mama" and "Preachin' the Blues."[221]

Patton grew up on plantations in Edwards and Bolton, Mississippi. After he hit his teen years, he went to Dockery Farms by the Sunflower River and, during this time, met H.C. Speir. Patton sang of the cotton fields in "Mississippi Bo Weavil Blues," the drought in "Dry Well Blues" and the flood in "High Water Everywhere." Patton died in 1934.[222]

Big Joe Williams (born in Crawford on October 16, 1903) played kazoo, guitar, accordion and harmonica and left his home in Crawford to work on traveling shows and jug bands. In the 1930s and '40s, he worked with blues artists like Honeyboy Edwards, who liked Williamson's Spanish playing in

open G with the capo, which produced a sound between a guitar and a mandolin. Big Joe recorded with others, such as Sonny Boy Williamson I. His first recording session was in 1935 and included "Somebody's Been Borrowing That Stuff."[223] He stayed on the road between Mississippi, St. Louis, Chicago, New York and Los Angeles playing at parties and work camps and in the streets and juke joints. For five decades, Williamson recorded for various labels such as Bluebird, Okeh, Vocalion and Paramount. He always came home to Mississippi and died there in 1982.[224]

The sharecropping family of Garfield Akers (born around 1900) moved to Hernando, where he met Joe Callicott (Nesbit, Mississippi) around 1920. They started playing together and in 1929 recorded for Vocalion/Brunswick in Memphis. Both musicians were skillful in their fingerpicking style. Their works included "Dough Roller Blues" and "Jumpin' and Shoutin' Blues." Two of Callicott's 1930 recordings were "Traveling Mama Blues" and "Fare Thee Well Blues."[225]

During the 1930s, "Blind" John Davis (born in 1913, Hattiesburg) and his blues piano were featured on many blues recordings. One was "Booze Drinking Benny."[226]

Arthur William "Big Boy" Crudup (born in 1905) did not start performing until 1939, but his talent began early with gospel music in the church choir. He wrote "That's All Right Mama," Elvis Presley's first release. Elvis would be born during the Great Depression in 1935 in Tupelo, Mississippi.[227]

Nehemiah Curtis "Skip" James (born in Yazoo City on June 9, 1902) was raised on a plantation in Bentonia, Mississippi, where he began playing guitar at the age of fifteen and later developed his piano playing under Henry Stuckey. He developed a three-finger picking style. In 1931, he went to Wisconsin, where he recorded twenty-six sides and toured with the gospel quartet his father put together. His cuts include "Cypress Grove Blues," "Hard Time Killin' Floor Blues" and "Devil Got My Woman." His hauntingly high voice evoked emotion from his listeners.[228]

Albert "Sunnyland Slim" Luandrew (born in Vance, Mississippi, on September 5, 1907) was known for his songs about the "Sunnyland" train running between Memphis and St. Louis. In the 1930s, he met artists in Memphis with whom he would later work.

Johnny Young was an avid guitar and mandolin player by the time he left Vicksburg, Mississippi, for Chicago. His first recordings included "Money Takin' Woman" and "Let Me Ride Your Mule."[229] Bluesman Tommy McClennan (born in Yazoo City on April 8, 1908) started Bluebird Recordings in 1939. In the 1920s, Charlie McCoy (born in Jackson on May

26, 1909) was considered an outstanding instrumentalist around Jackson, and he moved to Chicago in the 1930s. He first recorded in 1928 with Rosie Mae Moore, Tommy Johnson and Ishmon Bracey. He accompanied groups on guitar and mandolin.[230]

Although "Muddy Waters" Morganfield (born in Rolling Fork on April 4, 1913) did not start recording until the early 1940s, he was singing, playing guitar and harmonica and composing his songs on the Stovall Plantation outside of Clarksdale, where he worked the cotton fields for fifty cents a day.[231]

Part Cherokee, Andy Rodgers (born in Liberty, Mississippi, on March 14, 1922, to sharecroppers) played harmonica, and by the age of twelve, he was working the fields by day and at night playing the harmonica and guitar in clubs. In 1930, he bought his first guitar from Bo Diddley. As an early teen, he toured with Bob Wills and Texas Playboys and performed with them on the Grand Ole Opry circuit. During the 1930s, he played harmonica on Roy Acuff's radio station. He called himself the Midnight Cowboy.[232]

David "Honeyboy" Edwards (born in 1915, in Shaw) was playing Delta juke joints by the time he was fourteen. A boyhood friend of Robert Johnson, Honeyboy played during the 1930s with Johnson, Big Walter Horton and more.[233]

Lillian "Lil" Green (born in the Delta on December 22, 1919) went to Chicago in the 1930s and performed with other blues performers like Big Bill Broonzy.[234]

Armenter Chatmon (born near Bolton, Mississippi, in 1893), brother of Mississippi bluesmen Sam and Lonnie Chatmon, was known as "Bo" Carter,

Honeyboy Edwards. *Courtesy of Ken Flynt.*

the name under which he cut more than one hundred sides. He lost his sight in the 1930s. Brother Sam Chatmon led the legendary Mississippi Sheiks. He recorded with them as well as the Chatmon Brothers in the 1930s.[235]

Another member of the Mississippi Sheiks, Walter Jacob Vinson (born near Bolton in 1901), recorded under the names of Walter Vincson, Walter Jacobs and Sam Hill from Louisville. In 1930, he wrote "Sitting on Top of the World." He left Mississippi for Chicago in 1933.[236]

Big Bill Broonzy (born in Bolivar County on June 26, 1893) began his recording career in the 1920s, and these sessions reflected fast, ragtime stomps and shuffles, unlike the twelve-bar blues for which he later became known. He recorded more than 260 blues songs.[237]

In 1923, Othar Turner (born in Gravel Springs in 1908) started learning to play the fife, a bamboo cane flute-like instrument given to him by R.E. Williams, who promised Turner a real fife if he minded his mother. Turner never stopped working his land in Senatobia, even when he became a blues legend late in life. Trumpeter and composer Moon Mullin (born in Mayhew in 1916) worked with Louis Armstrong, Duke Ellington and Lionel Hampton.[238]

Robert Timothy Wilkins (born in Hernando on January 16, 1896) recorded for Victor in 1928. In 1915, he moved from Hernando to Memphis, where he performed in taverns and clubs through the 1920s and '30s. After witnessing violence at a party where he was playing, he renounced the blues and chose the ministry. Decades later, the Rolling Stones recorded his song "That's No Way to Get Along" and retitled it "Prodigal Son."[239]

Jim Crow may have segregated color, but it brought racial and ethnic minorities together geographically and culturally, and they blended musical styles into what we know today as jazz. As the Great Depression lagged on, record sales began to fall. Record companies began selling to radio stations. All types of music soared through the air streams, with swing and jazz music being performed live on the radio. Records sales for swing and jazz reached fifty million by 1939, greatly rising from the ten million in 1932. Dance halls held contests for cash prizes.

As swing dominated mainstream music, jazz legends like Duke Ellington, Louis Armstrong (who had recorded with Jimmie Rodgers before Jimmie's death), Lionel Hampton and others created a new style of jazzy bebop. Female singers, like Ella Fitzgerald and Billie Holiday, melded blues and jazz into their songs.[240]

Born in Quitman, Mississippi, on June 10, 1898, Andrew "Andy" Blakeney was known for his jazz trumpeting in the world of New Orleans jazz. He

performed with King Oliver, as well as Doc Cook, in 1925 in Chicago. In 1926, he moved to California and recorded with Sonny Clay and Reb Spikes and worked with Les Hite and Lionel Hampton. From 1935 to 1939, in Hawaii, he performed with Monk McFay's Five Clouds and led his own band. In 1941, he returned to the mainland, where he worked with Ceele Burke's big band from 1942 to 1946.[241] Blakeney continued playing and performing jazz until his death in 1988 at the age of ninety.[242]

Milt Hinton (born in Vicksburg on June 23, 1910) played tuba in the marching band and the fiddle. His first recording with his tuba was with Tiny Parham in 1930, and in 1933, he recorded some sides on "Old Man Harlem." In 1936, Hinton joined Cab Calloway, who had seen Hinton performing in a jazz nightclub in Chicago. His bass solo on "Pluckin' the Bass" is known to be the first featured bass solo.[243] Known as "The Judge," Hinton was called the dean of jazz bass players. His musical education began with violin lessons at Chicago's Wendell Phillips High School, where he also learned to play bass horn, tuba, cello and eventually the bass violin. During the late 1920s and early '30s, Milt freelanced with legendary jazz artists like Freddie Keppard, Zutty Singleton, Jabbo Smith, Erskine Tate and Art Tatum. He landed jobs with Tiny Parham and his band and violinist Eddie South's Orchestra.[244] In 1936, Milt joined Cab Calloway and for fifteen years performed with Danny Barker, Chu Berry, Doc Cheatham, Cozy Cole, Dizzy Gillespie, Quentin Jackson, Illinois Jacquet, Jonah Jones, Ike Quebec and Ben Webster. His session recordings with Benny Carter, Benny Goodman, Lionel Hampton, Coleman Hawkins, Billie Holiday, Ethel Waters and Teddy Wilson have become jazz classics. The Judge began taking photos in the 1930s and would later produce several photo books of musicians. He got his first camera in 1935, a thirty-five-millimeter Argus C3, which he received for his twenty-fifth birthday. He said, "Although I took a few posed shots, I was never much for taking formal pictures.…Whenever possible, I liked to shoot people when they were off guard or unaware. Of course, I was limited in some ways. I didn't have a flash in the early days, and the film speed was so slow you couldn't take photographs indoors without using a long exposure. Even so, I did get some unusual shots inside, like pictures of the guys sleeping on the train. There were also times when the stage lights were on and I could use them to get a better indoor exposure." The Judge died in New York City in 2000.[245]

Herbie Holmes (born in Yazoo City on September 27, 1912) played in a combo while attending Yazoo City High School, from which he graduated in 1929. He then attended the University of Mississippi and joined the

Ole Miss jazz band, the Mississippians. He won a trip to New York to be a guest on Eddie Cantor's radio show and to audition with NBC radio. In 1935, his band, the Herbie Holmes Orchestra, playing upbeat swing-style jazz and Dixieland pieces, joined the national circuit. Dressed in a satin evening gown, vocalist Nancy Hutson, from Isola, whom Holmes married in 1941, opened and closed the show with its theme song, "Darkness on the Delta." By the late 1930s, the motto of the Herbie Holmes Orchestra was "Music Served Southern Style," and Holmes was called the Young Maestro from the Mississippi Delta. *Billboard* magazine wrote, "The band, unusually framed, has three violins, three saxes, three rhythms, and two brass. The effect is a tasty musical dish." In 1941, Holmes's orchestra played USO shows to entertain troops at the onset of World War II. Holmes joined the navy in 1943 and rose to the rank of lieutenant commander. Herbie and his wife, Nancy, moved to Yazoo City after the war, and he worked in his father's bank.[246]

Originally organized by Laurence C. Jones, founder of Piney Woods School, the International Sweethearts of Rhythm toured in the late 1930s, mainly in the South, to raise money for the school's administration. The term "international" was used because some of the women were from foreign countries. The popularity of the International Sweethearts grew after their performances in Washington, D.C., in the late 1930s.[247] In 1941, when the Sweethearts became a professional group, two white players joined them, one being saxophonist Rosalind Cron, who had played mostly in cities like New York and Chicago, not in the Deep South. She and Millie Jones, who was part American Indian and part black, took the bus downtown and stopped in at Woolworth's for a soda. They were refused service because of Millie. Their road manager told Rosalind that in the South, Jim Crow ruled, and this is what her life would be like. He gave her the option to return home. She chose to stay. The International Sweethearts of Rhythm would become known as the best all-female jazz band of all time.[248]

Henry W. Jones Jr. (born in Vicksburg on July 31, 1918) was one of ten children. His family left Mississippi during the Great Migration from the rural South and moved to Pontiac, Michigan, near Detroit. Jones first performed professionally at thirteen, although his father, a Baptist deacon, disapproved. Henry continued to play throughout the 1940s and '50s with such greats as Ella Fitzgerald, Benny Goodman and Artie Shaw.[249]

Lester Young (born in Woodville on August 27, 1909) played drums, violin, trumpet and alto saxophone and learned from his father, Willis Handy Young. Refusing to tour the South, Young left home and his family band in

1927 and toured as a tenor sax player with Art Bronson's Bostonians. But by 1929, he was back in the family band. His freelance career included Walter Page's Blue Devils (1930, 1932–33), Eddie Barefield (1931) and Bennie Moten and King Oliver (1933). He first played with Count Basie in 1934 and then again in 1936. He stayed with Count until 1940. He was drafted into the service after starring in the short film *Jammin'*, and his experiences with racism in the military affected him mentally for the rest of his life.[250]

Jimmie Lunceford (born in Fulton in June 1902) earned his degree in music from Fisk University and went on to become an athletic instructor at Manassas High School in Memphis, Tennessee, where he organized the Chicksaw Syncopators, a student jazz band. Personnel members of the Syncopators included Moses Allen (bass) and Jimmy Crawford (drums), who all became part of Lunceford's band when it went professional in 1929. The band recorded for RCA in 1930 and was offered an engagement at the well-known Cotton Club in Harlem in 1934. Unlike most big bands of the Great Depression era, Jimmie Lunceford's Orchestra was recognized for its instrumental blending in a distinctive two-beat rather than four-beat swing. The beat, known as the Lunceford two-beat, was created by the band's principal arranger and trumpet man, Sy Oliver, who left the band in 1939 to work with Tommy Dorsey.

The band's distinctive showmanship—such as the trumpet section tossing their trumpets into the air and catching them in time to play the next note—was made possible only by hours and hours of practice. The male vocalists often sang in unison. By 1935, the band was slated as one of the top black swing bands in America. Their hits included "Tain't What You Do, It's the Way You Do It," "For Dancers Only," "Margie," "'Posin'," "Slumming on Park Avenue," "My Blue Heaven," "Organ Grinders Swing," "Belgium Stomp," "Monotony in Four Flats" and "I Got It." In 1942, Lunceford fired Moses Allen (bass), Snooker Young and Joe Wilson (trumpets), Ted Buckner (sax), Elmer Crumbley (trombone) and Dan Grissom (sax and vocalist). Lunceford claimed they were becoming prima donnas and were dissatisfied with their jobs. In 1947, while signing autographs after a performance in Oregon, Jimmie Lunceford suddenly died. Rumors publicized by *Downbeat* magazine spread that a racist restaurant owner who resented feeding the band poisoned Lunceford.[251]

Trumpeter Gerald Stanley Wilson (born in Shelby on September 4, 1918) joined the Jimmie Lunceford band in 1939, replacing Sy Oliver until 1942. He composed music for Duke Ellington, Count Basie, Dizzy Gillespie, Ella Fitzgerald, Sarah Vaughan and other jazz performers. His swing and

bop numbers consisted of multifaceted voicings and harmonies. An avid bullfighting fan, he also used Spanish influences in his compositions. One of Wilson's favorites was "Yard Dog Mazurka," which he wrote for Lunceford. The Stan Kenton band re-released this song as "Intermission Riff" and credited Ray Wetzel as composer. Wilson decided against suing and instead wrote about the situation to Kenton, who gave him credit for the song. Wilson died at the age of ninety-six.[252]

Mississippi colleges and universities took pride in all the arts, as described by *The WPA Guide to the Magnolia State.* The University of Mississippi's Glee Club had been active since the 1900s, and it added a regular music department in 1930. The State Teachers College's music department was known for its Vesper Choir, which performed before the National Federation of Music Clubs in Philadelphia in 1935 and the Louisiana Federation in 1936. The Mississippi Women's College and Belhaven College offered a bachelor of music degree. Delta State Teachers College and Blue Mountain College offered courses in piano, voice and violin, and Mississippi State prided itself on its military band.[253]

WRITERS, ARTISTS AND OTHER ENTERTAINERS

The number of famous artists, musicians and writers from Mississippi continues to amaze historians today. Even more extraordinary are the legends who grew out of the Great Depression who survived and even thrived by doing what they love during America's most trying economic crisis.

Born in Canton, Mississippi, in 1911, John McCrady was twenty-one when he studied art at the Arts and Crafts Club of New Orleans School of Art. From 1930 to 1932, McCrady attended the University of Mississippi and took courses at the Pennsylvania Academy of Fine Arts and the New Orleans Art School. In 1933, he won a scholarship to the Art Students League of New York for his *Portrait of a Negro.* He worked for the Federal Art Project and was commissioned by the Treasury Section of Fine Arts to create the mural *Amory, Mississippi 1889* for the Amory post office. He also painted murals for other federal buildings and earned a Guggenheim Fellowship "to paint the life and faith of the southern Negro" in 1939.[254]

James W. Washington was born and raised in Gloster, a rural Mississippi mill town, and was one of six children of Baptist minister James Washington, who fled from their house due to threats of violence. James W. was still a

young boy, and he never saw his father again. At the age of twelve, he started drawing and began an apprenticeship to become a shoemaker when he was fourteen. In 1938, he became involved with the Federal Works Progress Administration at the Baptist Academy in Vicksburg, Mississippi, where he worked as an assistant art instructor. Because blacks were excluded in the South from exhibiting in art shows with white artists, he created a WPA-sponsored exhibition of black artists, the first in Mississippi.[255]

Grand Ole Opry comedian Rodney Leon Brasfield, born in Smithville, Mississippi, started his comedy career in the late 1920s with Bisbee's Dramatic Shows, a touring tent show. In 1931, he married Eleanor Humphrey and was recruited for the Grand Ole Opry in the mid-1940s.[256]

Stark Young (born on October 11, 1881) was from Como, Mississippi. In 1930, Young contributed to the agrarian manifesto *I'll Take My Stand* as one of twelve southern writers known as the Southern Agrarians. His articles, essays and stories reflected the southern traditions with which he was reared. His novel, *So Red the Rose*, published in 1934, was a Civil War novel that covered the aftermath of the war. It was adapted for film in 1935. Directed by King Vidor, it starred Margaret Sullavan.[257]

James Madison Carpenter received his bachelor of arts and master of arts degrees from the University of Mississippi and doctor of philosophy degree from Harvard in 1929. He is remembered mostly for collecting and documenting folk songs of England, Scotland and Wales. He recorded well-known singers and musicians through Dictaphone recordings. While at Harvard in 1935, he lectured occasionally as he transcribed the ballads he collected. From 1938 to 1943, he taught part time in the English Department at Duke University.[258]

During the Great Depression, Herbert Creekmore worked with the Federal Writers' Project, a program encouraging writers to compile local literature and folklore. Creekmore was not happy in Mississippi, but he enjoyed his close circle of friends, which included Eudora Welty, who was related to him by marriage. They both loved and discussed literature and held contradicting views when it came to roles of men and women in the South. Creekmore, Welty and a few other friends formed the Night-Blooming Cereus Club to stay up at night to watch the cereus flower bloom while discussing literature. Creekmore, who was homosexual, later moved to New York, where he wrote about black Mississippians pressed beneath Jim Crow laws and the subjects of religious fundamentalism and homosexuality and marriage in the South.[259]

Writer John Faulkner (brother to William Faulkner) published his first novel, *Men Working*, in 1941, a satirical comedy exposing the negative effects

of government bureaucracy (in the form of the WPA) on the lives of a farm during the Great Depression. His next novel was *Dollar Cotton*, published in 1942. In 1935, his younger brother Dean was killed crashing the airplane that William Faulkner sold to him.[260]

In 1935, Shelby Foote was initially denied entry to the University of North Carolina at Chapel Hill after his high school principal gave him an unfavorable recommendation. However, after passing several admissions tests, he was accepted and, in 1936, was initiated in the Alpha Delta chapter of the Alpha Tau Omega fraternity. Foote returned to Greenville in 1937 and worked with the *Delta Democrat Times*. He joined the Mississippi National Guard in 1940 and was commissioned as captain of artillery. Foote and Walker Percy became lifelong friends after Walker and his brothers moved to Greenville to live with their uncle William Alexander Percy after the deaths of their parents.[261]

Walker Percy was thirteen in 1929 when his father committed suicide. Two years later, his mother was killed when she drove a car off a bridge and into Deer Creek near Leland, Mississippi. Walker and younger brothers LeRoy and Phinizy went to live with their uncle William Alexander Percy, a bachelor lawyer and poet in Greenville, Mississippi, where Walker met Shelby Foote. Walker earned a medical degree from Columbia University in 1941.[262]

From 1925 to 1932, William Alexander Percy edited the Yale Younger Poets series, the first of its kind in the country, and published four volumes of poetry with the Yale University Press. He was friends with William Faulkner and knew Langston Hughes through the Harlem Renaissance. A southern man of letters, Percy befriended many fellow writers, southern, northern and European. He published pieces under the name A.W. Percy in *Men and Boys*, an anonymous anthology of Uranian poetry (New York, 1934). His memoir, *Lanterns on the Levee: Recollections of a Planter's Son* (New York: Alfred A Knopf, 1941), covers the Great Flood of 1927 and his father, Leroy Percy.[263]

Charles Henri Ford (born on February 13, 1913, in Brookhaven, Mississippi) was in his teens when he had two poems—"Interlude" and "In the Park (For a Gold Digger)"—published in the *New Yorker*. In 1929, he dropped out of high school to publish, with Parker Tyler and Kathleen Tankersley, the small magazine titled *Blues: A Magazine of New Rhythms*. He spent time in Greenwich Village in 1930 and then sailed for Paris in 1931, where he mingled in the literary community. In 1932, Ford met Russian painter Pavel Tchelitchewm, and they moved in together in 1934. In 1933, *The Young and Evil*, a novel Ford wrote with Parker Tyler about the

homosexual world of Greenwich Village in the early 1930s, was published by the Obelisk Press in Paris. Other works Ford wrote and published during the Depression were "Letter from the Provinces" (1931); four poems in the anthology *Americans Abroad* (1932); a collection of poetry, *Pamphlet of Sonnets* (1936); and *The Garden of Disorder and Other Poems* (1938).[264]

Eudora Welty was born in 1909 in Jackson, Mississippi. From 1925 to 1927, she studied at the Mississippi State College for Women before transferring to the University of Wisconsin to complete studies in English literature. Her father, Christian Welty, suggested that Eudora study advertising at Columbia University. At the height of the Great Depression, Welty graduated from Columbia, but she could not find work in New York. After her father became ill, she returned to Jackson in 1931. Soon after, her father died of leukemia. In 1935, she worked for the WPA as a publicity agent collecting stories, doing interviews and photographing life in Mississippi. In 1936, her short story "The Death of a Traveling Salesman" was published in *Manuscript*, a small literary magazine. Her first short story collection, *A Curtain of Green*, was published in 1941. The *Atlantic Monthly* also published three of Welty's short stories in 1941. "A Worn Path" is considered one of Welty's best short stories and won the second-place O. Henry Award in 1941. She would later win first place for "The Wide Net" and "Livvie Is Back" in 1942 and 1943.[265]

Born on March 26, 1911, in Columbus, Mississippi, Thomas Lanier "Tennessee" Williams III attended the University of Missouri in Columbia, where he took journalism classes from 1929 to 1931. He submitted to contests his play *Beauty Is the Word* (1930), followed by *Hot Milk at Three in the Morning* (1932). For *Beauty*, he was the first freshman to ever receive an honorable mention in a writing competition. Williams enrolled at Washington University in St. Louis in 1936 and wrote the play *Me, Vashya* in 1937. He completed his undergraduate degree at the University of Iowa and graduated with a bachelor of arts in English and then studied in New York at the Dramatic Workshop of the New School. In 1939, his agent, Audrey Wood, played a part in Williams being awarded a $1,000 grant from the Rockefeller Foundation in recognition of his play *Battle of Angels*. Williams moved to New Orleans in 1939 to write for the WPA. The struggles in Williams's own life were often portrayed in his work, such as his later works, *A Streetcar Named Desire, Cat on a Hot Tin Roof* and *The Glass Menagerie*. He was awarded the Pulitzer Prize for Drama for *A Streetcar Named Desire* in 1948 and *Cat on a Hot Tin Roof* in 1955, both of which became successful as films.[266]

On September 4, 1908, Richard Nathaniel Wright was born at Rucker's Plantation, between Roxie and Natchez, Mississippi. Wright attended school in Jackson, and he and his family moved to Chicago in 1927. He was fired from the post office during the Depression and forced to go on relief in 1931. In 1932, he was involved with the John Reed Club, which was dominated by the Communist Party. Wright joined the party in late 1933. His first novel, *Cesspool* (1935), would be published posthumously in 1963 as *Lawd Today*. In January 1936, New Caravan accepted for publication Wright's story "Big Boy Leaves Home." His autobiography, *Black Boy*, covers his life from 1912 until May 1936. He worked on the Federal Writers' Project guidebook to the city, *New York Panorama* (1938), and wrote the book's essay on Harlem. That year, he was awarded $500 for first place in a *Story* magazine contest for his short story "Fire and Cloud."[267]

He found national acclaim with his collection of short stories titled *Uncle Tom's Children* (1938), and his book *Native Son*, published in 1940, opened in March 1941 as an Orson Welles Broadway play production. In collaboration with the Federal Service Administration (FSA) during the Depression, Richard Wright wrote the text for *12 Million Black Voices: A Folk History of the Negro in the United States*, published in October 1941 to critical acclaim.[268]

In 1926, William Faulkner's (his family name was spelled Falkner) first novel, *Soldiers' Pay*, was published. Inspired by friend and Louisiana writer Sherwood Anderson's suggestion, Faulkner started writing about and basing his characters on the people and places he knew from childhood. His 1929 novel, *The Sound and the Fury*, set in the fictional Yoknapatawpha County, clearly resembles Lafayette County, where Faulkner's Oxford home is located. *As I Lay Dying* (1930) depicts social issues—including slavery and southern aristocracy—uncomfortable subjects in the South but tame compared to his 1931 book, *Sanctuary*, which tells of the rape and kidnapping of a young woman at Ole Miss. Faulkner had married his old flame, Estelle Oldham, and in January 1931, their daughter was born prematurely. They named her Alabama, but she only lived for a little more than a week. Faulkner dedicated his collection of short stories, titled *These 13*, to "Estelle and Alabama." The novel *Light in August* (1932), set in Yoknapatawpha County, introduces Joanna Burden, a woman supporting voting rights for blacks. She is brutally murdered. Characters include Joe Christmas, Lena Grove and Reverend Gail Hightower.

Time magazine listed *Light in August* and *The Sound and the Fury* as two of the one hundred best English-language novels from 1923 to 2005. Also, during the Great Depression, Faulkner, under a six-week contract at Metro-

Goldwyn-Mayer, co-wrote 1933's *Today We Live*, starring Joan Crawford and Gary Cooper. In 1933, he also sold the rights to film *Sanctuary*, which was titled *The Story of Temple Drake*, and that same year, he and Estelle welcomed to the world their new daughter, Jill. To make money, Faulkner went to Hollywood many times between 1932 and 1945 to work as a scriptwriter and contribute to countless films. He also published more novels, including *Absalom, Absalom!* (1936), *The Hamlet* (1940) and *Go Down, Moses* (1942). Faulkner received the Nobel Prize in Literature in 1949, a Pulitzer in 1951 and 1955 and a National Book Award in 1955, along with many other awards. He was born in New Albany, Mississippi, in 1897 and died in Byhalia, Mississippi, in 1962.[269]

7

FARMING, FOOD SERVICE AND FOODWAYS

Foodways in the South derived from early European settlers, Native Americans, African Americans and immigrants who combined knowledge and practice with inspirations and strategies from other cultures around them. Native Americans were already growing vegetables like corn, squash and beans and harvested wild berries, plums and nuts. They hunted game that included bear, deer, turkey, rabbits, raccoons and opossums. From them, the early settlers learned much, like how to hunt, set snares, gather wild plants, catch fish and smoke meats and fish. Probably the most important thing the white man learned from the Native Americans was how to grow and use corn. Native Americans soaked corn kernels in lime to soften them before grinding, which activated niacin. In later commercial milling, the process would not include the soaking, which diminished the protein in the corn. This exclusion would be detrimental to the slave and sharecropper diets.[270]

Corn was prepared in three ways: corn pone, which was heavy and very sweet; corn mush, which was eaten by the African American slaves alongside cider, hog's lard and molasses; and hominy, in which corn was boiled and milk or butter was added.[271]

Corn and swine were staples in the southern diet. Vegetables were either fried or seasoned with fat-cured pork. Pork was served every day with the main meal, except maybe on Sunday and holidays when weekly tradition was broken with other meats like chicken, goose, turkey and more. Fried chicken was a delicacy. Beef, mostly veal, was served on rare occasions.[272]

On plantations, the dining table was often filled with an abundance of fruits and vegetables, meats and wines. The tables at farmhouses and town homes, while not quite so elaborate, might offer milk and coffee and homemade whiskey from corn.[273] Food was always the center of the domestic household, and the mistress of the house was the administrator who held the keys to locked larders. From the journals of white slaveholding women, their world of food, gardens and the dinner table was uncovered. Diaries and journals of white plantation owners and overseers also revealed much about food and crop yields and the duties of slaves.[274]

The food of slaves consisted of cured pork and cornmeal and some in-season vegetables, like turnip greens and potatoes. Because slaves usually cooked in one pot in a fireplace, meat was usually boiled.[275] Some plantation masters and mistresses used food to taunt or punish their slaves. On some southern plantations, corn mush was served to the slaves in a trough and the slaves had to lap it up like animals. A weekly ration was a peck of cornmeal and two to five pounds of pork, usually fatback. Included occasionally were molasses, sweet potatoes and other vegetables in season, as well as salt, coffee and fruit. Some slaves grew a few vegetables and raised small livestock. Some also hunted and fished and gathered wild foods. The cook in the big house was held to a strict high standard by the mistress, who eyed the cook's every move in the kitchen. She might be punished if the meal was not served on time or if the taste was not up to par.[276]

Slaves in Mississippi possibly had more to eat than sharecroppers, who relied on the same diet of salt pork, cornmeal and flour and molasses for sustenance.[277] Of the three Ms (meal, meat, molasses), molasses was the most nutritious, providing about a fifth of the recommended daily requirement of iron and copper, a quarter for manganese and a seventh for potassium. It was also a good source of calcium and vitamins, and therefore, poor southerners ate it three times daily. Molasses was an African food from sugar cane and sweetgrass sorghum introduced to the South during the Atlantic slave trade. Pressing the plant stalks between rollers, juice was squeezed from the stalks and boiled down to a sweet syrup.[278]

In WPA narratives taken during the Depression, ex-slaves often fondly remembered being able to eat regularly when they were slaves. Ex-slave Jim Allen of West Point, Mississippi, age eighty-seven, said, "Did we have good eating? Yes, ma'am, Old Master fed me so good, for I was his pet....I carried water to Marse Bob's store close by, and he would always give me candy by the double handful, and as many juice harps as I wanted. The best thing I ever did eat was that candy."

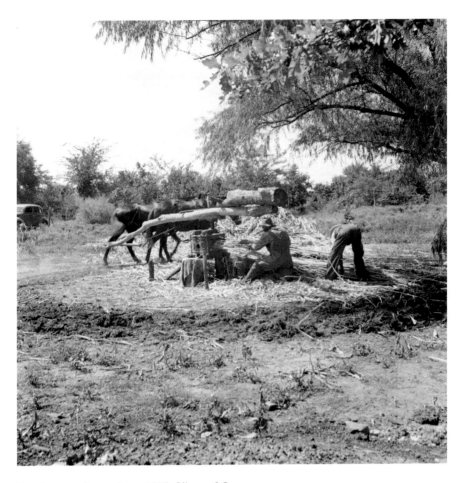

Pressing cane for sorghum, 1937. *Library of Congress.*

Jim described how all the slaves had "sight of good things to eat" from the master's garden and smokehouse. Lady Sally cooked for the slaves, and Ruth cooked in the "white folk's kitchen." He added, "I sure seed bad niggers whipped as many times as there is leaves on that ground," but that was at the neighbor's plantation, not his.[279] Ex-slaves were often hesitant to speak ill of their past masters or the way things were on the plantation for fear of repercussion from the whites who ruled the Jim Crow world. When sharing negative details about slavery, they often referred to neighboring plantations and their masters and overseers.[280]

The southern landscape, shaped by agriculture, farming and food, was most affected by one inedible crop: cotton. Cotton required little machinery

or know-how and could be stored without spoiling. Cotton and swine rather than cattle and hay dominated the three-hundred-mile Black Belt region extending across central Alabama and northeastern Mississippi into Tennessee. In lieu of vegetable gardens that required seed from the sharecropper, which he rarely had, and time to work the plot, which he rarely had, and a patch of soil, which the landowner rarely gave, the richest land in Mississippi was sacrificed for the cash crop that surrounded and swallowed the sharecropper's cabin like a ravenous mouth.

Director of the Commission on Interracial Cooperation Will W. Alexander, Fisk University sociologist Charles Johnson and Edwin Embree of the Rosenwald Fund stated, "Because the growing of household produce does not fit into the economy of a cash-crop, it is not encouraged by landlords, whose prerogative it is to determine the crops grown." Agricultural reform had been attempted in the 1900s when county agents visited landowners and requested that they diversify with food crops and allow tenants a small plot of land to plant their own vegetables. Landlords said no to both. The most affordable and most filling diet of cornmeal, salt pork, beans, field peas

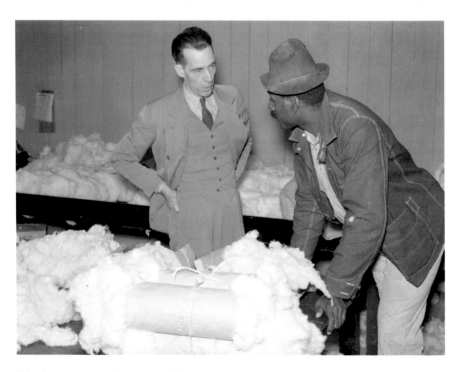

Bringing cotton samples to town, Clarksdale, 1939. *Library of Congress.*

Delta landscape dotted with cotton cabins for sharecroppers, Washington County, 1936. *Library of Congress.*

and molasses for the sharecropper relates directly to today's rates of obesity and diabetes.[281]

Physician and health crusader Dr. Joseph Goldberger, the son of Jewish immigrants, determined that the three-M diet was the cause of pellagra, which was characterized by the four Ds: dermatitis, diarrhea, dementia and death. He returned to Mississippi in 1914 to find the cause and determine why this disease was so prevalent in the South. He facilitated dietary studies in orphanages, mill villages and prisons. Goldberger conducted experiments on eleven inmates serving life imprisonment for murder who were promised pardons for participating in the experiments. (Experiments were usually done on blacks, such as the Tuskegee syphilis experiments from 1932 to 1972.) Prisoners were fed the three-M diet, and it only took six months for them to experience symptoms of pellagra. Dr. Goldberger shared his findings. With the flood of 1927 came an outbreak of pellagra, and Red Cross nurse Nan Cox in Cleveland, Mississippi, sought guidance from public health officials. Goldberger and his colleague Edgar Sydenstricker traveled to Mississippi and had relief agencies distribute tomatoes, canned salmon and beef to families. Goldberger and Sydenstricker reported on the health implications of the tenant farm system, stating that pellagra would have happened regardless of the flood.[282]

The *WPA Guide to the Magnolia State* gave a lighter glimpse into food and cotton culture of the 1930s through "White Folkways." The calendar revolved around cotton, beginning with planting time and ending with gathering time, and in between hoeing and chopping. Cotton was planted when the cottonwood bloomed. When it came to vegetable crops, there were signs, and the first twelve days of January held the key to the rest of the months. If the third day of January was dry and cold, then March would be dry and cold, and if the fifth day of January was rainy, then May would be a rainy month. During Christmas, moonlight meant light crop, and darkness meant heavy crops. Winter was over when the fig tree leafed out, so the garden plot could be prepared for planting. During the January thaw, cabbage, onions, greens and spinach could be planted. Valentine's Day was the next perfect time to plant, but "it is wise to wait until the moon is right because leafy vegetables grow better when planted in the light of the moon." For farmers, knowing the weather was crucial to being prepared. "On Sunday, if the sun set behind a bank of clouds, then it will rain before Wednesday." The red sunset brought wind rather than rain, and the late afternoon rainbow or streaked sunset brought fair and dry weather.

Hogs were fattened when frost fell three months after the katydid's first shrill call. With the cold snap came the hog killing. Then followed the curing of ham and preparing sausages, hogshead cheese, backbone, spareribs and chitterlings. Pork was eaten all year long, fresh in the winter, cured in the spring and salted in the summer. Vegetables such as peas, beans, collards, turnip greens and cabbages were served twice a day and cooked on a wood-burning stove. In fall and winter, dinner was served hot, but during the farming months, the meal was prepared in the early hours, placed in warmers and served cold at dinner (lunch) and supper.[283]

Sunday, the day of worship, was a time for fellowship and welcoming others to the table to enjoy a feast of fried ham, baked ham, fried chicken, dumplings, a variety of vegetables, biscuits, cornbread, cakes and pies. All dishes were crowded onto the table at one time, with the meats at the end. With everyone seated, except the lady of the house, the blessing was said and everyone passed the dishes around the table, the hostess standing ready to refill empty bowls and platters. The one claiming the last biscuit on the tray must kiss the cook. It was believed that any hostess encouraging healthy, hearty eating habits would make a good stepmother.[284]

In the same guidebook, the black folkways concentrated more on religion, folk medicine, funerals and wakes. The writer also explained the standard rations the "furnishing men allow the tenant Negro": a peck of cornmeal,

Wife of tenant farmer cutting piece of ham in smokehouse. *Library of Congress.*

three pounds of salt meat, two pounds of sugar, one pound of coffee, one gallon of black molasses and one plug on either "Red Coon," "Brown Mule," "Dixie Land" or "Wild Goose" chewing tobacco. "This collection is supposed to last him one week, but unless an eye is kept on him, he will eat it all before Saturday. On the other hand, if he is working for wages and 'eating himself,' he can live a surprisingly long time on three soda crackers, a can of sardines, and a nickel's worth of cheese."[285]

Rather than report on African American culture, white WPA writers focused on the stereotypical behaviors of black people and the insistence that the whites, specifically the white landowner, should see to and distribute any or all the blacks received, whether it be cash, crop or merchandise. John Lomax, then the WPA's national editor on folkways and folk culture, redirected Ex-Slave Project interviewers to discover more about black folk customs and folk tales. He preferred interviews about "the stories current at that time, the gossip of their associates, the small incidents of farm and home life, etc."[286]

The guide reported that when death strikes a black family in the Magnolia State,

the mirrors and pictures in the room are turned to the wall, or else they will tarnish and hold a lasting picture of the corpse....No kinsman dares assist in the preparation of the body for burial, but it is washed and the grave clothes are put on. A coin is put on each eye and a dish of salt is placed on his chest. The salt, it is said, keeps him from "purging" while the money closes his eyes. His hair is combed out (a woman's hair is never plaited, for the devil will send his blackbirds to unplait it and they will be heard at work inside the coffin even after it has been placed in the ground) and with his feet shoeless, he lies ready for the wake. During the wake, his body is never left alone, nor is the floor swept. "Neighbors," who may live miles away and have never seen him before, sit with him and food is served and songs are sung.[287]

Usually, the wake lasted three days, unless the deceased was of some importance, meaning the wake could last up to nine days when the family had to bury the body by law. After the funeral, in various parts of Mississippi, everything that held food during the wake—cups, pans, buckets—was emptied and food was thrown out to the west to keep the spirit from remaining on the premises because of easily accessible food and water. The clothes, cup and saucer of the deceased should never be used by anyone else. Cups and saucers were broken and placed on the grave, along with the medicine used during the last sickness.[288]

With the Great Migration, African Americans took their traditions of music, language, dance and food and expanded and shaped the nation's diversity with their food trucks, cafés, street stands and backyard gardens of squash, beans and collards.[289]

Detailed under the "Agriculture" section is cotton—the only crop defined in this section—and it somewhat innocently portrays the strangling hold cotton had on Mississippi:

Indeed, the growing of household produce is not encouraged by landlords, whose viewpoint must reflect the wishes of the financial backers. The final decision in the matter, as on the question of acreage to be planted or the amount of fertilizer to be used, also rests with the men who advance money for the crop. Obviously, the diet of the tenants is largely limited to dried and canned goods from commissaries and local stores. This food and other necessities, obtained on credit during the crop season, is called "furnishings." It must be paid for out of the tenant's share of the crop at harvest time.[290]

Tenant farmers' cemetery. *Library of Congress.*

The WPA guide exposed how cotton held a monopoly on the land for over 139 years, since Whitney's invention of the cotton gin up until the Agricultural Adjustment Administration in 1933. Conservation units, headquartered in Meridian and established to check the erosion in various soils around Mississippi, demonstrated strategies for erosion control and land re-fertilization by reforestation, proper land usage and terracing. Through soil conservation techniques, the Mississippi farmer increased food and feed crops, especially corn and hay, by 63 percent and pasture acreage by 27 percent, cattle by 66 percent and swine by 26 percent. The farmer also decreased his cotton acreage by 36 percent. Even on the reduced acreage, in 1936, the planter produced 1,910,661 bales of cotton, the third-largest crop in the history of Mississippi.[291]

New Deal programs affected how Mississippi approached industry and agriculture through agribusiness that called for a great reduction in the production of food while the working poor were given access to the government's surplus food, such as canned meat, cheese and flour and cornmeal. The U.S. Department of Agriculture (USDA) favored white farmers over black, just as the Agricultural Adjustment Administration (1933)

paid mostly well-to-do white farmers to reduce the production of cotton to raise its value and to share 50 percent of their government payments with their tenants and sharecroppers. In most cases, landowners spent the money on mechanized cotton pickers, tractors and other farm elements and evicted the tenant farmers and sharecroppers from their land, leaving them with no resources and no food. Roosevelt's resettlement programs were established to confront these rural poverty problems.[292]

Entering the twentieth century, most Mississippians still lived on the land or in small towns dependent on agriculture. Former state agent in charge of home demonstration work of the Mississippi Agricultural Extension Service Susie V. Powell was sixty-nine when the market crashed in 1929. During her work in the early 1900s, she asserted the heart of the farm was the woman who took care of her family while maintaining house and garden on land that rarely had running water or electricity.[293] During the Depression, women had to work as well to help take care of their families. Mississippian Ellen Sullivan Woodward, federal director of work relief for women, helped develop work relief programs for Mississippi women, including food

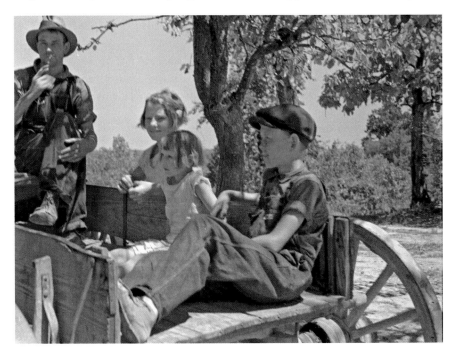

Tenant farmer being aided by the Resettlement Administration, Lee County. *Library of Congress.*

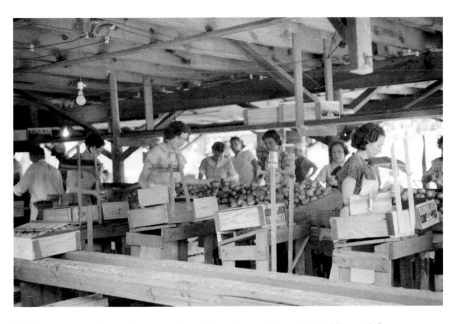

Packing tomatoes for market at small packing depot at Terry, 1936. *Library of Congress.*

programs where women worked in gardening and canning in the summer and, during the school year, oversaw school lunchrooms. By 1939, the lunch program fed an average of forty-nine thousand children daily during the school week.[294]

FOODWAYS

It is generally accepted that Mexican migrant laborers brought the tamale tradition to Mississippi when they worked the big cotton crops in the 1920s and '30s alongside African Americans who realized the basic tamale ingredients—cornmeal and pork—were the ingredients of their daily diet. Oral histories with tamale vendors and makers in Mississippi help us understand the evolution of the tamale within the foodways of the South.[295]

The Southern Foodways Alliance documents, studies and explores the diverse food cultures of the changing American South through oral histories, films, podcasts and articles. One Southern Foodways Alliance interviewee was Geno Lee, a fourth-generation owner of the Big Apple Inn on Farish Street in Jackson. His great-grandfather Juan "Big John" Mora was born in

Mexico City and arrived in Jackson in the 1930s. A peddler of hot tamales on street corners, by 1939, Mora had enough money to buy a Sicilian-owned grocery store in the center of African American culture. He named it Big Apple Inn after his favorite dance, the Big Apple. Lee spoke of his ancestor:

> *I guess that was around the mid-'30s, and [Juan] worked for the Railway station doing little odds and ends jobs, building viaducts, bridges for the railroad company, you know, laying tracks and got hurt and decided to start selling his homemade recipe—or his mother's homemade recipe for tamales and started selling them on the street corner here in Jackson....I know that during that time there were a lot of immigrants or illegal aliens here at the time. And in fact, the first year he had a lot of—of Mexicans down here who were making tamales. There was another guy down here called Mexican Joe. And he sold tamales, and he was the one that, I think, gave Big John the idea to go on and start doing tamales for himself.*[296]

Juan also diversified his menu to meet the appetites of many clientele:

> *When they opened the place in 1939, they knew that they couldn't just have a restaurant strictly selling tamales....So they came in with the tamales, and they came up with some different sandwiches. Now smokes came first and what—what a smoke is—is just ground Red Rose [brand] smoked sausage. We take the skin off of Red Rose smoked sausage and grind it up and put it on a griddle and cook it like hamburger meat and put it on a Krystal-sized bun with mustard sauce, slaw, and hot sauce. And they sold that and bologna sandwiches and tamales for a long time.*

Geno described Farish Street in Jackson, Mississippi, as the only street where African Americans could go during that time without worrying about the white people. Everything on Farish Street had been built by freed slaves who had no architectural or college degrees. "They just built a building. And they had their own little—their own little city. They had their own restaurants, their own grocery stores, their own clothing stores, and this is where commerce for African Americans was."[297]

Many considered Dockery Plantation in the Mississippi Delta the birthplace of the blues. In 1900, Bill and Annie Patton brought their son Charley to Dockery. Howlin' Wolf, Robert Johnson and Son House also visited and played music on Dockery. The plantation became a community of self-sufficient farmers who raised their own cows, hogs and chickens; planted

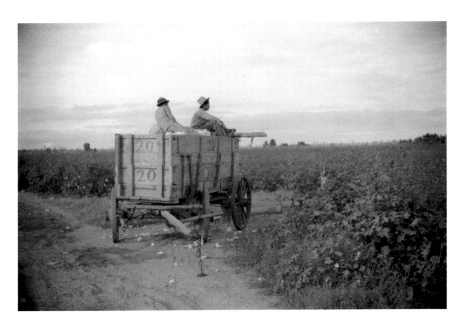

Mexican laborers on wagonload of cotton in the field on Knowlton Plantation, Perthshire, Mississippi Delta, 1936. *Library of Congress.*

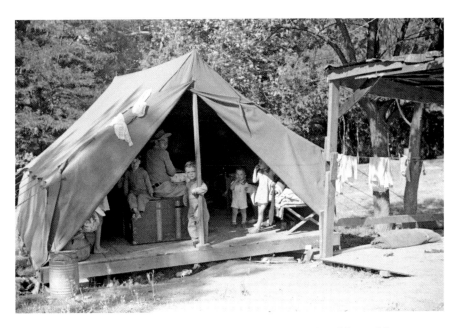

Tent belonging to Mexican laborers from Texas, Hopson Plantation. *Library of Congress.*

gardens of beans, tomatoes, corn, okra, squash, sugar cane and sorghum cane; and hunted the land. Sharecroppers began leaving Dockery in the 1940s when machinery replaced manual labor. In her Southern Foodways Alliance interview, Gentle Lee Rainey said Dockery Plantation was also the birthplace of the Delta hot tamale. Her grandfather Sylvester Blaylock, who worked on the Dockery Plantation, created his version using cornhusks from the fields to earn money on the weekends. In time, all the men in the family learned to make and peddle tamales in Ruleville on Saturday nights.[298]

The tradition of the Mississippi slugburger or doughburger is rooted in the early twentieth century, some say because of the rationing of red meat during World War I. One recipe originated with John Weeks, who acquired his recipe from a German immigrant and then brought it to Corinth, Mississippi, where he and his four brothers opened mobile hamburger stands across the lower Tennessee Valley. Weeksburgers were a mixture of beef and potato flakes and sold for a nickel in 1917. The Weeks brothers catered to working-class farmers who came to town on business and to factory workers who ate a quick lunch, according to Booneville, Mississippi native Willie Weeks, owner of Weeks Diner in Booneville with his wife, Dianne Weeks, in

International cotton picker on Hopson Plantation, Clarksdale, Mississippi Delta, 1939. *Library of Congress.*

Southern Foodways Alliance's *A Hamburger by Any Other Name*.[299] In another interview, Camille Borroum-Mitchell was only thirteen or fourteen (around 1939 or 1940) when she worked at her father's drugstore/soda foundation, Borroums, in Corinth. She said that they sold tea sandwiches, ice cream cones, ice cream sodas, milkshakes, banana splits, sundaes and slugburgers. Camille shared with Southern Foodways Alliance interviewer Kate Williams that their slugburger "is crisp and we deep-fry it."[300]

Many accounts of the burger relate to the Great Depression, when, to save money, cooks mixed cheap and filling ingredients like cornmeal and bread crumbs into ground beef patties and fried them to serve families and restaurant clientele. The burger wears many names: slugburger, (derived from the term *slug*, slang for a nickel, possibly the original cost of the hamburger), doughburger, cerealburger, potatoburger, fillerburger and mysteryburger. Some restaurants simply call it a hamburger or an old-fashioned. Today's fillers include soymeal grits, flour and oatmeal.

The Southern Foodways Alliance website explains that

> *two historical developments frame the trajectory of the slugburger. In 1933, the Tennessee Valley Authority, a New Deal initiative signed into law by President Franklin D. Roosevelt, brought cheap, abundant electricity to the lower Tennessee Valley, attracting textile plants and chemical manufacturers to the region. As new workers moved into the region and locals left farms for factories, those workers required weekday lunches, served quick and cheap. From the lower Tennessee Valley, the phenomenon spread. Trace the rail routes of Kansas City Southern, CSX, and Norfolk Southern, and follow the path of the ports along the Tombigbee River, and you get a picture of how this style of hamburger dispersed.*[301]

The slugburger/hamburger, still sold in Alabama, Mississippi and Tennessee counties, "is a token of survival, a tie to the past, an homage to creativity in a region that has weathered the expansions and contractions of industry," explained oral historian Amy C. Evans.

In the early 1900s, Greek immigrants came to Jackson to find opportunities, and many chose the restaurant industry, such as George Kountouris and John Gouras, friends from the island of Patmos, who opened the Mayflower Café in Jackson in 1935. What started as a hamburger stand grew into the neighboring beer garden and then a full-service restaurant with a menu showcasing ethnic diversity. Diners enjoyed sandwiches, Greek and Chinese dishes and soul food.

Peter Zouboukos, born Panagiotis Constantine Zouboukos, did not come to Mississippi until 1947, but his story around survival during the Great Depression deserves space within these pages. With no knowledge of the English language or a penny to his name, Peter arrived at Ellis Island in 1929. Because he did not know the way to Waco, Texas, where his uncles, George and Mike Colias, resided, Pete took a job cooking for the Colias brothers, who ran the restaurant Elite on the Circle. There Pete learned to cook chicken fried steak, enchiladas and meringue-topped pies. The restaurant featured Greek dishes like broiled fish and Greek salads. In 1947, Peter, known to all as Mr. Pete, and his younger brother Jimmy moved to Mississippi and opened the Elite in Jackson.[302]

Another story relating to sharecroppers and the Depression belongs to Willora "Peaches" Ephram, born in Utica, Mississippi, in 1924 to sharecropper parents. While others in her family worked the fields, Willora learned to cook beside her mother and grandmother. By the age of eight (1932), she prepared and had ready to serve the evening meal to her family when they returned from the cotton fields. In search of a better life, with only eight dollars, Peaches moved to Jackson in 1948. She worked as a cook at Blackstone Café on Farish Street and saved up enough money to open Peaches' Restaurant in 1961, serving breakfast, lunch and dinner. During the 1960s, Peaches' Restaurant served as a safe haven for civil rights activists.[303]

In search of the fabled Gam Sahn or Golden Mountain, Chinese arrived in the Mississippi Delta during Reconstruction. Some Chinese returned to China, but others moved off the plantations and opened small neighborhood grocery stores that were alternatives to plantation commissaries.[304] In the small town of Jonestown, the Ming family grocery store had both white and black clientele. Luck Wing enrolled in the University of Mississippi in 1946 and was one of the first Chinese men to attend the university. He later opened Mississippi's only Chinese-run pharmacy in Sledge and would go on to serve as the town's mayor. He told Southern Foodways Alliance interviewer Jung Min (Kevin) Kim of Swarthmore College that

you know back then in the grocery, something else, we delivered. You know the people would call up and we had—we did—in town we knew all the customers and everybody—white customers. Most of the time the blacks we didn't have—we didn't deliver to them, not because we wouldn't but most of the time they came up and bought their own things. But most of the white families would call in orders and say even for lunch or for lunch and supper, they'd call in and we'd get on our bicycle. That's the way I grew

up in grocery—delivering groceries. We got on our bicycles and delivered groceries. The three youngest of us more or less—was delivery boys.[305]

Luck Wing remembered having a Chinese family garden every year and spoke about friends in Coahoma, Mississippi, who also sold Oriental vegetables:

He would ship Chinese vegetables to Chicago quite often because the train ran right into the little town of Coahoma. And I remember as a child going down there and watching him pack greens and the freshwater chestnuts. He's—he had—he ran really a Chinese garden with his—maybe his—one of his younger relatives was going to take it over, but it was different. The man that started it he really worked it like—like the Chinese peasants would I guess. But he'd go out every day and work it. And he had the—had a market for his vegetables. He'd ship out when it comes in season; I guess he'd make two or three shipments a week to Chicago and to California, wherever he shipped the stuff—quite amazing.[306]

Life for a Chinese grocer began with a hurried breakfast before donning aprons and preparing the cash register, removing fresh fruit and vegetables from refrigerators to display on shelves and discarding badly overripe fruits. To avoid meat spoilage, Chinese grocers tried to cut only what would be sold that day. Delivery by bicycle was free, and no tips were expected. On the bicycle was a basket in front and one on back to control the balance of groceries during delivery. Every piece of merchandise being delivered was checked off and verified. Deliveries were made in any weather.[307]

The America Eats archive portrayed cooking by African Americans as "purely and solely for profit," whether as domestic workers in white households or as community entrepreneurs, and they often did both, considering their meager wages. In the South, African American cooks supplemented wages by "pitching frequent Saturday night fish suppers." In Mississippi, mullet was described as "not usually prized as food" because it is "commonly eaten by Negroes." Yet "in the coast region…many white people eat it and have come to call it Biloxi bacon."[308]

By the 1930s, the stereotyped image of the southern black mammy offered comfort, reassurance and stability amid economic depression.[309] Introduced in Chicago at the 1893 World's Fair, Aunt Jemima represented gentility and servility in the South. The woman whose image was on the first ready-mix pancake mix was Nancy Green, a freed slave. Her heavy dialect seasoned her

tales of the Old South. This product and image was not built in the South, but in the North, by a northern corporation. During the 1920s and '30s, southern culture was often romanticized, especially in marketing products. Maxwell House Coffee, whose name derived from the Maxwell House Hotel in Nashville, created a live radio show and, in its advertising, had black waiters standing happily serving coffee to the whites comfortably seated.[310]

In 1933, Roosevelt's National Recovery Administration established industry-wide codes to stop labor strife, ease competition and get production moving again. Southern black workers found fault with the codes planned for the textile industry because textile industry jobs open to black workers were excluded from code coverage. Domestic workers, mostly black women cooking and cleaning in white homes, noted the omission of efforts to produce a code for the occupation of household work. By 1934, a group named the National Association for Domestic Workers headquartered in Jackson, Mississippi, had taken a stand:

> *May I take this opportunity to write you on behalf of the hundreds of thousands of Negroes and whites employed in Domestic and Personal service in the United States. The attached code has been drawn up after an intelligent study of the conditions of these workers by a representative group of colored men and women from all parts of the South and we are asking your sincere consideration of the contents. In our survey of the Southern States we find the average wage of these workers $3.50 per week. Does this mean a living wage? If not, what protection do they have? Every type of industry has applied for some form of regulation with regard to hours, wages and general conditions. Are there workers of a group of more importance than those working in the homes of public and private citizens?*[311]

Another representative wrote in pencil on lined notebook paper to First Lady Eleanor Roosevelt, asking,

> *Please try to help the cooks in private homes to have some kind of working schedule about our jobs....We only get a small salary...when we keep the house, wash, iron the clothes, cook the meals, come to work at 7 a.m. [and] no limit to the hour we get off. No rest on the job, not an hour to lie down or sit down to rest. But we poor Negro women have to work. Our husbands only get a small salary to pay a few bills, that is rent and a few other utility bills, and we must help. And we don't mind the work, but 18 hours out of 24 hours a day is killing our women.*[312]

While census records document that 5 percent of American households hired domestic workers, in Jackson, Mississippi, only 19 percent of white households were "unable" to hire domestic work, with the most significant ability indicator, besides income, being the wife's educational level. It was common for a housewife with at least a high school degree to hire a servant who could free her time for club work, self-improvement or child development, community activities in line with her husband's white-collar or professional job status. In the home, the wife supervised her domestic help much like her husband supervised his workers.[313]

By 1938, 93 percent of those hired in the WPA housekeeping aide project were adult black women, and these aides taught cooking nutritious meals from government commodities, preserving fresh produce, nursing and housework. For many in the black community, the jobs provided reasonable, government-funded wages and finally gave the black community pride in officially recognized work. National Youth Administration relief programs trained teenage girls for adult roles, but the roles were gender and race specific. White girls gained skills as future homemakers and housewives while black girls learned domestic service work. The 1937 Mississippi state report showed "450 NYA youth in homemaking classes and 800 in domestic service classes."[314]

8

RELIGION

Nothing influenced the rural South more than religion. Whatever happened, however it happened and whenever it happened was God ordained. Bountiful harvests, prosperous businesses and scorching droughts and ravaging floods were His will, His message, His reward, His judgment. Religion was distinguished not by denomination but by conservative Christian fundamentalism. A church's weekly multiple services and activities became the center of southern family life and helped create the unique cultural landscape of Mississippi.[315] It was a common sight to see the gathering of people on the banks of rivers and streams, standing as witnesses to outdoor baptisms that usually took place in the mid- to late summer after crops were in the ground. This and other evangelistic campaigns were major social and cultural activities because of the concern for the conversion of the lost.[316]

Entering the Great Depression years, Catholics and Jews immediately supported Roosevelt as their presidential candidate—Protestants, not so much. Still, by election time, Roosevelt was the choice in the South, winning 57 percent of the popular vote and at least 60 percent in southern states. In the two states where the poll tax and voter restrictions denied the poor white and African Americans the vote, Roosevelt won by 96 percent in Mississippi and 86 percent in Arkansas. While famine struck Russia and Hitler took control of Germany, First Lady Eleanor Roosevelt called for "a new standard which will set above everything else certain spiritual values." She called for revival.[317]

The largest religious denomination was the Baptist, which covered Georgia, Alabama and Mississippi, as well as Appalachia, northern Louisiana, east Texas, southern Arkansas and southeastern Oklahoma.[318] Distribution of the denomination related directly to the region in which the church was planted. In the land of cotton, there was another god planted in the churches: the landowning planter. From the pulpit, pastors vehemently hurled Bible verses at poor sharecroppers about the importance of hard work and a duty to repay debt, ignoring the verses reflecting the "master's duty to the servant," found on the same page.[319]

In Mississippi and Memphis, black Pentecostalism connected to the Church of God in Christ, which had grown out of the Presbyterian faith and became a culturally powerful religious group from middle Tennessee down through north Mississippi and Arkansas. Jews and the Jewish religion enjoyed a significant presence but faced growing anti-Semitism.[320]

Along the Mississippi Gulf Coast, the Roman Catholic Church had a large following, even among African Americans. In Biloxi, after worshipping for years with the white Catholics, the Our Mother of Sorrows Church, a wooden structure in Gothic design, was built for black worshippers in 1914. The Catholic Church also established a school there for black children in 1917. In 1933, the school began adding grades, starting with the ninth grade. The twelfth grade was added in 1937, and the first class graduated from high school.[321]

The ministry of Protestant churches also extended into the education of minorities. In 1928, the white Baptist church in Rosedale, Mississippi, decided to provide classroom instruction to the Chinese that had been denied them. For the Baptist mission, this meant, also, that the Chinese might join the church. Rosedale's Chinese children began attending primary school at the Baptist church. In 1934, Greenville's Galla Paxton, president of the Women's Mission Union, began efforts to educate Chinese children through First Baptist Church. A special church service was held for the Chinese, in Chinese. Separate services, according to John Jung (*Chopsticks in the Land of Cotton*), were not due to discrimination.[322]

In Cleveland, Mississippi, Reverend Ira Eavenson had done mission work in China. In 1934, he steered the efforts of a Chinese Mission School. Chinese merchants and leaders, with the assistance of Chinese preacher S.Y. Lee, traveled throughout the Delta region requesting contributions to fund this school, which would educate around 150 Chinese children. In 1937, the First Baptist Church completed the school building and a dormitory to house Chinese children from around the region. The county paid two

white teachers, Mrs. McCain and Mrs. Miller, who taught in the white school. Chinese teachers taught lessons in Chinese, and students throughout the Delta region roomed at a boardinghouse while attending school. The problem at graduation was that the schools were not accredited, making it difficult to apply to college. Some Chinese families in the Mississippi Delta sent their children to white schools in California and Texas for their secondary education.[323]

During Reconstruction, African Americans started their own churches in Mississippi, which became the strength of their communities and the largest institutions under their control. By the 1930s, the black Baptists had become the state's largest denomination, with more than twice the membership of white Baptist churches.[324] Church became the one place where religion affirmed the equality of the African American as an individual and it didn't matter what southern white society believed or said.[325]

In the 1920s, southern churches borrowed money to expand their charitable missions, so when the market crashed and the banks closed, churches faced the same downward spiral as any other business and industry. Religious leaders felt spiritual revival was the only way to rise from the pit of moral decay, which they believed had led to the Great Depression, combined with a lack of Christian commitment. These leaders chose evangelizing over charity and focused on a spiritual rather than an economic famine, claiming they were to save the souls of the poor, not their bodies.[326]

When donations to the church and denominations stopped due to the Depression, southern Baptists cut home missions to a minimum to fund the church. Added to financial misery was the Home Missions Board treasurer fleeing to Canada after embezzling $900,000. Large denominations, like the Baptists and Methodists, pulled missionaries and workers from Indian reservations and African American schools and greatly decreased funding to foreign and educational missions. In 1931, describing drought and depression, an African American Methodist proclaimed, "In the midst of good times, many people usually forget God. But many now see the folly of it all and are ready to hear what God has to say about things."[327]

Southern Baptist and Pentecostal denominations did not allow women in the pulpit but welcomed them in other leadership roles. Assembly of God and African American churches were more open to women being ministers, like Cindy Mitchell from Leflore County, who was called the Good Shepherd, and Ethel Christian, who, after her husband died, was called the head of the church by the Living God congregation in the Delta. In the 1900s, it was the women, as members of social organizations and church societies,

Church turned into a movie house, Woodville, 1935, Resettlement Administration. *Library of Congress.*

who campaigned for reform in working conditions and child labor and who demanded services and protections for mothers and children who most often fell victim to the South's industries.

The moral compass of the Victorian era and antebellum Mississippi had long placed on southern white women the responsibility and obligation of the household and that household independence was made possible only through their loving, dedicated hands. Women took care of household chores, bore the children and saw to their needs, tended the garden, prepared meals and cut and sewed the clothes for their families.[328] As the guardians of the family, they were expected to celebrate frequent childbirth with joy and ignore the pain that accompanied that frequency. Then, their task was to rear the children, oversee their education and be a Christian example to them through abiding faith and providing a good, moral home for their families.[329]

Nonetheless, black women were expected to labor outside their homes, for middle- and upper-class white families. They worked their fields and, as maids, took care of the children of white families while also cleaning the home and cooking the meals. Plus, a black woman was considered lazy if she didn't work. William Faulkner, in *The Sound and the Fury*, clearly exemplified the religious strength of his Mammy character, Dilsey.[330]

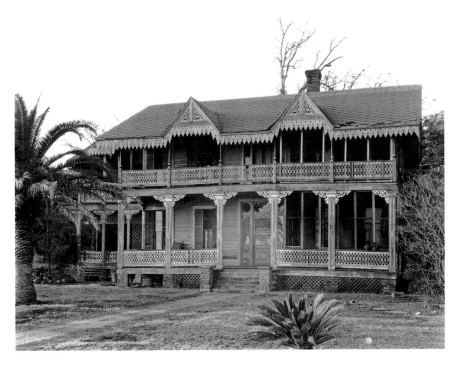

Victorian cottage, Waveland, 1936. *Library of Congress*.

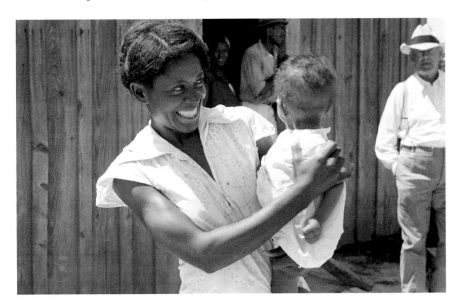

Wife and children of a Tupelo tenant farmer. *Library of Congress*.

The church encouraged women to fulfill their roles. Methodist minister Charles B. Galloway urged women to use sewing and repairing clothes to relieve suffering, using the biblical character Dorcas as an example of virtue and the temptress Eve, weakened by pleasure and indulgence, as the counter character good Christian women should shun. Preachers condemned the woman wasting money on store-bought clothes and cloth. Methodist leader William Winans said, "Some claim a distinction for the dress they wear—perhaps for the color of a ribbon or the richness of a lace, the casing of a bracelet or the brilliancy of its jewels."[331]

Women's Progress
Sweet Sister! stoop not thou to be a man!
Man has his place as woman hers; and she
As made to comfort, minister and help;
Moulded for gentler duties, ill fulfils
His jarring destinies. Her mission is
To labour and to pray; to help, to heal,
To soothe, to bear; patient, with smiles, to suffer;
And with self-abnegation noble lose
Her private interest in the dearer weal
Of those she loves and lives for. Call not this—
(The all-fulfilling of her destiny;
She the world's soothing mother)—call it not,
With scorn and mocking sneer, a drudgery.
The ribald tongue profanes Heaven's holiest things,
But holy still they are. The lowliest tasks
Are sanctified in nobly acting them.
Christ washed the apostles' feet, not thus cast shame
Upon the God-like in him. Woman lives
Man's constant prophet. If her life be true
And based upon the instincts of her being,
She is a living sermon of that truth
Which ever through her gentle actions speaks,
That life is given to labour and to love.
—Louisa Susanna Cheves McCord, "Woman's Progress," 1853

In the 1930s, black and white Methodist women worked together to establish a leadership training program at the Mississippi Industrial College for black women. Plus, they began a study and protest over the state's

unwillingness to fund black schools. Although white Southern Baptist and Methodist women organized the Association of Southern Women for the Prevention of Lynching (ASWPL), they failed to support the anti-lynching bills in 1933 and 1938.[332]

In the black church, field hands became deacons and maids became mothers of the church. In a Jim Crow world, black parents explained to their children the "ways of Mississippi," where you treat white people nice, never look a white woman in the eye and always step off the sidewalk to let whites pass by. In the black church, black men could steer the pulpits and control the church in both power and politics.[333] Black women, especially those considered middle class, participated in the church by organizing various social services, reading groups, temperance associations and missionary societies. They, too, fought for suffrage and social reform. Black female writers, like Ida B. Wells, who died during the early Depression era, wrote in religious periodicals and newspapers to promote respectability and womanhood and to protest racial injustice, lynching and violence.[334] The church offered blacks an escape from the caste system and, as Hortense Powdermaker reported, helped them gain and maintain self-respect "in a situation geared to destroy it." God's Word spoke of equality to all people before God, and their importance to Him was the theme of sermons and Sunday school lessons. Blacks could also, using the Holy Bible as a measuring stick, regard the actions of whites as "unchristian" and consider themselves superior to whites in Christ's precepts.[335]

Growing up in Chickasaw County, Mississippi, toughened up Ida Mae Brandon. She chopped wood and learned to fight with ferocity. She was only six or seven when she rode her horse to the blacksmith to have a piece of plow sharpened. While there, the two sons of the white blacksmith bullied and abused Ida Mae by dangling her over a well. She also felt the blow of prejudice when she traveled with her white employer to Okolona to help sell the eggs she had gathered for him. She walked with her employer to a customer's house to deliver the eggs. The customer ostracized the white man for bringing a "nigger" to the front door.[336]

It was in the church that Ida Mae met her future husband, George Gladney. Smitten with fifteen-year-old Ida Mae, George walked four miles every Sunday to see her. The two married in 1929. Ida Mae and George moved to a cabin close to the Natchez Trace, where they sharecropped for Edd Pearson, picking cotton—a woman was supposed to pick one hundred pounds of cotton per day—from "can see to can't see" to break even with their debt, according to Mr. Pearson. Ida Mae bore several children but

lost her second-born. Her third was a son, and to give him luck, she named him after the son of a white family in town for whom she worked. His name was James.[337]

George had a cousin, Joe Lee. On a night in 1937, Edd Pearson and four white men came to George's looking for Joe Lee, whom they claimed had stolen some turkeys. When they found Joe Lee in the back, they hog-tied him, dragged him into the woods, beat him with chains and threw him in jail. The turkeys strutted back into their yard the next morning, and George rushed to the jail to get Joe Lee. Because Joe Lee had been beaten so severely, George used grease to peel off Joe Lee's bloody clothes. That year was the last crop for George and Ida Mae. In secret, they sold off their personal belongings and went north to Milwaukee, where Ida Mae's sister had moved. Yet Ida Mae still wanted to have her child in Mississippi, her childhood home, and she did. In 1938, she had a daughter in the home of her mother, Miss Theenie, and named her Eleanor, after the first lady.[338]

The year Ida Mae gave birth to another black child in Mississippi, Mississippi senator Theodore Bilbo joined in the filibuster against the bill to make lynching a federal crime, saying, "If you succeed in the passage of this bill, you will open the floodgates of Hell."

Ida Mae returned north and joined George in Chicago, where he worked as an iceman and later worked for Campbell's Soup Factory. Ida Mae voted in 1940 for the very first time at a firehouse on the South Side of Chicago. Roosevelt went on to win that election.[339]

The strength and courage of George, Ida Mae, Ida B. Wells and many African Americans from Mississippi can be traced back to their churches, where seeds of faith, hope, equality and justice were first planted and where the civil rights movement was born. With the Great Migration, membership in the black churches declined, but some denominations built new churches in new northern locations and therefore expanded their reach in the nation.[340]

All religions understood the importance of revival, which focused on returning to the will of God and Christian values. But in a Jim Crow world, African Americans knew jobs would be filled first by whites. Some African American religious leaders were bold enough to question and criticize capitalism for ignoring human values and service because of color and social status. These leaders would also witness Roosevelt's New Deal programs give in to the Jim Crow laws that went against Christian principles.[341]

Hortense Powdermaker, in her late 1930s findings, reported that whites and blacks enjoyed a strong faith in Christianity and in the afterlife. Most middle-

City jail, Mississippi Delta, 1939. *Library of Congress.*

class whites attended Sunday school, Sunday worship and Wednesday night activities. Black services were highly emotional. Older Christians were set in their prejudice and segregationist ways, but flexibility in ways and beliefs was found in younger Christians.[342]

In the 1930s, former slaves in WPA narratives criticized the younger African Americans for their immorality and lack of concern for their families. "God intended for every man in the world to have a living and to live for each other, but too many of 'em livin' for themselves." Others claimed independence was the best way to avoid ambition, luxury and debt. Former slave Isaac Stier said it wasn't the thing that costs money that gives the most happiness. William Henry Rooks thought everybody was going crazy over money and that young African Americans were just trying to keep up with the white folk. Escaping debt and owning land were the hope of the poor and downtrodden, and with that hope came the suspicion of materialism rooted in the Protestant faith of self-denial and self-sacrifice. The elders clung to a dream; the younger African Americans realized the dream was just that—a dream.

Many clung instead to the blues, the devil's music.[343] Black music and musicians were separated into two categories: gospel and blues. These genres grew up together, side by side, and used similar techniques like call-and-

response, slide guitars and blue notes. But, still, gospel was "God's" music and the blues belonged to the devil.[344]

Author Richard Wright preferred his grandmother's Seventh-day Adventist all-night prayer meetings with music and emotion to his mother's Methodist church, which formed clans, practiced snobbery and gossiped. Gospel music permeated the black Pentecostal churches, and the blues musicians who performed the devil's music on Saturday night sang God's music on Sunday morning.[345]

Bluesman and preacher Charlie Patton and Son House, a former "once in grace, always in grace" Baptist, recorded both blues and gospel music. In one legendary blues recording session, the two got up with Willie Brown and Louise Johnson, both from Clarksdale, Mississippi, on May 28, 1930. In these tracks, Son House reveals the vacillation of his Baptist faith, even to the point of atheism, in "Preachin' the Blues":

Hey, tain't no heaven,
Tain't no burnin' hell,
Say, where I'm goin' when I die
Can't nobody tell.

Oh, could had religion,
Lord, this very day;
Who, I'd had religion,
Lord, this very day
But the womens and whisky,
Well, they would not let me pray.

For the black man, there were little or no job opportunities in Mississippi except the fields. Two alternatives were preaching and singing, if you had the talent and the gift. Mississippi bluesmen who did both blues and religion included Son House, Charlie Patton, Robert Wilkins and Ishman Bracey.[346]

The Depression broke the backs of many, but it helped launch modern gospel through the radio.[347] Religion also played an integral part in the programming of the first licensed radio station in 1924, which spread the gospel over the airwaves. First Presbyterian received its own station license in Meridian. In 1931, the Laurel station had lines to its Methodist, Presbyterian and Baptist churches. In Hattiesburg, Howard S. Williams secured his license and the permission to move his station with his revival tent around the state. Membership grew in white fundamentalists/

Pentecostalists, black Baptists and Catholics but decreased in middle-class churches.[348]

Church donations held steady until 1933. As donations declined, the need for charity increased. The president of the Southern Baptist Convention said, "We are putting off the Lord's cause while we try to settle with our other creditors." The orphanages, schools and hospitals established and supported by black and white churches and other religious and charitable organizations also faced financial strain. Churches joined the requests around the nation for federal assistance.[349]

The response of churches and charitable organizations to federal assistance contrasted sharply with earlier views of charity and federal aid. Normally, white, middle-class southerners believed charity displaced social order. They, for the most part, blamed the poor for being poor, believing their suffering self-inflicted. If the poor found God, they could become productive members of society. Money given to the poor, white and black, would be wasted away on alcohol and other evil acts.[350]

The exception to frugal versus frivolous was a religious holiday—Christmas, which included shopping, food and leniency in the strict rules for children and African Americans. Shop owners spent their money on advertising to lure parents and children into their buying den. Some stores even offered delivery on Christmas morning. McGaughey's in Tupelo directed men to "make shopping a pleasure" and advertised the first showing of "Gorgeous Christmas Lingerie" in 1936. Stores also discovered the power of children. Santa Claus took up space beside the Christ child in displays, and letters to Santa were published in local newspapers. In 1936, Penny's in Tupelo created Toyland, where a "Carnival of Joy Bushels of Toys for Boys and Girls" beckoned. The analysis of Leigh Eric Schmidt, the widely published cultural historian, essayist and reviewer, was that the main factors in the modern Christmas were domestication, Christianization and commercialization.[351]

In September 1935, Roosevelt wrote to the nation's clergy requesting their opinions on the New Deal. Among Mississippi clergy, 92 percent responded more positively than negatively, with only 4 percent being opposed to the programs. One Mississippi rabbi referred to Social Security as being "drawn up in the spirit of Israel's ancient prophets, those eloquent and fearless protagonists of social justice and righteousness." White Methodist editor D.B. Raulins commended the National Recovery Administration's regulation of hours and wages of workers, as it made provisions for the workers' right to unionize and put people to work on

infrastructure projects, actions "for which the Christian church has been contending for a quarter of a century."[352]

Black clergy also responded, but cautiously, because programs offered to African Americans had been limited. Many white clergy claimed the New Deal reduced local whites' control over the wages and opportunities of African Americans, which, in turn, threatened the segregation the whites and white clergy fought so hard to maintain. Roosevelt had prohibited explicit racial discrimination, and black clergy fought to ensure benefits to black Mississippians. One black minister replied in support of Social Security, "providing this Act is carried out with an equally divided share to all poverty stricken American citizens, regardless of race or color." Contrary to this caveat, congressmen in the South made sure Social Security did not apply to agricultural or domestic workers, jobs mostly held by African Americans.[353]

IN THEIR OWN WORDS

In a Mississippi Moments interview, Mr. F.L. Mills of New Augusta said he was the son of a yeoman farmer during the Great Depression and often had to wear hand-me-down shoes and play with homemade toys. Somehow, his family managed to get F.L. and his siblings new clothes and shoes for Easter and a few gifts for Christmas. The rest of the year, they wore hand-me-downs.

To make his worn shoes last another year, F.L. explained how he bought a piece of rubber, glued it onto the bottom of his shoe and then set a weight on top; by morning, the rubber held fast. Using his knife, he carved the rubber to the shape of his shoe. F.L.'s father worked for a relief program and made sure his neighbors had food to eat. It was Mr. Mills's job to interview people who wanted to receive relief, and F.L. often went with him. "We never had any money but we never went hungry. But I saw many people who were hungry. Families after families, hungry and starving."

Mr. Mills visited families who had cane syrup and sweet potatoes and told them that some people didn't have anything. They would give Mr. Mills cane syrup and sweet potatoes so he could distribute them to those who had no food. "I saw children so hungry that they would eat raw sweet potato," said F.L.

F.L. remembered a family member with a new baby, but she didn't have enough milk to feed the baby. The infant became very sick. "My daddy took the baby to the doctor and the doctor said the baby was starving to death."

Mr. Mills knew a woman who had just had a baby, and she had plenty of milk. For three months, twice a day, Mr. Mills took the baby to this mother to be fed.

F.L.'s father died when he was ten years old. His family lost the place because it had been mortgaged during the Depression. At the age of sixteen, F.L. ran away to work with the CCC for thirty dollars a month.

Mrs. Susie W. Walker, age seventy, was a former staff member of Jackson State University. At the time of the Great Depression, she lived in both Canton and Jackson. The following is an excerpt taken from Mrs. Walker's interview on November 16, 1977:

I know things were hard all over because we were always hearing about banks going out of business. However, the two banks in Canton, the First National bank and the Canton Exchange Bank never closed. Some of the people had money in the bank, but we were not that fortunate. We had no bank account. A couple of years into the Depression, my husband was laid off for a while. . . . To get the food, my husband had to go down and stand in line until his turn came. Sometimes he had to stand in line for hours. He usually came home with meal, grits, salt pork and cheese. We also had a little garden where we raised okra, greens, corn, tomatoes and cucumbers. Along with this we raised a few chickens and pigs. When we moved to Canton just as the Depression was starting, we bought a four-room house which cost us about one thousand dollars. As the Depression got worse, it got hard and harder to pay the house notes. We had very little money, so we very seldom went to the store to buy food or clothes. We ate the food from our garden and the food that we got from the commodity house. Whenever we did buy new clothes, we ordered them from the Sears-Roebuck catalogue. In those days, we could get shoes for a dollar or two. Everything was very cheap. Most of the people in our neighborhood didn't know how the Depression started or who was to blame. . . . Since we didn't vote, we didn't have any reason to think about politics. Before the Depression really got hard, we weren't doing too bad. We would get up in the morning and we would usually have salt pork, biscuits and syrup for breakfast. In the evening, we might have something like greens, salt pork, potatoes and cornbread. We ate quite a bit of rough stew meat and neckbones in those days, too. It was a frightening time. A lot of people didn't know where the next meal was coming from. For us the worse time came in 1931 when my husband was laid off. At that time, we had no money coming into the house at all. I know that it was 1931 because my daughter was born that year. She

was delivered by a midwife who charged us twenty-five dollars and stayed with me nine days after the baby was born. I couldn't even produce breast milk for the baby because we weren't getting enough to eat. We were given two cans of condensed milk for the baby each week, which I watered down and stretched as far as I could. At one time, we were forced to feed the baby mashed greens in water. I thought my child was going to be damaged for life.

The following are from letters written by African Americans in Mississippi during the Depression, from *Down and Out in the Great Depression*, edited by Robert S. McElvaine. These letters expose the neglect of educational opportunities in reading and writing and other studies for African Americans in Mississippi. But, as evidenced below, African Americans did the best they could to tell of their plights during the Depression.[354]

Picayune, Mississippi
September 3, 1935

Dear Sir:
I am ritening you a few Lines to Let you no how they are treating we colored people on this releaf. I went up to our home Vister and replied for some Thing to do and Some Thing to eat and She told me that she has nothing for me at all the they give all the worke to White people and give us nothing an Sir I wont you to no how we are treated here.
So please help us if you can.

Anonymous

⊞ ⊞ ⊞

Tupelo. Miss.
Feb. 4, 1935

Im about to ask you A Question that I hate to trouble you with. But Ive tired hard to get by With out any assistance but Ive Nearly got to road end. I Just Cant make my way as I will explain. Now Mr. President I owe Several Squires an colector To me every week. I hate not to pay them but I Just can not. Ive a Job, but owing from 8 to 12 different ones It make it difficult To pay be Sides the fuel food House rent That has to be paid each week an fuel

each Time it is order Then Mr. president the food is a Necessity We have to have that to keep going on our Jobs. Every thing is very high in Tupelo but Im thankful To have a job....I have tried to borrow money from the white people here and they say they have not got any money. So I cannot get help from them as I used to....My bill Totals $150.00 that is for The Thing to put every cent to good use please help me in the Name of the lord and I will pay you back. I have not got any thing for Security but my honor if you will Trust me. Thank you.

A Colored friend down in Tupelo, Miss G.T.
General delivery

P.S. please answer direct to me

<center>▣ ▣ ▣</center>

May 1936
Hattiesburg Miss

Mr. Presedent Sir We are starving in Hattiesburg we poor White's + Negrows too I wish you could See the poor hungry and naket half clad's at the relief office an is turned away With tears in their eyes Mississippi is made her own laws an don't treat her estuted as her Pres. Has laid the plans for us to live if the legislators would do as our good Pres. Has Said What few days we have here we could be happy in our last old days both old white + Colard.

Cencerely looking for our old age pension's an will thank you they has made us Sighn for $3.00 a Month Cant live at that

[Anonymous]

<center>▣ ▣ ▣</center>

Vicksburg, Miss
9-22-35

President Theo D. Rosevelt U.S.A.

Gentlemen: I think you Should invistigate this matter your Self. The way they are treating the Darkies here is A Shame. They wont give them food nor Cloths nor Work to do. When they ask for Any thing they drive them away as they were dogs. They wont even let them talk to the head man here.... And its more than 200 Darkies in groups Standing on the Road each day. Begging for food and Cloths....The Darkies in Flooded District are not able to pay they Taxes and they wont let them make enough to pay them. And I Judge the Relief Workers are taking all of the Poor Darkies Money and buying fine cars.

[Anonymous]

Mississippi congressman William H. Colmer, who took his seat in 1933, also received many letters from Mississippians. Here are a select few from Kenneth G. McCarty's "Depression and Hard Times in Mississippi: Letters from the William M. Colmer Papers," on the Mississippi History Now website, said collection available at the William D. McCain Library at the University of Southern Mississippi.[355]

June 25, 1934
Hon Bill Colmer

Dear Sir:

I am writing you a few lines to see if you could use your influence in getting a little relief for me and my family some way Im a disabeled veteran had my pension cut out last July and since then have had no work at all to speak of and no relief what ever since Jan of this year I have a wife daughter and an aged invalid mother that had been sick with perlegra for the past 3 years and hasent been able to get any relief since last Sept or any attention from a Dr or any medicine and Mr. Colmer we are absolutely up against it we are all naked and are actually on starvation and cant seem to do a thing about it we have appealed to the local relief agent time after time with out avail and if we dont get help soon it will be too late there isnt any

jobs to be had around here any way Im not able to do hard labor as I have my hospital records showing I have leakage of the heart a dislocated hop traumatism Pheumatic fever and several other things the matter I served one year 5 months and 28 days in the service as inlisted man and now that is the appreciation shown me here on sufference and cant get help from any source tried to catch and sell fish but had to quit that as you cant sell fish without a license which cost $5.25 and I havent it.

My poor old mother is in a bad way and Miss Clark our local agent wont even talk to her because she lives here with me and knowing too that we havent a thing she is also a voter and none of the men she voted for seem to be the least interested in her now so if you could use your influence in getting help for us we surely would appreciate it and thank you a thousand times

Yours Resptfully
W.F.G.
Merrill Miss

◘ ◘ ◘

Aug 14, 1934
My dear Congressman and friend.

From our past relations and as your files will show that you have previously handled correspondence for me. As I am a disabled soldier not drawing anything as a traveling preacher, that preaches somewhere in your district, and constantly meeting your friends and those who you want as your friends.
Being a traveling preacher and depending on free will collections and you know there is no money. I need to be rigged out with some clothes from hat to shoes. Being a traveler more than likely rules me out of local relief. But I should receive help someway or another. Perhaps through the Travelers aid Transit Bureau. But I need influence and that is why I am coming to you to cut througfh the red tape and get something done for me, as the millions are being spent for the needy. I am a needy preacher. Do not need lodging or transportation only need a few clothes and need them quick.

Hat 7 1/8
Shoes 11 width c or d. Black shoes not low quarters.
Shirt 18
Underwear (Summer)
Shirts 40
Drawers 43. 42
Inseam 28
Coat
Chest 40
Back length 29½
Arm from shoulder bended arm to wrist 33.
Please do what you can to get action for me Mister Bill. And if you can as a personal favor and gift contribution to God's cause at this time would appreciate a personal check from you of any small donation for even just a dollar or two. God will richly bless and reward you.

Always your friend,
B.R.
Route 1
Moselle, Mississippi

□ □ □

11/15/1935

Hon. Wm Colmer,
Pascagoula, Miss.

Dear Sir.

Am asking you for some assistance please. I am a citizen of Harrison co. 25 year. I Have 5 children the wife being dead 6 years. and I havent worked but 41 Hours since the month of May. was cut off the Relief last November and I have been trying to get a Relief card for four months. Have bin promised a card However for four months. but on the strength of those promises my things have been put out of the House and my children are any place I can keep them now. And these people in this beauro refuse to do anything. so if you have any idea you could bring about an investigation as

to why my little children should suffer Why I would apprecieate it. I have strived to keep them this long and I hate like hell to have to part from them. Thanking you in advance for any countesy shown an servicibly your Resp

D.E.P. Gen Del
Gulfport Miss

◫ ◫ ◫

Jan 14, 1936
Mr. Bill Colmer;
Washington D.C.

Dear friend:

I am writting you a few words inreguards of you sending me enough money to pay me and my wifes poll taxes. you no How I always stood 100 Per Cent for you. So now if I dont get my taxes paid we cant vote. So send me the money at once which will be $4.00. you see our taxes has got to be paid by the first of [February] *you no we have a hard time they are 5 of us in family I dont owne a cow a house are nothing. my wages only pay me $20.00 per month and this dont feed us. We need clothes and cant get them. So you see I am not able to pay my Taxes my children is going to school with out books.*
So send me the money to pay our taxes so we can vote for you.

J.S.M.

P.S. I also have to pay house rent.

◫ ◫ ◫

Oct. 22, 1937

Dear Mr. Colmer,

Im writing you a few lines, begging you to help me and my family. My wife and I walked and voted for you. Now Im old, and crippled with Rheumatism I have a wife suffering with a Goitre and neuritis. Have 2 sweet little girls I want to educate but without help all will be in vain. I am 64 years old be 65 in Jan. and Im not able to work and support my family. Would to God you men up at Washington would take pity on us poor old farmers who has worked and tryed all our lives just for a scant living, would get busy and help us all by giving us an old age pension of from $15.00 or even $30.00 per month. We are not going to live long. And God knows we outht to share some conforts and pleasure in our last days. If we could draw a few dollars a month to buy medicine and some good things to eat and some decent clothes to wear. It would be a blessing so please Mr. Colmer please do every thing in your power to pass the old age pension, right now. And I hope it will be passed from 55 years to one need of a pension. Write me right back you promise and when can I draw a pension. My wife and myself and 2 girls made 8 bales of cotton, but every bit of it went to the man that we rented from so theres the way things go somedays I would almost fall in the field at my plowhandles. Don't you think I've worked long enough.

Hoping to hear from you at once
Your friend Respt. E.B.
P.S. there is a poor old lady lives near me. Mrs M.S. age 82 years don't get any pension or relief. So I hope you will write her. If you can get a pension for her, poor old thing has reared 7 children and several of them is in need also, so if you could get a pension for her I would make the poor old soul happy and she could bey her some fruit and eats that would make her happy and probably prolong her life. She voted for you to, so write her and make her happy in her last days
Thanking you for anything you can do for us all
her name
Mrs. M.S.
Newhebron, Miss
Route 1.
Magee Miss.

□ □ □

June 12, 1937
Hon. Bill Colmer MC
Washington, D.C.
Dear Mr. Colmer,

First I want to thank you for the stand you took in trying to secure an old age pension. If all the people concerned would see us old people as we really are I believe it would go thru without any conflict.

Old people like myself are just hanging over the deep chasm by a slender thread.

We have no income, no means of support, the only thing we can do is just sit and wait around like a poor off casted dog just take what crumbs fall from the other fellows table and as you know now these are so few.

We old people who live between wars seem to be a neglected people. We too are just as brave as those who went to war. We have fought our battles too but not on the bloody battlefield as our brothers but we are here and have done our best to carry on.

I am old and sick. My wife is most past the years of work too so what are we to do. We can not get help from any source they tell me they have nothing for me. I ask for help on old age assistance in my county [Stone] and I was turned away.

I am your friend and my people are your friends. When you started the trip to our capital I helped you on the way. Can you do any thing for a tried and true friend in need.

P.S.
C/0 Mrs. V. S.
Rt. 4
Lumberton, Miss.
Newhebron, Miss R 1.

▣ ▣ ▣

July 7, 1938

Mr. Wm.(Bill) Colmer
Washington D.C.

Dear Sir;

The first time I heard you Speak was at Sanford Miss. when you first ran for the office you now aspire at a W.O.E. picnic they were only a few stayed in the house to hear you and your opponent speak, but I was instered so I was one of the few that stayed and was very much impressed with your speach, so I have suported you from that day untill this.

Since 34 I have had nothign but bad luck, I lost a 6 year old girl in that year had two opperations and in, 36 had another opperation and big Dr's bills beside all this and lost my home by fire. During all this time I have had no work, only what I got out of my little farm. I have tried from every sourse to get work but have not gotten any It seems that you can-not get on the W.P.A. in our district if you have every worked, if you do you have to sign up you haven't every done anything and dont expect to and you can get work. I can't sign up like that. No longer than this after noon some of my good friends in Ellisville were trying to get me to help to remove you from your office.

Listen this is what I am striking at. if you will help me to get a Job I will still suport you as I have in the past, but if not I will help the other man to get the office.

I am 39 yrs. old and in good health can do most amy kind of work. so if you can help me to get work please let me hear from you at an early date.

Respectifuly
S. V.O.
Ellisville, Miss R. 3

◫ ◫ ◫

Ellisville Miss
Oct 14, 1939

Hon. Wm. M. Colmer,

Dear Sir:

I'm writing to you to try to get some kind of relief. I am in that rainly section of George County Miss. where there was not but little made. I did not make but just a little cotton and not enough corn to feed my team until plow time. My place is in debt. I borrow money to make this crop. I did not make enought to live on much less pay any of my debt. I have one arm broken and can only use it just a little. I got my leg broke in Jan. 1939. that cause me to have to have to harrow all my crop work.

I have never been able to get any relief or work on W.P.A. for I am not able to do any work by the day. I never done nothing but farm. If we farmers in George Co. dont get some kind of relief from the Government we cant live much less farm. I hope and trust you do all you can.

Your Truly
W.L.G.

◻ ◻ ◻

Sumrall Miss
Feb 3, 1944

Hon Wm M. Colmer, Washington, D.C.

Dear Mr Colmer,

I saw in the Biloxi Daily Herald *of Feb 1st where you was appointed Chairman of a committee for post war organization* [House Special Committee on Postwar Economic Policy and Planning]. *I hope that you and your committee will bring the country back to a better condition for the old people. Many who like myself have suffered much by this war.*

I am 81 years old. I have to live by myself as I have no one to help me. I have to pay $11.00 a month for a place to stay. And I only get a small pension of $9.00 a month. I have been sick since the first of December, and I have been crippled in my feet for several months. My right leg and foot is swelled much larger than my left. It hurts me to walk. I am not able to make enough to live on in my present condition. If you committee really wants to do any good, why no sign the petition to bring the Townsend Bill HR 1649 to the floor for a discussion and a vote. It is the only post war plan that will do any good. By allowing the old people 60 years old and past a good pension, that will retire them from work. To be spent every 30 days will give the work to the younger people. I don't see that any Congressman from Mississippi has signed the petition yet. Why not take the lead in doing so? All Congressmen from Florida have signed it. Many of us old people have voted for you, so that you have a good office in Washington, why not do something to help us.

The Townsend movement is a Christian movement. If the people of this country would all learn to co-operate together as the most of them have in this war. By doing so in time of peace, we would have the most prosperous country in the world. It would create so much wealth that none would have to live in poverty any more.

Yours truly
C.A.P.
441 Magnolia Street

☒ ☒ ☒

Jan 21, 1936

Bill Colmer:
Washington D.C.

Dear friend:

I am writing you a few lines to let you no I am in distress. I have been trying a long time to get some work. But when I ask for work they only put me off. I dont feel like I can stand this much longer. I am so worried until I am sick.

But I have bad health. Here I am with three children, and they are necked for clothes, and have had to go to school all this term with out books are tablets are pencil. My husband only draws $20.00 per month, and we have to pay house rent, and buy my wood and ever thing I eat and wear out of that, and I have to pay for my furniture. I owe Woodruff Furniture Stores Hattiesburg Miss and Kirtwood Furniture Co, Hattiesburg so it looks like I am going to loose my stove and all my beds I even have to buy medicine. So now is a time for a friend in need, is a friend indeed. So I want you to send me $10.00 to buy me and my children some clothes, and I want you to help me get some work through that W.P.A., for if I dont get some work and some help right away I dont see no way for us to pull through. So now I have always been your friend and all my folks. So now be sure and send me some money I havent got no body to help me. this is from my heart. awaiting an early reply.

Your friend
E.M.

✠ ✠ ✠

Congress of the United States
January 23, 1936 Dr. Wayne Alliston
Works Progress Administration
Jackson, Mississippi.

Dear Dr. Alliston:

I am writing you in the interest of a constituent and friend of mine, Mrs. E.M. of New Augusta, Mississippi, who needs employment very badly.

Mrs. M. is the wife of a disabled veteran, who only draws a very small amount of compensation, and as they have three small children to support, it is imperative that she find something to do immediately. I understand that they are not getting the bare necessities of life, and I sincerely hope that you may be able to assist her in some capacity.

Thanking you, I am

Sincerely yours, William M. Colmer

In the 1930s, the federal government, through the WPA, organized the efforts to preserve cultural traditions and the lives and experiences of the ordinary American through sound recordings, photographs and manuscripts. This included former slaves.[356] In 1937, estimates show that around 20,000 former slaves were still alive and living in Mississippi. Noted in WPA material were 560, and of that number, 450 were interviewed for the WPA Slave Narratives. Evaluators of the narratives described those from Mississippi as being "colorful, interesting and most of them rich in description and color regarding slavery, plantation life and the Civil War." When evaluating these narratives, readers must also understand the harsh Jim Crow codes of the South, especially in Mississippi, and that most interviews of slaves were done by white women. Scholar Kenneth Stamp determined that 7 percent of the slaves interviewed by whites remembered slavery as harsh and cruel as compared to the 25 percent interviewed by blacks. In the North, 38 percent recalled slavery as being brutal as compared to 16 percent in the South.[357] Another consideration are the times, the Great Depression, and the severe hardships for everyone in Mississippi, especially African Americans, who, though freed from slavery, were forced into another kind of slavery still tied to the cotton fields. They continued to be forced to submit in labor and living, in an almost worshipful way, to the entire white community, as if freedom had only given them many more masters.

WPA transcribers wrote in misspelled dialect. Though I have not changed what former slaves said or the way they said it, I chose not to misspell the words the slaves used.

Anna Baker, a 90-year-old slave in Aberdeen—I don't recollect what my ma's mammy and pappy was named, but I know that her pappy was a full-blooded Indian. (I guess that is where I get my brown hair.) Her mammy was a full-blooded African though, a great big woman. I recollect a tale my mammy told me about my grandpa. When he took up with my grand-mammy, the white man what owned her say, "If you want to stay with her I'll give you a home if you'll work for me like the Niggers do." He agreed because he thought a heap of his black woman. (That's what he called her.) Everything was all right until one of them uppity overseers tried to get smart. He say he going to beat him. My grand-pappy wen' home that night and barred the door. When the overseer and some of his friends came after him, he say he ain't going to open that door....Whilst they was breaking, he filled a shovel full of red hot coals and when they come he throwed it on them. Whilst they were hollering, he run away. He ain't never been seen again to this good day.[358]

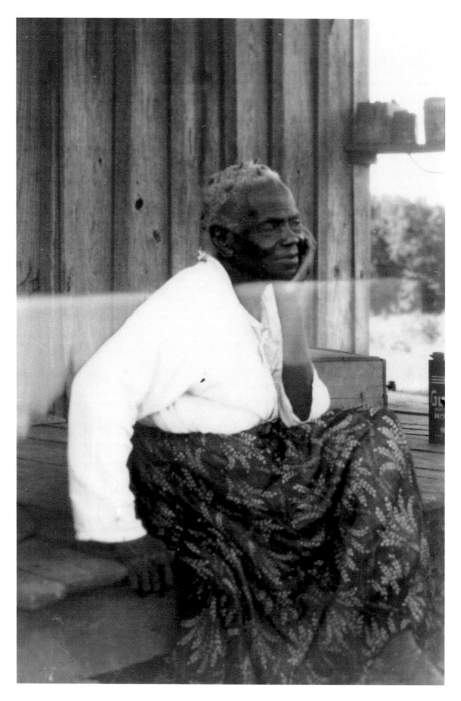

Molly Williams, an eighty-four-year-old freed slave from Mississippi, circa 1937–38. *Library of Congress.*

John Cameron, born 1842, Jackson—My old master was the best man in the world. I just wish I could tell, and make it plain, just how good him and old missus was. Master was a rich man. He owned about 1,500 acres of land and around one hundred slaves. Master's big two-story white house with lightning rods standing all about on the roof set on top of the hill. The slave cabins across a valley from the big house was built in rows. Us was allowed to sing, play the diffles and have a good time. Us had plenty to eat and warm clothes and shoes in the winter time. The cabins was kept in good shape. Us ain't never mind working for old master, cause us got good returns. That meant good living and being took care of right. Master always fed his slaves in the big house.[359]

Charlie Davenport, around one hundred years old, Natchez—Aventine, where I was born and bred, was across Second Creek. It was a big plantation with about one hundred head of folks living on it. It was only one of the master's place, because he was one of the richest and highest quality gentlemen in the whole country. I'm telling you the truth, us didn't belong to no white trash. The master was the Honorable Mister Gabriel Shields himself. Everybody knowed about him. He married a Surget. The Surgets was pretty devilish, for all they were the richest family in the land. They was the out-fightingest, out-cussingnest, faster-riding, hardest drinking, out-spendingnest folks I ever seen. But Lord, Lord, they was gentlemen even in their cups. The ladies was beautiful with big black eyes and soft white hands, but they was high strung, too.[360]

Berry Smith, around 107 years old, Forest—I was born a slave to Old Master Jim Harper and I fell to Master Bob. Master Jim bought my pa and ma from a man by the name of Smith, and Pa kept the name. That's how come I is Berry Smith. They didn't have no schools for us and didn't teach us nothing but work. The bull-whip and the paddle was all the teaching we got. The white preachers used to preach to the niggers sometimes in the white folks' church, but I didn't go much....A heap of white folk was good to their niggers, just as good as they could be, but a heap of them was mean, too. My missus was good to us and so was Master Jim Harper. He wouldn't let the boys abuse us while he lived, but when he died they was wild and cruel. They was hard taskmasters. We was fed good three times a day, but we whipped too much. That got me. I couldn't stand it. The old master give us good dinners at Christmas, but the young ones stopped all that.[361]

Belle Caruthers, age ninety, Marshall County—The overseer was nothing, just common white trash. If the niggers didn't get to the field by daylight, he would beat them. But he didn't put them in jail because he wanted them to work. And we worked all day Saturday. And my but we were afraid of the patterollers. They marched about the country and whenever they found a nigger belonging to one man on another man's plantation, they punished him hard.[362]

Calline Brown, age unknown, Coahoma County—Them was terrible days. My master and miss was the meanest folks what ever lived. They wasn't nothing but poor white trash what had never had nothing in their lives....It sure was pitiful the way things went them days....We worked daylight to dark, but there wasn't no such thing as satisfying Master or Missus. We never knew when we were going to be whipped. Even after Master got so crippled he couldn't walk, he would call us to him and strike us with his crutch.[363]

Nettie Henry, age eighty-two, Meridian—Me and my mammy and my sister, Liza and Tempe, was give to Miss Lizzie. I ain't no country nigger. I was raised in town. My mammy cooked and washed and ironed and done everything for Miss Lizzie. She live right where Miss Annie—she was Miss Lizzie's daughter—live now. But then the house face Eighth Street instead of Seventh Street like it do now. They warn't any other houses in that block....My pappy didn't go with us to Meridian. He belonged to one set of white people, you see, and my mammy belonged to another....But after the war he come back to us us, walked 'most all the way from Texas. He rented some land from Mr. Ragsdale. My pappy built us a shack on that land....I was ten years old at the surrender, but I took notice. Them was scary times and when you is scared you take trigger notice. It was next to the last year of the war 'fore Sherman got to Meridian—not Sherman hisself but soldier. They burnt up that big house on Eighth Street hill and built camps for the soldiers in the flower garden.[364]

CONCLUSION

With the attack on Pearl Harbor the morning of December 7, 1941, America proclaimed war.

Camp Shelby (Hattiesburg) had been deactivated in 1919, but in 1940, it was again designated a training camp. Construction started at the base in 1941, employing over twelve thousand people. Upon completion, the camp trained approximately fifty thousand troops at a time, and as many as thirty thousand military and nonmilitary personnel worked on base. That year, Keesler Field in Biloxi was constructed and grew to be the largest air base in the world, with a military population of sixty-nine thousand. Ingalls Shipyard became the largest industrial employer during the World War II era, employing over twelve thousand men and women to build ships. Mississippi's first ammunition plant was built in Flora, and a larger artillery plant in Prairie took up 6,200 acres. Over seven thousand workers constructed an estimated three hundred buildings at the site.[365]

Establishing thirty-six military camps in Mississippi boosted the economy by bringing into the state over one million men and women from around the country. Mississippi had four prisoner-of-war base camps, and airfields were in Starkville, Jackson, Clarksdale, Hattiesburg, Greenville, Columbus, Greenwood, Laurel, Grenada, Gulfport, Madison and Meridian.[366]

During the 1940s, the rural farm population in Mississippi decreased by 19 percent and increased 38 percent in urban areas. Along with Mississippi's increased population came new demands on towns and cities to provide enough schools, police and fire departments and adequate water and sewer

Soldier from West Virginia at Camp Shelby, 1941. *Library of Congress.*

systems and roadways. With additional employment opportunities and more consumers living in the state, small businesses confronting shortages in raw materials caused by war found it impossible to maintain normal production and had to close.[367]

In 1942, the War Manpower Commission (WMC) provided funds for Mississippi farm workers to take on temporary wartime jobs between planting crops and harvest time. Fretting plantation owners believed this would cause a labor shortage, especially in their low-wage workers, and adversely affect the social order between whites and blacks. These plantation owners dominating Mississippi's political arena achieved the passage of a law to move control of farm labor to the U.S. Department of Agriculture, which could be handled at the state level. With the federal agency out of the way, landowners expanded control of the local draft boards. Yet the drive to serve America and be American had already begun. Thousands of agricultural workers joined the military and found higher-paying industrial jobs.[368]

And the fear of the planters came true. Men and women of color returning from war did change. An American soldier cannot fight for freedom on foreign land and not fight for that same freedom in their homeland. Many more treacherous years and lives would be sacrificed

for that freedom. Being American has nothing to do with race, religion, ethnicity or political party. From *Brown v. Board of Education* to the civil rights movement, the human spirit cannot be forever dominated and controlled—for there is power in the spirit.

The Great Migration from the Jim Crow South that began centuries earlier began reversing in the twenty-first century. In Chicago, Charlie Cox was retiring after thirty-five years at General Motors. He wanted to go home to West Point, Mississippi. His family had moved north when Charlie was nine years old, but Charlie explained in a *Christian Science Monitor* interview that "his heart had never quite followed and his spirit yearned for the South." Charlie's wife, Darlene, was hesitant, because her roots were in Chicago and her ancestors had toiled as slaves in Tunica, Mississippi.[369]

But maybe they understood that the fields, hills, plains and coastal areas of Mississippi had been just as helpless in the grips of natural disasters, economic calamities and the ravenous greed that stripped its pines, oaks, maples and soil.

It takes decades, even centuries, to mend a land and the souls so deeply battered and scarred. Though the spirit is bruised and even crushed, it cannot be destroyed, cannot be stolen and cannot be owned. With each blow it becomes stronger, aching to survive, determined to thrive. Many who

Mexican children carrying water during cotton-picking season, 1939. *Library of Congress.*

left return to their Mississippi roots because their sweat is still in the once neglected, depleted soil. Many forgive its past because they are its past and the desire for home is like the spirit—it never dies. Their spirits long for its spirit rumbling beneath the soil, deep within its eternal soul.

Charlie and Darlene Cox retired to West Point to relax but also to work within their community and church to make Mississippi a better place—for everyone.[370]

NOTES

Chapter 1

1. McElvaine, *Great Depression*, 27–28.
2. C. Nelson, "About the Great Depression," Modern American Poetry, http://www.english.illinois.edu/maps/depression/about.htm.
3. Charles C. Bolton, "Farmers Without Land: The Plight of White Tenant Farmers and Sharecroppers," Mississippi History Now, last modified March 2004, http://www.mshistorynow.mdah.ms.gov/articles/228/farmers-without-land-the-plight-of-white-tenant-farmers-and-sharecroppers.
4. Wilson and Ferris, *Encyclopedia of Southern Culture*, 29–31.
5. Ibid.
6. "Mississippi River Facts," National Park Service, https://www.nps.gov/miss/riverfacts.htm.
7. Barry, *Rising Tide*, 175–76.
8. W.P. Nowell, "The Flood of 1927 and Its Impact in Greenville, Mississippi," Mississippi History Now, last modified March 2006, http://mshistorynow.mdah.state.ms.us/articles/230/the-flood-of-1927-and-its-impact-in-greenville-mississippi.
9. Ibid.
10. Ibid.
11. Barry, *Rising Tide*, 304.
12. Ibid., 306.
13. Ibid., 302.
14. Mitchell, *New History of Mississippi*, 301–5.

15. Barry, *Rising Tide*, 312.
16. Nowell, "Flood of 1927."
17. Cobb, *Most Southern Place*, 123.
18. Barry, *Rising Tide*, 312.
19. Betty Jo Harris, "The Flood of 1927 and the Great Depression: Two Delta Disasters," Folklife in Louisiana, http://www.louisianafolklife.org/LT/Articles_Essays/DeltaDepression.html.
20. Ibid.
21. Barry, *Rising Tide*.
22. Harris, "Two Delta Disasters."
23. Ibid.
24. Ibid.
25. Nowell, "Flood of 1927."
26. Cobb, *Most Southern Place*, 123.
27. P.L. Brown, "When the Levee Breaks (All Things Considered)," interview by Michelle Norris, NPR, May 18, 2011.
28. Cobb, *Most Southern Place*.
29. Nowell, "Flood of 1927."
30. Wright, *12 Million Black Voices*, 93.
31. Hoyt, *Droughts of 1930 and 1934*.
32. Coe, *Square Meal*, 104.
33. Fickle, *Mississippi Forests and Forestry*, 57.
34. Tony Howe, "Growth of the Lumber Industry, (1840 to 1930)," Mississippi History Now, last modified May 2001, http://mshistorynow.mdah.state.ms.us/articles/171/growth-of-the-lumber-industry-1840-to-%091930.
35. Fickle, *Timber*, 15.
36. Fickle, *Mississippi Forests and Forestry*,133.
37. Howe, "Growth of the Lumber Industry."
38. Ibid.
39. Fickle, *Mississippi Forests and Forestry*, 113–14.
40. Ibid.
41. King, "Long-Bell Lumber Company."
42. Fickle, *Mississippi Forests and Forestry*, 114.
43. Fickle, *Timber*, 69.
44. Howe, "Growth of the Lumber Industry."
45. Fickle, *Mississippi Forests and Forestry*, 117–19.

Chapter 2

46. Wheelock, *Regulation*.
47. Kelly Martin, "What Was the Great Depression?," American History, last modified June 13, 2017, http://americanhistory.about.com/od/greatdepression/a/facts_great_dep.htm.
48. Wynne, *Mississippi*, 112.
49. Ibid., 113.
50. Cobb, *Most Southern Place*, 185.
51. B.O. Sperry, "Walter Sillers and His Fifty Years Inside Mississippi Politics," Mississippi History Now, last modified November 2010, http://mshistorynow.mdah.state.ms.us/articles/356/walter-sillers-and-his-fifty-years-inside-mississippi-politics.
52. Cobb, *Most Southern Place*, 185.
53. Wright, *12 Million Black Voices*, vii.
54. Sonia Benson, "Sharecropping and Tenant Farming," US History in Context, http://ic.galegroup.com/ic/uhic/ReferenceDetailsPage/ReferenceDetailsWindow?zid=de00f766cfb0b9313f5771bdcb26fa2d&action=2&catId=&documentId=GALE%7CCX3048900548&userGroupName=mlin_m_fadayms&jsid=65f6acb4944bf70d42db0e37bc6f0087.
55. Wilson and Ferris, *Encyclopedia of Southern Culture*, 29–31.
56. Wright, *12 Million Black Voices*, 38.
57. Wilson and Ferris, *Encyclopedia of Southern Culture*, 31.
58. Ownby, *American Dreams*, 79.
59. Mitchell, *New History of Mississippi*, 329.
60. Jeff Wallenfeldt, David G. Sansing and John N. Burrus, "Mississippi," *Encyclopaedia Brittanica Online*, last modified June 4, 2017, https://www.britannica.com/place/Mississippi-state.
61. Isenberg, *White Trash*, 217.
62. Mitchell, *New History of Mississippi*, 229.
63. "Delta and Pine Land Company," Sunflower Plantation, http://www.sunflowerplantation.org/delta--pine-land-company.html.
64. Cobb, *Most Southern Place*, 153.
65. Richard Wormser, "The Great Depression: 1929–1939," PBS, last modified 2002, http://www.pbs.org/wnet/jimcrow/stories_events_depression.html.
66. Cobb, *Most Southern Place*, 154.
67. Gordon, "Southern Trauma."
68. Ownby, *American Dreams*, 95.

69. Ibid., 100.

70. Ibid.

71. Ibid., 104–5.

72. Ibid.

73. K.G. McCarty, "Depression and Hard Times in Mississippi: Letters from the William M. Colmer Papers," Mississippi History Now, last modified December 2010, http://www.mshistorynow.mdah.ms.gov/articles/221/depression-and-hard-times-in-mississippi-letters-from-the-william-m-colmer-papers.

74. Mitchell, *New History of Mississippi*, 337.

75. "The Timber Industry in the Great Depression. Meridian," oral history, Lauderdale County Deparment of Archives and History, Meridian.

76. Mitchell, *New History of Mississippi*, 337–38.

77. Fickle, *Mississippi Forests and Forestry*, 136.

78. Ibid., 135.

79. Mitchell, *New History of Mississippi*, 340–41.

80. Fickle, *Mississippi Forests and Forestry*, 137–38.

81. Putnam, *Lauderdale County*, 110–11.

82. Ibid.

83. Margo, *Race and Schooling*.

84. "Mound Bayou History," Mound Bayou Movement, http://moundbayoumovement.org/assets/history.pdf.

85. Jung, *Chopsticks*, 160–62.

86. Ibid., 42–43.

87. Morris, *Hattiesburg, Mississippi*, 116–22.

88. Ibid., 123.

89. Putnam, *Lauderdale County*, 108–9.

90. Mitchell, *Rich Past, Vibrant Future*, 15, 49.

91. "Showplace of the South," Temple Theatre for the Performing Arts, http://meridiantempletheater.com.

92. Mitchell, *Rich Past, Vibrant Future*, 59–61.

93. Ibid., 70–71.

94. Ibid., 71–72.

95. Putnam, *Lauderdale County*, 100–3.

96. McElvaine, *WPA Guide*, 231.

97. Ibid., 213–14.

98. Stubbs, *Mississippi's Giant Houseparty*.

99. McElvaine, *WPA Guide*, 168.

100. D.S. Nuwer, "The Seafood Industry in Biloxi: Its Early History, 1848–1930," *Mississippi History Now*, last modified June 2006, http://www.mshistorynow.mdah.ms.gov/articles/209/the-seafood-industry-in-biloxi-its-early-history-1848-1930.

101. McElvaine, *WPA Guide*, 169.

102. Ibid., 197–98.

103. Narvell Strickland, "A History of Cotton Mills and the Industrial Revolution," last modified February 6, 2007, http://narvellstrickland1.tripod.com/cottonmillhistory2/index1.html.

104. Ibid.

105. Ibid.

106. McElvaine, *WPA Guide*, 237–38.

107. Strickland, "History of Cotton Mills."

108. Ibid.

109. Ibid.

110. David G. Sansing, "Martin Sennett (Mike) Conner: Forty-Fourth Governor of Mississippi: 1932–1936," *Mississippi History Now*, last modified January 2004, http://www.mshistorynow.mdah.ms.gov/articles/265/index.php?s=extra&id=144.

111. C. Lester, "Economic Development in the 1930s: Balance Agriculture with Industry," *Mississippi History Now*, last modified May 2004, http://mshistorynow.mdah.state.ms.us/articles/224/economic-development-in-the-1930s-balance-agriculture-with-industry.

112. Ibid.

113. D.S. Nuwer, "Shipbuilding Along the Mississippi Gulf Coast," *Mississippi History Now*, last modified 2010, http://www.mshistorynow.mdah.ms.gov/articles/351/shipbuilding-along-the-mississippi-gulf-coast.

114. T. Sanders, "Architecture in Mississippi During the 20th Century," *Mississippi History Now*, last modified January 2010, http://www.mshistorynow.mdah.ms.gov/articles/331/architecture-in-mississippi-during-the-20th-century.

115. McElvaine, *WPA Guide*, 91–92, 118–28.

Chapter 3

116. Wilson and Ferris, *Encyclopedia of Southern Culture*, 139.

117. Carpenter, *Ethnic Heritage in Mississippi*, 70.

118. Ibid., 160.

119. C. Reagan, "Mississippi Delta," Southern Spaces, last modified April 4, 2004, https://southernspaces.org/2004/mississippi-delta.

120. Sunflower Plantation, "Delta and Pine Land Company."

121. Jung, *Chopsticks*, 16–18.

122. Ibid., 29–30.

123. Ibid., 30–31.

124. McKenzie, "Paper Sons," 50.

125. John Jung, "Mississippi School Segregation of Chinese: Gong Lum v. Rice," Mississippi Delta Chinese, http://mississippideltachinese.webs.com/schooling.htm.

126. C.P. Gutierrez, "The Mississippi Coast and Its People: A History for Students," Biloxi Department of Marine Resources, Marine Discovery Series, 1987.

127. Arnold, *Contemporary Immigration in America*.

128. Mullins, "Italians in the Delta."

129. Carpenter, *Ethnic Heritage in Mississippi*, 170–71.

130. Gutierrez, "Mississippi Coast."

131. Cobb, *Most Southern Place*, 110–12.

132. C.R. Wilson, "Italians in Mississippi," Mississippi History Now, last modified August 2004, http://www.mshistorynow.mdah.ms.gov/articles/88/italians-in-mississippi.

133. Mullins, "Italians in the Delta."

134. Gutierrez, "Mississippi Coast."

135. McElvaine, *WPA Guide*, 166.

136. S. Rockoff, "Jews in Mississippi," Mississippi History Now, last modified 2006, http://www.mshistorynow.mdah.ms.gov/articles/90/jews-in-mississippi.

137. "Mississippi," Encyclopedia of Southern Jewish Communities, http://www.isjl.org/mississippi-encyclopedia.html.

138. Rockoff, "Jews in Mississippi."

139. Encyclopedia of Southern Jewish Communities, "Mississippi."

140. Ibid.

141. Ibid.

142. Ibid.

143. Ibid.

144. Ibid.

145. Ibid.

146. Ibid.

147. Ibid.

148. Ibid.

149. Ibid.
150. Mitchell, *Rich Past, Vibrant Future*, 4–5.
151. Rockoff, "Jews in Mississippi."
152. Ibid.
153. Encyclopedia of Southern Jewish Communities, "Mississippi."
154. Rockoff, "Jews in Mississippi."

Chapter 4

155. Kyvig, *Daily Life*, 209.
156. Greene, *No Depression in Heaven*, 81.
157. Kyvig, *Daily Life*, 232–33.
158. "Great Depression and World War II, 1929–1945," Library of Congress, http://www.loc.gov/teachers/classroommaterials/presentationsandactivities/presentations/timeline/depwwii/newdeal.
159. Brent McKee, "New Deal Programs," The Living New Deal, https://livingnewdeal.org/what-was-the-new-deal/programs.
160. Smith, *Trouble in Goshen*.
161. McKee, "New Deal Programs."

Chapter 5

162. Coe, *Square Meal*, 100–3.
163. Ownby, *American Dreams*, 63.
164. Wright, *12 Million Black Voices*, 49.
165. Coe, *Square Meal*, 112–13.
166. Smith, *Trouble in Goshen*, 121.
167. F.C. Smith, "Cooperative Farming in Mississippi," Mississippi History Now, last modified November 2004, http://www.mshistorynow.mdah.ms.gov/articles/219/cooperative-farming-in-mississippi.
168. Ibid.
169. Ibid.
170. Ibid.
171. Ibid.
172. Ibid.

173. F.C. Smith, "The Tupelo Homesteads: New Deal Agrarian Experimentation," Mississippi Department of Archives and History, https://www.mdah.ms.gov/new/wp-content/uploads/2013/07/homesteads.pdf.

174. Ibid.

175. Ibid.

176. Ibid.

177. M.H. Swain, "Senator Pat Harrison: New Deal Wheelhorse (1933–1941) Suspicious of His Load," Mississippi History Now, last modified September 2011, http://www.mshistorynow.mdah.ms.gov/articles/374/senator-pat-harrison-new-deal-wheelhorse-suspicious-of-his-load-1933-1941.

178. Smith, *Trouble in Goshen*, 35.

179. Ibid., 36–40.

180. Ibid.

181. Ibid.

182. Ibid., 42–43.

183. Ibid., 44.

184. McElvaine, *WPA Guide*, 261.

185. Smith, "Tupelo Homesteads."

Chapter 6

186. "Manufacturing Memory: American Popular Music in the 1930s: Introduction," American Studies at the University of Virginia, http://xroads.virginia.edu/~UG03/Jukebox/front.html.

187. "Earl Bascom Biography," IMDb, http://www.imdb.com/name/nm3327612/?ref_=nv_sr_1.

188. "Alvin Childress...Just Call Him 'Amos'," *The Afro American*, September 25, 1954, 4.

189. "Willie Best Biography," IMDb, http://www.imdb.com/name/nm0079008/?ref_=nv_sr_1.

190. R. Coons, "Dana Andrews Has Makings of Stardom," *Big Spring Daily Herald*, August 8, 1941.

191. "Dana Andrews Biography," IMDb, http://www.imdb.com/name/nm0000763/?ref_=nv_sr_1.

192. Hal Erickson, "Roscoe Ates," All Movie, http://www.allmovie.com/artist/roscoe-ates-p2680.

193. Brewer, *Mississippi Musicians*.
194. American Studies at the University of Virginia, "Manufacturing Memory."
195. N. Gunnell, "Swing Music and the Great Depression," Bright Hub Education, last modified January 2012, http://www.brighthubeducation.com/history-homework-help/87939-swing-music-during-the-great-depression.
196. American Studies at the University of Virginia, "Manufacturing Memory."
197. Gayle Dean Wardlow, "Godfather of the Delta Blues: H.C. Speir," Interview by Pat Howse and Jimmy Phillips, 1995, https://web.archive.org/web/20070927000312/http://www.bluesworld.com/SpierOne.html.
198. Ibid.
199. Ibid.
200. Stolle, *Hidden History of Mississippi Blues*, 39.
201. Wardlow, "Godfather of the Delta Blues."
202. Ibid.
203. Brewer, *Mississippi Musicians*, 14.
204. Wardlow, "Godfather of the Delta Blues."
205. Ibid.
206. Ibid.
207. Ibid.
208. Ibid.
209. Ibid.
210. Ibid.
211. Ralph Peer, "Ralph Peer Remembers Jimmie Rodgers," Bluegrass West, http://bluegrasswest.com/ideas/jr-rpeer.html.
212. Ibid.
213. Ibid.
214. Ibid.
215. Porterfield, *Jimmie Rodgers*, 350–55.
216. Smith, *Blues Recordings*, 297–98.
217. Ibid., 514–15.
218. Ibid., 715–16.
219. Brewer, *Mississippi Musicians*, 27–28.
220. Smith, *Blues Recordings*, 328–29.
221. Ibid., 284–85.
222. Brewer, *Mississippi Musicians*, 35–36.
223. Smith, *Blues Recordings*, 207–8.
224. Brewer, *Mississippi Musicians*, 41.

225. Smith, *Blues Recordings*, 101.
226. Ibid., 157.
227. Brewer, *Mississippi Musicians*, 18–19.
228. Ibid., 25.
229. Smith, *Blues Recordings*, 734–35.
230. Ibid., 436.
231. Brewer, *Mississippi Musicians*, 33–34.
232. Ibid., 36–37.
233. Ibid., 20–21.
234. Ibid., 21.
235. Smith, *Blues Recordings*, 109–10.
236. Brewer, *Mississippi Musicians*, 40.
237. Smith, *Blues Recordings*, 68–69.
238. Brewer, *Mississippi Musicians*, 70.
239. Smith, *Blues Recordings*, 704–5.
240. Gunnell, "Swing Music."
241. S. Yanow, "Andrew Blakeney Artist Biography," All Music, http://www.allmusic.com/artist/andrew-blakeney-mn0001206432/biography.
242. Ibid.
243. Brewer, *Mississippi Musicians*, 104.
244. Ibid., 105.
245. D.G. Maxson, "Milt Hinton," last modified 2010, http://milthinton.com.
246. J.P. Morris, "The Story Behind Darkness on the Delta," *Delta Magazine*, January 16, 2014, http://deltamagazine.com/features/darkness-on-the-delta.
247. Brewer, *Mississippi Musicians*, 107–8.
248. Brown, "When the Levee Breaks."
249. P. Keepnews, "Hank Jones, Versatile Jazz Pianist, Is Dead at 91," *New York Times*, May 17, 2010.
250. S. Yanow, "Lester Young Biography," All Music, http://www.allmusic.com/artist/lester-young-mn0000259529/biography.
251. "Legends of Big Band Jazz History—Jimmie Lunceford," Swing Music, http://www.swingmusic.net/Big_Band_Music_Biography_Jimmie_Lunceford.html.
252. R.S. Ginnell, "Gerald Wilson Biography," All Music, http://www.allmusic.com/artist/p7838.
253. McElvaine, *WPA Guide*, 159–61.
254. "John McCrady," Wikipedia, last modified June 4, 2017, https://en.wikipedia.org/wiki/John_McCrady.

255. "James W. Washington, Jr.," Wikipedia, last modified September 2, 2017, https://en.wikipedia.org/wiki/James_W._Washington_Jr.

256. "Rod Brasfield," All Music, http://www.allmusic.com/artist/rod-brasfield-mn0000293320.

257. Lloyd, *Lives of Mississippi Authors*, 484.

258. American Folklife Center, James Madison Carpenter Collection, http://loc.gov/folklife/guides/carpenter.html.

259. Lloyd, *Lives of Mississippi Authors*, 108–9.

260. Ibid., 164–65.

261. Ibid., 176–77.

262. Ibid., 362–63.

263. Ibid., 365–66.

264. Ibid., 178–80.

265. Ibid., 459–64.

266. Ibid., 475–78.

267. Ibid., 481–84.

268. Ibid.

269. Ibid., 166–68.

Chapter 7

270. Wilson and Ferris, *Encyclopedia of Southern Culture.*

271. Ferris, *Edible South*, 29.

272. Wilson and Ferris, *Encyclopedia of Southern Culture*, 613–14.

273. Ibid.

274. Ferris, *Edible South*, 23.

275. Wilson and Ferris, *Encyclopedia of Southern Culture*, 615.

276. Ferris, *Edible South*, 43.

277. Wilson and Ferris, *Encyclopedia of Southern Culture*, 615–16.

278. Ferris, *Edible South*, 127–28.

279. Federal Writers' Project, *Slave Narratives*, 1–10.

280. Ibid.

281. Ferris, *Edible South*, 123–24.

282. Ibid., 128–30.

283. McElvaine, *WPA Guide*, 9–13.

284. Ibid., 13.

285. Ibid., 27.

286. Rebecca Onion, "Is the Greatest Collection of Slave Narratives Tainted by Racism?" *Slate*, July 6, 2016, http://www.slate.com/articles/news_ and_politics/history/2016/07/can_wpa_slave_narratives_be_trusted_ or_are_they_tainted_by_depression_era.html.

287. McElvaine, *WPA Guide*, 29.

288. Ibid., 30.

289. Ibid.

290. Ibid., 104–5.

291. Ibid.

292. Ferris, *Edible South*, 104.

293. D. Moore, "Girls' Tomato Clubs in Mississippi, 1911–1915," Mississippi History Now, last modified June 2003, http://www.mshistorynow.mdah. ms.gov/articles/235/girls-tomato-clubs-in-mississippi-1911-1915.

294. M.H. Swain, "Women's Work Relief in the Great Depression," Mississippi History Now, last modified February 2004, http://www. mshistorynow.mdah.ms.gov/articles/251/womens-work-relief-in-the-great-depression.

295. Amy C. Evans, "An Introduction: Hot Tamales & the Mississippi Delta," Southern Foodways Alliance, http://www.southernfoodways. org/interview/hot-tamales-the-mississippi-delta.

296. Amy C. Evans, "Jackson's Iconic Restaurants: Big Apple Inn," Southern Foodways Alliance, March 24, 2011, http://www.southernfoodways.org/ interview/big-apple-inn.

297. Ibid.

298. Gentle Lee Rainey, "Delta Fast Food," interview by Amy C. Evans, Southern Foodways Alliance, June 23, 2005, http://www. southernfoodways.org/interview/delta-fast-food.

299. "A Hamburger by Any Other Name," Southern Foodways Alliance, http://www.southernfoodways.org/oral-history/a-hamburger-by-any-other-name/#_ftn1.

300. Ibid.

301. Ibid.

302. "Jackson's Iconic Restaurants: Elite Restaurant," Southern Foodways Alliance, last modified June 5, 2015, http://www.southernfoodways.org/ jacksons-iconic-restaurants-elite-restaurant.

303. "Jackson's Iconic Restaurants: Peaches Cafe," Southern Foodways Alliance, last modified June 3, 2014, http://www.southernfoodways.org/ jacksons-iconic-restaurants-peaches-café.

304. J. Mason, "Chinese Grocers in the Mississippi Delta," Southern Foodways Alliance, last modified May 23, 2016, http://www.southernfoodways. org/chinese-grocers-in-the-mississippi-delta.

305. Ibid.

306. Ibid.

307. Jung, *Chopsticks*.

308. Bégin, "America Eats."

309. Ibid.

310. M.B. Lasseter, "Southern Food and Pop Culture," Southern Foodways Alliance, Last modified May 1, 2015, http://www.southernfoodways. org/southern-food-and-pop-culture.

311. Palmer, "Black Domestics," 1

312. Ibid.

313. Ibid.

314. Ibid.

Chapter 8

315. Wilson and Ferris, *Encyclopedia of Southern Culture*, 8–10.

316. C.R. Wilson, "Religion and the U.S. South," Southern Spaces, last modified March 16, 2004, https://southernspaces.org/2004/overview-religion-and-us-south.

317. Greene, *No Depression in Heaven*, 104.

318. Ibid., 40–41.

319. Wilson and Ferris, *Encyclopedia of Southern Culture*, 323.

320. Wilson, "Religion and the U.S. South."

321. McElvaine, *WPA Guide*, 168.

322. Jung, *Chopsticks*, 113–14.

323. Ibid., 116–17.

324. R.J. Sparks, "Religion in Mississippi," Mississippi History Now, last modified November 2003, http://mshistorynow.mdah.state.ms.us/index. php?id=96.

325. Wilson, "Religion and the U.S. South."

326. Greene, *No Depression in Heaven*, 79.

327. Ibid.

328. Ownby, *American Dreams*, 27–29.

329. Wilson and Ferris, *Encyclopedia of Southern Culture*, 9.

330. Ibid.

331. Ownby, *American Dreams*, 27.
332. Greene, *No Depression in Heaven*, 172.
333. Cobb, *Most Southern Place*, 165.
334. Marilyn Mellowes, "The Black Church," PBS: God in America, last modified October 11, 2010, http://www.pbs.org/godinamerica/black-church.
335. Cobb, *Most Southern Place*, 167.
336. Lepore, "Chronicling the Great Migration."
337. Ibid.
338. Ibid.
339. Ibid.
340. Greene, *No Depression in Heaven*, 74.
341. Ibid.
342. Mitchell, *New History of Mississippi*, 332–33.
343. Ownby, *American Dreams*, 116.
344. Cohn, *Nothing but the Blues*, 107–9.
345. Mitchell, *New History of Mississippi*, 331.
346. Cohn, *Nothing but the Blues*, 132–33.
347. Ibid., 134.
348. Mitchell, *New History of Mississippi*, 331–32.
349. Greene, *No Depression in Heaven*, 80.
350. Ibid., 69.
351. Ownby, *American Dreams*, 92–93.
352. Greene, *No Depression in Heaven*, 116.
353. Ibid., 128–29.

Chapter 9

354. McElvaine, *Great Depression*.
355. McCarty, "Depression and Hard Times."
356. Federal Writers' Project, *Slave Narratives*.
357. Waters, *Prayin' to Be Set Free*, 4–6.
358. Federal Writers Project, *Slave Narratives*, 11–17.
359. Ibid., 18–21.
360. Ibid., 34–43.
361. Ibid., 128–34.
362. Waters, *Prayin' to Be Set Free*, 13.
363. Ibid., 28.
364. Ibid., 111.

Conclusion

365. S. Farrell, "Not Just Farms Anymore: The Effects of World War II on Mississippi's Economy," Mississippi History Now, last modified September 2001, http://mshistorynow.mdah.state.ms.us/articles/247/the-effects-of-world-war-II-on-mississippis-economy.
366. Ibid.
367. Ibid.
368. Ibid.
369. Sisson, "Moving Back to the South."
370. Ibid.

SELECTED BIBLIOGRAPHY

Arnold, Kathleen R. *Contemporary Immigration in America: A State-by-State Encyclopedia*. Santa Barbara, CA: Greenwood, 2015.

Barry, John M. *Rising Tide: The Great Mississippi Flood of 1927 and How It Changed America*. New York: Simon & Schuster, 1997.

Bégin, Camille. "America Eats: Taste and Race in the New Deal Sensory Economy." PhD thesis, University of Toronto, 2012.

Brewer, James H. *Mississippi Musicians Hall of Fame: Legendary Musicians Whose Art Has Changed the World*. Jackson, MS: Quail Ridge Press, 2001.

Carpenter, Barbara. *Ethnic Heritage in Mississippi*. Jackson: University Press of Mississippi, 1992.

Cobb, J.C. *The Most Southern Place on Earth*. New York: Oxford University Press, 1992.

Coe, J.Z. *A Square Meal: A Culinary History of the Great Depression*. New York: HarperCollins, 2016.

Cohn, L. *Nothing but the Blues: The Music and the Musicians*. New York: Abbeville Press, 1999.

Corbett, P. Scott, Volker Janssen, John M. Lund, Todd Pfannestiel, Paul Vickery and Sylvie Waskiewicz. *U.S. History*. N.p.: OpenStax, 2014. http://openstaxcollege.org/textbooks/us-history.

Deveaux, S. *Jazz: Essential Listening*. New York: W.W. Norton, 2011.

Federal Writers' Project. *Slave Narratives: Mississippi*. Washington, D.C.: Federal Writers' Project, 1941.

Ferris, M.C. *The Edible South: The Power of Food and the Making of an American Region.* Chapel Hill: University of North Carolina Press, 2014.

Fickle, J.E. *Mississippi Forests and Forestry.* Jackson: University Press of Mississippi, 2001.

———. *Timber, a Photographic History of Mississippi Forestry.* Jackson: Mississippi Forestry Foundation Inc., 2004.

Gordon, J.A. "Southern Trauma: Revisiting Caste and Class." *American Anthropologist* 106, no. 2 (June 2004).

Greene, A.C. *No Depression in Heaven.* New York: Oxford University Press, 2016.

Hoyt, John C. *Droughts of 1930 and 1934.* Washington, D.C.: U.S. Printing Office, 1936.

Isenberg, Nancy. *White Trash: The 400 Year Untold History of Class in America.* New York: Viking, 2016.

Jung, John. *Chopsticks in the Land of Cotton.* Greenville, CA: Yin & Yang Press, 2008.

King, H. "Long-Bell Lumber Company." Thesis, Louisiana State University, 1936.

Kyvig, D.E. *Daily Life in the United States 1920–1940.* Chicago: Ivan R. Dee, 2002.

Lepore, J. "The Uprooted: Chronicling the Great Migration." *The New Yorker,* September 6, 2010. http://www.newyorker.com/magazine/2010/09/06/the-uprooted.

Lloyd, James B. *Lives of Mississippi Authors, 1817–1967.* Jackson: University Press of Mississippi, 1981.

Margo, R.A. *Race and Schooling in the South, 1880–1950.* Chicago: University Press of Chicago, 1990.

McElvaine, R.S. *The Great Depression, America 1929–1941.* New York: Three Rivers Press, 1984.

———. *Mississippi: The WPA Guide to the Magnolia State.* Jackson: University Press of Mississippi, 2009.

McKenzie, R. "Paper Sons." In *The Chinese Experience in 19th Century America,* by Roberta Gumport and Marcella M. Smith, 50. Chicago: University of Chicago Press, 1928.

Mitchell, D.J. *A New History of Mississippi.* Jackson: University Press of Mississippi, 2014.

———. *A Rich Past, A Vibrant Future.* Birmingham, AL: Commercial Printing Company, 2006.

Morris, Benjamin. *Hattiesburg, Mississippi: A History of the Hub City.* Charleston, SC: The History Press, 2014.

Mullins, Camille E. "Italians in the Delta: The Evolution of an Unusual Immigration." Undergraduate thesis, University of Mississippi, 2015.

Ownby, Ted. *American Dreams in Mississippi: Consumers, Poverty, & Culture 1830–1998*. Chapel Hill: University of North Carolina, 1999.

Palmer, Phyllis. "Black Domestics During the Depression: Workers, Organizers, Social Commentators." *Prologue: Federal Records and African American History* 29, no. 2 (Summer 1997).

Porterfield, Nolan. *Jimmie Rodgers: The Life and Times of America's Blue Yodeler*. Jackson: University Press of Mississippi, 2007.

Putnam, Richelle. *Lauderdale County, Mississippi: A Brief History*. Charleston, SC: The History Press, 2011.

Sisson, C.S. "Why African Americans Are Moving Back to the South." *Christian Science Monitor*, March 16, 2014. http://www.csmonitor.com/USA/Society/2014/0316/Why-African-Americans-are-moving-back-to-the-South.

Smith, F.C. *Trouble in Goshen*. Jackson: University of Mississippi, 2014.

Smith, T.R. *The Penguin Guide to Blues Recordings*. New York: The Penguin Group, 2006.

Stolle, Roger. *Hidden History of Mississippi Blues*. Charleston, SC: The History Press, 2011.

Stubbs, Steven H. *Mississippi's Giant Houseparty: The History of the Neshoba County Fair*. Philadelphia: Dancing Rabbit Press, 2005.

Waters, Andrew. *Prayin' to Be Set Free*. Winston Salem, NC: John E. Blair, 2002.

Wheelock, David C. *Regulation, Market Structure, and the Bank Failures of the Great Depression*. Ann Arbor, MI: Inter-university Consortium for Political and Social Research, 1998.

Wilson, Charles Reagan, and William R. Ferris. *Encyclopedia of Southern Culture*. Chapel Hill: University of North Carolina Press, 1989.

Wright, Richard. *12 Million Black Voices*. New York: Basic Books, 1941.

Wynne, Ben. *Mississippi*. Northampton, MA: Interlink Books, 2008.

INDEX

A

Adams, Jane 43
agriculture 35, 53, 65, 118, 143,
 149, 150
Akers, Garfield 128
Alexander, Will W. 144
Allen, Jim 142
Allen, Moses 133
Alphabet Agencies 84
Amberson, William 109
America Eats 157
Anderson, Jeff 59
Andrews, Dana 121
Aponaug Cotton Mills 62
architecture 89
Associated Negro Press, the 19
Aunt Jemima 157
automobiles 48

B

Baker, Anna 187

banks 19, 23, 33, 37, 43, 58, 84,
 161, 163, 174
Baptist 132, 134, 162, 163, 167,
 170, 171
Bascum, Earl 119
Beal, Velma E. 57
Best, Willie 120
Big Apple Inn 151
Bilbo, Theodore 34
Biloxi 60, 73, 74, 88, 94, 96, 101,
 157, 184, 191
Black Shirts 42
Blakeney, Andrew "Andy" 130
Blaylock, Sylvester 154
blues 123, 124, 126, 127, 128, 129,
 130, 136, 152, 169, 170
boll weevil 14, 19, 80
Brandon, Ida Mae 167
Brasfield, Rodney Leon 135
Brookshire 57
Broonzy, Big Bill 129, 130
Brown, Calline 190
Brown, Luther 22

Bruce, E.L. 26
Buchalter, Louis 78

C

Cabin Teele 20
Cajun 74
Cameron, John 189
Camp Shelby 191
Carpenter, James Madison 135
Caruthers, Belle 190
Catholic 70, 74, 162
Chatmon, Armenter 129
Chevis, Parmelee 56
children 17, 19, 37, 42, 43, 52, 54,
 55, 58, 59, 60, 61, 72, 74, 81,
 105, 106, 109, 111, 112, 117,
 132, 134, 151, 162, 164, 167,
 171, 173, 179, 180, 181, 186
Childress, Alvin 120
Chinese 55, 70, 71, 72, 155, 156,
 157, 162
Choctaw 69, 96, 100, 102
Chow, Joe 55
Christianity 168
Christmas 99, 138, 146, 171, 173,
 189
churches 28, 62, 63, 71, 83, 111,
 162, 163, 170, 171
Church of God 162
city halls 97
civic auditoriums 96
Cleveland 40, 55, 77, 93, 97, 101,
 145, 162
college 48, 57, 62, 68, 93, 101, 120,
 134, 137, 156, 166
Colmer, William H. 177
Communist 42, 138
community houses 94

Conarro, Ray M. 51
Conner, Martin S. 64
Cook, Fannye A. 49
Cooperative 54, 109, 111, 112
Corinth 19, 154
corn 41, 48, 141, 142, 146, 149,
 151, 154, 174, 184
cornmeal 105, 106, 142, 144, 149,
 155
cotton 13, 23, 24, 34, 37, 39, 40,
 41, 42, 48, 53, 54, 59, 62, 70,
 73, 78, 80, 105, 109, 143,
 146, 148, 149, 150, 151, 156,
 162, 167, 181, 184, 187
courthouses and jails 95
Cox, Charlie 193
Cox, Jimmie 63, 64
Crawford, Jimmy 133
Creekmore, Herbert 135
Crosby, L.O. 25, 40
Crosby Lumber 50
Crudup, Arthur William "Big Boy"
 128
cutover 29, 31

D

Davenport, Charlie 189
Davidson, Louis 81
Davis, "Blind" John 128
Delta 17, 19, 21, 22, 34, 35, 39,
 40, 41, 42, 43, 44, 45, 48, 51,
 55, 56, 62, 68, 70, 72, 73, 74,
 75, 92, 93, 98, 100, 101, 103,
 105, 109, 111, 112, 126, 129,
 132, 134, 136, 152, 156, 162,
 163
demonstrations workers 46
DeWeese, Ab 51

DeWeese Lumber 51
Dickins, Dorothy 39, 45
diversify 144
Dockery Plantation 124, 152
Dollard, John 42
domestic workers 60, 157, 159, 172
D&PL 40
drought 23, 106, 127, 163

E

Eastman-Gardiner 26, 28
Eddy, Sherwood 109
education 50, 72, 131, 163, 164
Edwards, "Honeyboy" 129
Elite 156
Embree, Edwin 144
Emergency Banking Relief Act 84
Emergency Peace Campaign 111
Emmons Brothers 57
Emporium, The 82
Eola Hotel 78
Ephram, Willora "Peaches" 156
ethnicities 69

F

Farish Street 122, 151, 152, 156
farmers 13, 19, 31, 34, 35, 37, 40,
 42, 46, 50, 54, 57, 73, 74, 84,
 105, 109, 112, 146, 149, 152,
 154, 181, 184
farming 14, 24, 46, 59, 62, 74, 75,
 98, 117, 143, 146
Faulkner, John 135
Faulkner, William 135, 136, 138,
 164
Federal Deposit Insurance
 Corporation 84

Federal Emergency Relief
 Administration (FERA) 85,
 86, 92, 112
ferry 20
Fink, Joe 77
Flood Control Act 23, 51
flood of 1927 15, 21, 22, 75, 136,
 145
folklore 135
folkways 146
Foote, Shelby 136
Ford, Charles Henri 136
forests 24, 100
Franklin, Sam 109, 111

G

Galloway, Charles B. 166
Gardiner, Philip S. 26
Gilchrist 26
Goldberger, Dr. Joseph 145
Gordon, Jack 78
gospel 22, 122, 128, 169, 170
Gouras, John 155
Government Economy Act 84
Grand Opera House 57, 58, 81
Great Migration 19, 22, 122, 132,
 148, 193
Greek 155, 156
Green, Lillian "Lil" 129
Greenville 15, 16, 17, 19, 20, 21,
 40, 55, 73, 74, 75, 89, 101,
 136, 162, 191
Grishman, Moody 75
Gulfport 17, 61, 75, 91, 92, 101,
 180, 191

H

Hagood, Margaret J. 69
Harrison, Pat 51, 87, 114
Hattiesburg 28, 31, 55, 56, 68, 78,
 112, 113, 124, 128, 170, 176,
 186, 191
Henry, Nettie 190
Herskovitz, Melville J. 69
highway program 67
Hillhouse 109
Hinton, Milt 131
Holmes, Herbie 131, 132
Home Owners Loan Act, the 84
Homesteads of Mississippi 116
Hoover, Herbert 13, 19, 83
House, Son 123, 126, 127, 152,
 170
Hulett, F.A. 57
Hunter, D. 52
Hurt, John 124, 126
H. Weston Lumber 50

I

immigrants 69, 70, 71, 73, 74, 75,
 80, 141, 145, 152, 155
immigration 71, 78
industry 19, 24, 25, 26, 29, 31, 37,
 49, 60, 62, 64, 65, 66, 73, 74,
 78, 80, 98, 112, 118, 119,
 120, 149, 155, 158, 163, 164
Ingalls 65, 66, 191
Italians 70, 73

J

Jackson 24, 28, 46, 59, 62, 65, 66,
 67, 68, 81, 88, 96, 99, 112,
 118, 121, 123, 124, 129, 131,
 137, 138, 151, 152, 155, 156,
 158, 159, 174, 186, 189, 191
James, "Skip" 128
Jews 46, 70, 71, 74, 75, 78, 80, 81,
 82, 161, 162
Jim Crow 71, 120, 122, 130, 132,
 135, 143, 167, 168, 187, 193
J. Kantor's and Weiler Jewelry Store
 75
Johnson, Charles 53, 144
Johnson, Robert 123, 126, 129, 152
Johnston, Oscar 22
Jones, Henry W., Jr. 132

K

Kaplan's Variety Store 77
Kaufman Brothers 77
Keesler Field 191
Keeton, James 52
Key brothers 52
Kosciusko 62, 89
Kountouris, George 155
Krewe of Zeus 56

L

landowners 14, 19, 35, 37, 40, 54,
 144, 150, 192
Laub, Saul 78
Lauderdale County 48, 57, 58, 81,
 95, 124
Laurel 25, 28, 31, 51, 78, 113, 120,
 170, 191

Lebanese 55
Lee, Geno 151
Lehman 81, 121
letters 19, 136, 171, 177
levee 16, 18, 136
Loeb, Simon 77, 78
Long-Bell Lumber 26, 29
longleaf 24
Lorman 20
Luandrew, "Sunnyland Slim" 128
lumber 24, 25, 26, 29, 30, 31, 37, 49, 50, 51, 57, 59, 80, 90
Lum, Martha Gong 73
Lunceford, Jimmie 133

M

Marks, Sara Sugarman 81
Masonite 28, 51
Mason, William H. 28, 51
McClennan, Tommy 128
McCrady, John 134
Meridian 31, 48, 52, 57, 58, 59, 62, 66, 75, 78, 81, 82, 87, 90, 91, 92, 102, 113, 120, 124, 126, 149, 170, 190, 191
Meridian Union Stockyards 59
Methodists 163
Mexican 151, 152
Meyer, Harold 81
Meywebb 81
mill towns 28
minorities 71, 72, 130
Minor, J.H. 57
Mississippi Farms 112
Mississippi Forestry Commission 30
Mississippi legislature 35
Mississippi River 14, 15, 20, 23, 73, 102

Mississippi Sheiks 130
molasses 106, 107, 141, 142, 145, 147
Montgomery, Isaiah T. 54
monthly rations 106
Mound Bayou 54
Mound Landing 16
music market 122

N

NAACP 35
Natchez 20, 24, 26, 62, 66, 73, 78, 80, 98, 102, 118, 138, 167, 189
National Association for Domestic Workers 158
National Flood Control 23
National Industrial Recovery Act (NIRA) 85, 87, 112, 114
National Park Service 118
National Recovery Administration (NRA) 158, 171
National Youth Administration (NYA) 85, 92, 159
Neshoba County Fair 60
New Deal programs 51, 65, 87, 98, 102, 149, 168, 171, 172

O

Old South 158

P

Pascagoula 24, 66, 73, 179
Patton, Charlie 123, 124, 126, 127, 170
Pearl Harbor 191

Peer, Ralph 123, 124, 125, 126

pellagra 105, 106, 145

Peltz, Marion 80

Pentecostalism 162

Percy, Leroy 17, 21, 100, 136

Percy, Walker 136

Percy, William Alexander 136

Perkins, Pinetop 126

Philips-Jones 57

plantation 19, 22, 35, 40, 45, 53, 80, 105, 128, 142, 143, 152, 156, 187, 189, 190, 192

Polish 74

pork 43, 105, 141, 142, 144, 151, 174

post offices, murals and sculptures 97

Powdermaker, Hortense 42, 167, 168

Powell, Susie V. 150

"Preachin' the Blues" 170

prejudice 73, 167, 169

Presbyterian 162, 170

prohibition 84, 114

Q

Quitman 26, 130

R

radio 52, 119, 120, 121, 122, 124, 129, 130, 132, 158, 170

railroad 16, 24, 25, 42, 48, 66, 70, 74, 80, 101, 124, 152

Rainey, Gentle Lee 154

Rankin, John 87, 114

Red Cross 17, 18, 22, 23, 35, 75, 80, 106, 125, 145

refugee camps 19

relief 19, 23, 42, 75, 78, 92, 99, 105, 107, 112, 138, 145, 150, 159, 173, 176, 177, 178, 181, 184

religion 70, 146, 161, 162, 163, 170, 193

Riley, Gail 59

Riley Hospital 59

Rodgers, Andy 129

Rodgers, Jimmie 124, 125, 126, 130

Roosevelt, Franklin D. 100, 114, 155, 158

Rosedale 73, 74, 162

Rosenthal, Sam 80

Rose Seed Company 75

Rothenberg, Marks 57, 58, 59, 81, 82

Rumbough, Constance 111, 112

S

Saenger Theater 56, 57, 58

Sanders Industries 62

Sanders, James 62

sawmills 25, 26, 28, 31, 49, 50

schools 28, 53, 63, 66, 69, 71, 73, 91, 92, 107, 117, 120, 163, 167, 171, 189, 191

schools and teacher houses 87

Seafood Festival 60

Securities Act, the 84

sharecroppers 13, 17, 22, 34, 35, 37, 39, 42, 45, 54, 56, 105, 109, 129, 142, 150, 156, 162

Shoenholz, Leo 77

Sicilians 73

Sillers, Walter, Jr. 34

Simkins, Francis Butler 69
Slave Narratives 187
slugburger 154, 155
Smith, Berry 189
Socialist Party 109
Social Security Act 84, 85, 87, 114
Southern Foodways Alliance 151, 155, 156
Speir, H.C. 127
Starkville 49, 62, 99, 191
state parks 51, 100
Stein, Sam 75
stock market 13, 78, 83, 84
Stonewall 62
store 37, 54, 55, 58, 73, 75, 78, 80, 81, 82, 94, 109, 112, 122, 123, 142, 148, 152, 156, 166, 174
Sumter 26
Sunnyside Plantation 73

T

tamale 151, 154
Temple Theater 58
tenant farmers 14, 37, 39, 150
Tennessee Valley Authority 80, 85, 116, 155
textile mills 46, 62
Threefoot 58, 66, 81
timber 48
Tully 26
Tupelo 48, 62, 63, 64, 80, 87, 89, 103, 113, 116, 117, 118, 128, 171, 175, 176
Turner, Othar 130
turpentine 29

U

University of Mississippi's Glee Club 134
USDA's Bureau of Home Economics 106

V

Vance, Rupert B. 69
Vicksburg 15, 20, 26, 55, 73, 80, 81, 103, 128, 131, 132, 135, 177
Vinson, Walter Jacob 130

W

Waldauer, Lillie Johl 75
Walker, Susie W. 174
War Manpower Commission (WMC) 192
Washington County 16, 19, 22, 75
Washington, James W. 134
Waters, Muddy 126, 129
Webb, Hunter 81
Weeksburgers 154
Weeks, Dianne 154
Weeks, Willie 154
Weiner, Sol 80
Wells, Ida B. 167
Welty, Eudora 66, 121, 135, 137
Whale Store, the 75
White, Hugh 63, 65
Wilkins, Robert Timothy 130
Williamson, Joe 127
Williamson, Sonny Boy 126, 128
Williams, "Tennessee" 137
Wilson, Gerald Stanley 133

Wing, Luck 156, 157
Woodward, Ellen Sullivan 150
work relief 150
World War I 13, 29, 62, 154
World War II 52, 54, 62, 132, 191
WPA Guide to the Magnolia State 59,
 74, 118, 134, 146
Wright, Ethel 55
Wright, Richard Nathaniel 37, 105,
 138, 170

Y

Young, E.F. 57
Young, Lester 132
Young, Stark 135
Yugoslavian 74

ABOUT THE AUTHOR

Richelle Putnam is a Mississippi Arts Commission (MAC) Teaching Artist/Roster Artist (Literary), a Mississippi Humanities Speaker and a 2014 MAC Literary Arts Fellowship recipient. Her YA biography, *The Inspiring Life of Eudora Welty* (The History Press, April 2014), received the 2014 Moonbeam Children's Book Awards Silver Medal. She is also the author of *Lauderdale County, Mississippi: A Brief History* (The History Press, 2011) and coauthor of *Legendary Locals of Meridian, Mississippi* (Arcadia Publishing, 2013). The Mississippi Secretary of State's Office commissioned Richelle to write the history of the nine counties (Clarke, Kemper, Lauderdale, Newton, Neshoba, Leake, Smith, Scott, Jasper) in east-central Mississippi for the 2017 Mississippi bicentennial anniversary. Her literary work has been published in *Pif Magazine*, the *Copperfield Review*, *Birmingham Arts Journal* and several bestselling anthologies. Her freelance articles can be found in *Town & Gown Magazine*, *Mississippi Magazine*, *eat. drink. MISSISSIPPI*, *Parents & Kids*, *Well Being*, *Portico* and *Social South*.